작업 중

Work in Progress

KB077381

Typography Chapter 99: Ornament Compositon

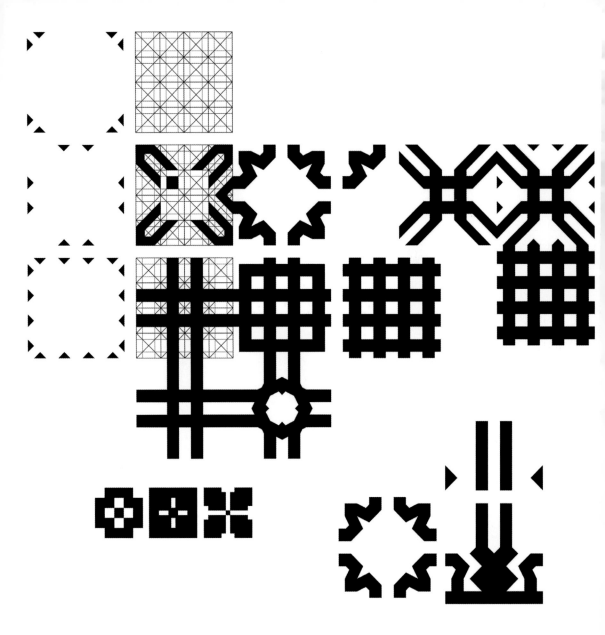

Job 8:7

Though your beginning was insignificant,
Yet your end will increase greatly.

My help comes from the LORD, the Maker of heaven and earth.

Typography 3

✳ La Divina Commedia ✳

Dante Alighieri

Nel mezzo del cammin di nostra vita
mi ritrovai per una selva oscura,
ché la diritta via era smarrita.

Ahi quanto a dir qual era è cosa dura
esta selva selvaggia e aspra e forte
che nel pensier rinova la paura!

Tant'è amara che poco è più morte;
ma per trattar del ben ch'i' vi trovai,
dirò de l'altre cose ch'i' v'ho scorte.

Inferno, Canto I, Linea 1-9.

CHI CERCA, TROVA

Third Impact

I know, I know I've let you down. I've been a fool to myself. I thought that I could live for no one else. But now through all the hurt and pain. It's time for me to respect the ones you love mean more than anything. So with sadness in my heart, I feel the best thing I could do is end it all and leave forever. what is done is done it feels so bad what once was happy now is sad. I'll never ever fall in love again.

I know we can't forget the past. you can't forget love and pride. because of that, it's kill'in me inside. It all returns to nothing, it all comes tumbling down, tumbling down tumbling down. It all returns to nothing, I just keep letting me down, letting me down, letting me down. In my heart of hearts I know that I called never love again. I've lost everything, everything that matters to me, matters to me.

the end of evangelion

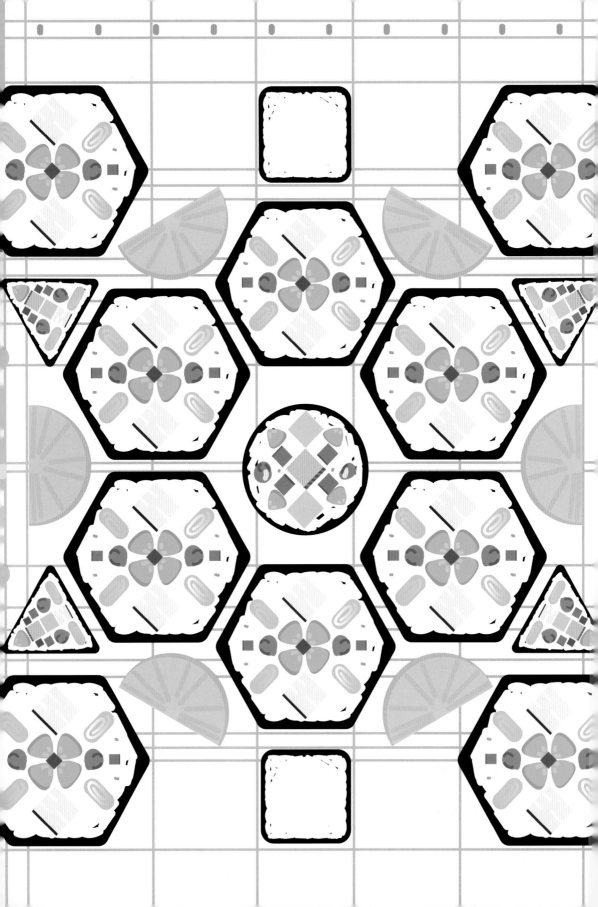

GIMBAP

Gimbap or kimbap is a popular Korean dish made from steamed bab (white rice) and various other ingredients, rolled in gim (Dried seaweed) and served in bite-size slices. Gimbap is often eaten during picnics or outdoor events or as a light lunch, served with danmuji or kimchi.

Prep Time: 30 minutes **Cook Time:** 40 minutes
Total Time: 1 hour, 10 minutes

Ingredients:

Dried seaweed (nori) 4 sheets, 2 cups cooked rice, 2 tsp sesame oil, 2 tsp salt, carrot radish, julienned cucumber, 2 eggs, ham, 1/2 pound of spinach parboiled, pickled radish, lotus root boiled in soy sauce, imitation crab.

Preparation:

1 When rice is almost cooled, mix with sesame oil and salt.
2 Stir fry carrots briefly with a dash of salt.
3 Stir fry cucumber, ham and imitation crab separately.
4 Whisk eggs until evenly yellow and fry into flat omelet. Cut cooked egg into long strips.
5 Using a bamboo sushi roller or a piece of tin foil, lay the dried seaweed shiny side down.
6 Spread about cup of rice onto 2/3 of the seaweed, leaving the top 1/3 bare.
7 Lay the first ingredient down around 1/3 of the way up from the bottom of the seaweed.
8 Lay the other fillings down on top.
9 Roll from the bottom, pressing down to make the fillings stay in. As you continue to roll, pull the whole thing down towards the end of the bamboo mat.
10 Spread a tiny dab of water along the top seam to hold the roll together.
11 Set aside and continue with other seaweed sheets.
12 Cut each roll into 7-8 pieces.

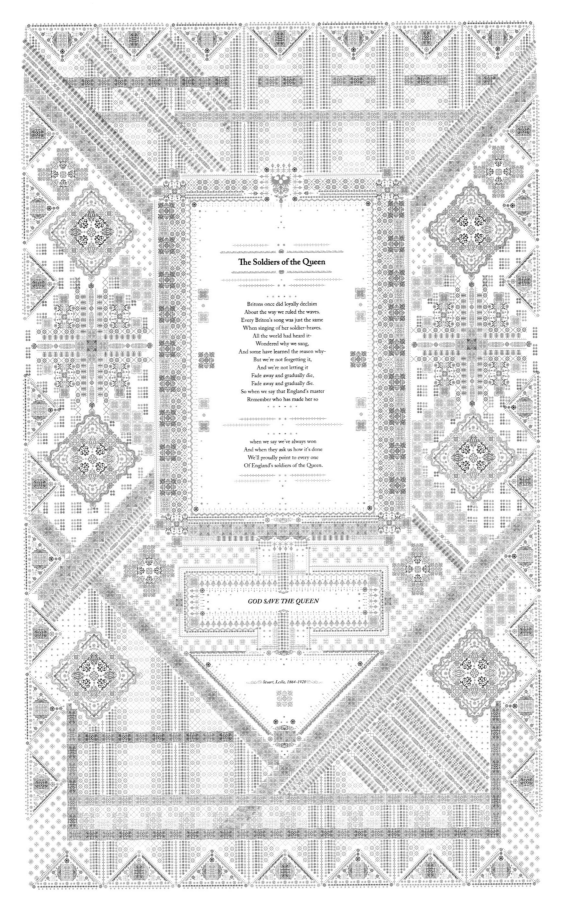

The Soldiers of the Queen

Britons once did loyally declaim
About the way we ruled the waves.
Every Briton's song was just the same
When singing of her soldier-braves.
All the world had heard it-
Wondered why we sang,
And some have learned the reason why-
But we're not forgetting it,
And we're not letting it
Fade away and gradually die,
Fade away and gradually die.
So when we say that England's master
Remember who has made her so

· · · · ·

when we say we've always won
And when they ask us how it's done
We'll proudly point to every one
Of England's soldiers of the Queen.

GOD SAVE THE QUEEN

Stuart, Leslie, 1864–1928

fin.

→ 조열음 , 챕터 타이틀 페이지를 위한 재작업, 171 × 240 mm
→ 김형민, 컴포지션 2, 297 × 420 mm
→ 김성진, 보도니 오나먼트, 584 × 841 mm
→ 임주희, 선, 225 × 405 mm
→ 최규성, 혼란과 규칙, 430 × 600 mm
→ 이아현, 김밥, 297 × 420 mm
→ 서원경, 여왕의 군인들, 450 × 720 mm
→ 임다인, 나비 무덤, 400 × 400 mm

이 작품들은 국민대학교 시각디자인과 3학년 학생들과 타이포그래피 연구자 유지원이 2013년 1학기에 진행한 워크숍 타이포그래피 챕터 99의 작업 과정과 결과물의 일부이다. 이 워크숍은 많은 타이포그래피 교과서에서 중요하게 다루고 있지는 않지만, 나름의 가치를 지니고 존재해온 타이포그래피의 현상 가운데 하나를 비판적으로 다루며 그로부터 새로운 의미를 이끌어낸다. 이번 타이포그래피 챕터 99 워크숍의 주제는 '장식 컴포지션'이었다. 오너먼트의 원칙과 문화적 배경을 이해하고 이 시대에 맞는 새로운 컴포지션 원칙을 탐구했다.

↗

→ Cho Yeol-eum, Rework for Chapter Title page, 171 × 240 mm
→ Kim Hyung-min, Composition 2, 297 × 420 mm
→ Kim Sung-jin, Bodoni Ornament, 584 × 841 mm
→ Yim Joo-hee, Linear Ornaments, 225 × 405 mm
→ Choi Kyu-sung, Confusion and Regulation, 430 × 600 mm
→ Lee Ah-hyun, Gimbap, 297 × 420 mm
→ Seo Won-kyoung, The Soldiers of the Queen, 450 × 720 mm
→ Lim da-in, Tomb of Butterfly, 400 × 400 mm

This series of works are selected from a workshop conducted by typographic researcher Yu Jiwon and the 3rd year Graphic Design major students of Kookmin University, Typography Chapter 99. This workshop dealt with issues not really addressed in usual typography textbooks but that nonetheless have meaning and importance from a critical perspective. The theme of the workshop Typography Chapter 99 was 'Ornament Composition.' This workshop explored the regularities and cultural background of ornaments and looked to a contemporary re-working of those regulations of composition.

↗

논고

Article

인쇄가의 꽃: 플러런과 아라베스크

The Flower of the Printer: Fleuron and Arabesque

이병학

취그라프, 한국

Lee Byoung-hak

CHUIGRAF, Korea

요약

이 논문은 박사 학위 논문으로 제출한 표지 장식의 역사에 기반을 둔 장식적 디자인 연구에서 표지 장식의 역사 부분을 발췌해 개괄한 것이다. 르네상스 시대에 표제지의 기원과 더불어 시작된 표지의 장식은 각 시대의 양식을 반영하며 발달했고, 활자 꾸러미에 포함된 플러런이라는 장식활자의 등장은 조판과는 달리 다양한 방향으로의 반복적 조형에 대한 가능성을 열었다. 하지만 20세기를 기해 책이 대중화되기 시작하면서 더욱 투명한 소통을 위해 이미지와 삽화가 장식을 대체했기에 오늘날 장식된 표지를 접하기는 쉽지 않다. '사용자 중심'이 수용자의 입장에 온전히 무게를 실었다면, 오늘날 다양한 실험을 위해 필요한 것은 창작자의 감상 또한 자연스럽게 발현할 수 있는 '인간 중심'의 디자인이다. 장식에 대한 욕망이 거세된 듯 구매자를 향한 소통이 주를 이루는 현실에서 이에 대한 별다른 고려가 없었던 시절의 자연스러운 꾸밈새를 살펴보고자 이 연구를 시작했다. 이를 통해 은연중에 압박되어 있던 디자이너의 내밀한 잠재성에 대해 다시 생각해보는 계기가 되기를 기대한다.

Abstract

This paper is a general summary of part of my Ph.D dissertation Decorative Design Based on a History of Title Page Decoration. From the Renaissance, book cover decoration started with the appearance of the front page and was developed according to the style of each era. Fleuron, which was included in a set of letters, was created as a decorative print and, unlike the other typeset letters, opened up the possibility of repetitive patterns spread into diverse directions. However, from the 20th century, when the book was publicized, the decorations were replaced by images and illustrations for more effective communication and it's not easy to see decorative front pages anymore. If today's trend focuses on user interface and puts weight on the readers' tastes and convenience, the humanitarian design would enable the feelings of the creators to be included on pages. In the current era, where the desire for decoration seems to be castrated and the communication with the purchasers is claimed to be the main issue, this study intends to look back on the days when the natural decoration was available without regarding much about communication matters and to rethink the unconsciously suppressed potential of designers nowadays.

주제어
플러런, 아라베스크, 오너먼트

Keywords
Fleuron, Arabesque, Ornament

→

1. 서론

디자인과의 신입생이나 비전공생들이 만든 프리젠테이션 자료일수록 내용에 비해 템플릿이 화려한 경우가 많다. 학생들은 점차 '내용물을 강조하기 위해 구조적인 요소는 최대한 투명하게 한다'는 기술을 알게 모르게 체득하기 시작하고 졸업 전시에서 최소한 그들의 작품을 '액자'에 넣지는 않는다. 대신 교묘하게 포스터의 가장자리에 작은 크기의 글줄을 삽입한다거나 아름다운 장소에서 촬영한 사진에 합성해 작품의 최소한의 구조적 경계를 표현한다. 무릇 액자를 만들고 꾸미려는 본성은 다분히 인간적이다. 우리는 이런 본성을 교정하려고 힘쓰기보다는 그것을 어떤 방식으로 반영할 것인가에 문제 의식을 두어야 한다. 이를 교정하고자 한다는 것은 이미 이에 대한 견해가 존재한다는 것이기에, 맥루언의 말대로 나는 내용물과 액자에 대한 편견이 존재하지 않았던 시대를 찾아가보고자 했다.

역사를 되짚어본 결과, 초기의 인쇄본에서 시작된 '플러런'이라는 장식 활자와 그 배경이 된 '아라베스크 양식'이 본 연구의 주제가 되었다. 플러런이 어디서 어떻게 시작되었으며, 어떤 연유로 오늘날 디지털 글자체에까지 포함되었는지의 과정을 추적하는 것이 본 연구의 처음이자 끝이다. 다행히 20세기 초 영국에서 '플러런'이라는 동명의 학회를 중심으로 플러런 및 고전적인 타이포그래피에 대한 연구가 활발히 진행된 바

1. Introduction

Presentation layouts tend to be glamorous when they are made by freshmen in design departments or students not majoring in design. Those who major in design, whether consciously or not, learn the technique based on the principle of 'making the structural elements light so that the content can be emphasised.' At least they display their final project for graduation with no frame. Instead, they insert some multi-layer text images or compose an impressive picture with great scenery to draw the minimum border around their works. It is of human nature itself to attempt to make frames and decorate them. Rather than trying to fix this nature, we may as well question how to make the best of it. Trying to fix it means there exists a certain premise about nature. That's why I wanted to date back to the days when there were no specific prejudices on the content and its frame as McLuhan also suggested.

Looking back into history, I selected the subjects of this study: the fleuron — a kind of decorative type — and the arabesque motif, which provided a backdrop for the type. This study aims at tracing down when the fleuron first appeared and how it has been included in the types of this present digital era. Fortunately, there were

번역: 임유나 Translation: Im Yoona

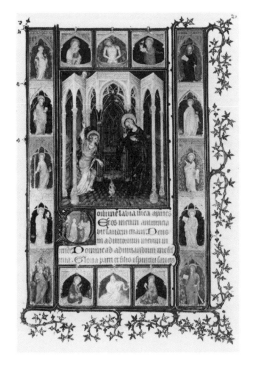

[1] (왼쪽) 1375년의 Les Petites Heures de Jean de Berry / (오른쪽) 1405년의 Belles Heures of Jean de Berry
(left) Les Petites Heures de Jean de Berry (1375) / (right) Belles Heures of Jean de Berry (1405)

있었기에 학회지에 실린 논문들이 많은 도움이 되었다. 이 글은 그것들의 번역 및 주석에 불과하다. 본 논고는 그들이 다루었던 시대 그 이전과 그 이후의 맥락을 함께 조망했으며, 중점적인 부분에서는 더욱 심도 있는 조사를 진행했다. 모더니즘의 폭격에 묻혀 적어도 한국에서는 접하기 쉽지 않았던 이 장식 활자의 역사를 간단히 소개함으로써 왼쪽에 치우치지 않는 균형 잡힌 시각을 제공하고자 한다.

2. 4차 십자군 원정과 동방문화의 유입

이슬람교도의 포로였던 중국인들을 통해 제지술이 유럽으로 전파된 것처럼 중세 서아시아의 이슬람교는 유럽의 그리스도와 대립하는 동시에 동서문화의 교두보가 되었다. 동방의 문물이 본격적으로 유럽으로 확산되기 시작한 것은 4차 십자군 원정으로 볼 수 있는데, 그 이유는 베네치아와의 이해관계에 의해 4차 십자군이 예루살렘이 아닌 콘스탄티노플로 향했기 때문이다. 1204년 4월 십자군이 콘스탄티노플을 함락하면서 로마의 수많은 문화재와 예술 작품이 파괴되었고 수많은 역사적 유산이 베네치아로 흘러들어갔다. 이후 1453년 오스만투르크에 의해 동로마의 수도인 콘스탄티노플이 함락될 때까지 페르시아 양식을 담고 있는 동양의 서적들은 이탈리아를 통해 전 유럽으로 확산되었다. 1375년과 1405년에 프랑스의 장이 제작한

a lot of studies conducted on fleurons and classic typography mainly by the Society of The Fleuron and their achievements are printed in The Fleuron. This article is merely their translation and annotation. With an attempt to shed light on the contexts before and after the selected period, this article will go into further details on some of the main points. This introduction of the brief history of the fleuron — which is at least domestically not easy to be encountered after the bombarding of modernism — will lead the readers to get more balanced perspectives on the field of the frame and decoration.

2. The Fourth Crusade and Introduction of Culture from the East

Like Chinese who transmitted the technique of manufacturing paper to Europe while captivated by Islam, while opposing Christianity, Islams were the bridge between Eastern and Western culture. The Eastern culture started to spread into Europe when the Fourth Crusade took place: the Crusaders headed off not to Jerusalem but to Constantinople because the sponsoring Venetians didn't offer enough funds. In the end, the 'sack of Constantinople' in April 1204 destroyed and looted a number of cultural assets and art works,

[2] (왼쪽) 1529년 알렉스 파가니노, II Brato, 105쪽 / (오른쪽) 1313년 경의 코란
(left) II Brato by Alex Paganino (1529) on page 105 / (right) the Quran (around 1313)

두 필사본에서 나타나는 고딕 장식의 변화를 통해 동방 문물의 확산을 살펴볼 수 있다.

1375년의 이파리들이 별다른 구성 원리에 바탕을 두지 않고 불규칙하게 자라나 있는 반면, 1405년의 이파리들은 비록 형태는 끝이 삐쭉한 것으로 별 차이가 없지만 전체 구성은 줄기가 둥글게 나선을 이루며 일정한 밀도로 여백을 채우는 모습을 보인다. [1] 이런 양상은 15세기 전반의 필사본에서 공통적으로 나타나는 현상이다. 이런 초기 아라베스크 양식의 영향은 베니스의 특산품인 레이스 공예를 위한 자수 문양집에서 더욱 확연히 드러난다. 당시 자수 공예의 일종인 레이스 공예는 귀부인들의 취미생활이기도 했기에 자수를 위한 다양한 문양 견본집이 인쇄되었고, 그중 가장 오래된 것은 1529년 발행된 알렉스 파가니노의 직물 도감이다. 이후 대부분의 문양집이 서로를 베끼거나 새로운 것을 더해가면서 아라베스크 문양은 유럽 일대로 번져나갔으며 이탈리아, 프랑스, 독일 일대에서 140권 내외의 문양집이 간행되었다.[1] 나선형의 줄기가 방사대칭 형태로 복잡하게 얽혀 있는 1313년경 코란의 장식된 지면에서 이들의 기원을 찾을 수 있다. [2]

1
스탠리 모리슨, 프랜시스 메이넬, 인쇄가의 꽃과 아라베스크, 더 플러런 1권, 1923, 14쪽
Stanley Morison and Francis Meynell, Printers' Flowers and Arabesques, The FLEURON vol. I, 1923, p. 14

bringing historical heritage from Rome to Venice. Before the siege and fall of the Eastern Empire capital Constantinople by the Ottoman Turks in 1453, the books from the East spread through Italy all over Europe. The expansion of Eastern culture is reflected in two manuscripts of Jean from France which were made and written in 1375 and 1405.

While the decorative leaves drawn in 1375 seem irregular and not based on a certain compositional principle, the leaves from 1405 seem more even, though similar to the former with regard to the sharp edges, the density of filling the margins, overall forming circular spirals with their stalks. [1] This style is shown in the manuscripts from the 15th century in general. Such an influence from the early arabesque motif appears more distinctively in the pattern books for lace-making. By then, the lace-making was like a kind of embroidery, a pastime for noblewomen. There were diverse pattern samplers printed, the oldest of which were Il Burao by Alex Paganino published in 1529. After it, most samplers copied each other as well as they added something new, popularizing the arabesque motif in European countries. Approximately 140 varieties of pattern books were published in Italy, France and Germany.[1] Their origin can be found in the Quran from 1313 with

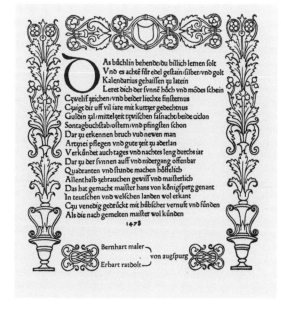

[3] (왼쪽) 푸스트와 쉐퍼의 시편 표제지 / (오른쪽) 라트돌트가 간행한 칼렌다리움 제3판의 표제지
(left) The title page of Schoeffer's Psalter in Latin / (right) The title page of the third edition of Calendarium published by Erhard Ratdolt

3. 표제지의 분리

스탠리 모리슨은 타이포그래피의 첫 번째 원칙들에서 "보다 거시적인 관점에서 보았을 때 인쇄의 역사는 표제지의 역사이다."라고 썼는데,[2] 필사본에서 활자 인쇄로의 이행 과정에서 가장 괄목할 만한 책의 구조적인 변화는 표제지의 등장이다. 중세의 필사본은 성경을 중심으로 한 복음서가 대다수를 차지하고 있었기 때문에 누가 이 책을 지었으며, 누가 이 책을 필사했고 그 시기는 언제인지에 대한 정보는 별로 중요하지 않았다. 르네상스의 시작과 인쇄술의 보급으로 책의 종류와 수량이 급격히 늘어나기 시작하고 책을 사고파는 것이 산업으로 발달하면서 비로소 르네상스 시대의 사람들은 인문학적 명성과 지적 자산이라는 관점에서 책을 바라보기 시작할 수 있었다. 최초로 표제지를 별도로 분리한 사례는 1457년의 요아힘 푸스트와 쇠퍼의 라틴어로 된 시편으로 일컬어지지만, 책 자체의 내용이 성경의 일부였기 때문에 제목과 저자에 대한 언급이 없어서 표제지라기보다는 간기에 가까웠다. [3]

책을 분명히 식별할 수 있도록 제목, 저자, 요약 및 인쇄가의 이름을 명시한 가장 오래된 표제지는 1476년 베니스에서 에르하르트 라트돌트가

2
스탠리 모리슨, 타이포그래피의 첫 번째 원칙들, 더 플러런 7권, 1926, 61쪽
Stanley Morison, First Principles of Typography, The FLEURON Vol. VII, 1926, p. 61

the decorated pages with the stalks entwined in a radial, symmetric shape. [2]

3. The Separation of the Title Page

Stanley Morison says in First Principles in Typography "in a broader point of view, the history of print is the history of the title pages."[2] During the transformation from handwritten books to printed ones, one of the most significant changes in the elements of a book is the introduction of the title page. In the Middle Age, the handwritten manuscripts were mostly the Gospels, the books related to the Bible, so not really important was the information like when they were written, who copied the books, or when they were done. The beginning of the Renaissance and the dissemination of printing enabled the increase of the number and variety of books, making people see the buying and selling of books as an industry. It was now that people started to see the books in terms of literary reputation and intelligent property. The first example with the title page from the content is known to be Joachim Fust and Peter Schoeffer's Psalter in Latin published in 1457, but its content was the part of the Bible, so the title page didn't contain a title, nor an author's name, seeming to be there only to mark the imprint. [3]

[4] (왼쪽) 죽음의 기술의 표제지 / (오른쪽) 1479년 아치오 주코의 이솝우화의 내지(1473년, 베로나 재인쇄판)
(left) The title page of Ars Moriendi / (right) The inside front cover of Aesop's Fables (1479) published by Accio Zucco
(reprinted in Verona)

간행한 아우크스부르크의 요하네스 레지오몬타누스의 칼렌다리움(달력)이다. 이 표제지에는 위쪽과 양쪽에 줄무늬 형태의 목판 장식이 위치하며 아래쪽에는 인쇄가의 이름이 간단한 매듭 형태를 가진 두 개의 장식 조각이 있다. 목판 장식이 분절되어 작은 정방형의 형태로 축소된 이 두 개의 조각이 지오반니와 알베르토 알비세 형제가 사용한 꽃무늬 활자의 원형이 된 것이다. 푸스트와 쇠퍼의 시편 이후 전파된 초기의 표제지는 독자와의 커뮤니케이션보다는 내지의 보존을 위한 먼지 덮개의 성격이 강했던 반면, 라트돌트의 표제지는 독자의 흥미를 끌 수 있는 장식적 요소와 함께 책의 내용이 요약되어 있었기에 3판 및 다국어로 간행되는 상업적 성공을 거두었다. 이후 표제지의 장식과 타이포그래피는 16세기 전반에 걸쳐 유행했고 이후 바로크, 로코코, 신고전주의, 아르누보에 이르기까지 독서 인구의 일반적 취향을 반영하는 거울이 되었다.

4. 플러런의 기원

라트돌트의 작은 목판 장식을 활자와 함께 조판할 수 있도록 금속 활자로 발전시킨 것이 플러런의 기원이 되었다. 가장 오래된 사례는 지오반니와 알베르토 알비세 형제의 것이다. 1478년 4월 28일 간행된 죽음의 기술은 이후 15세기 내내 베스트셀러를 차지했으며, 1501년까지 필사본 형태와 목판 인쇄본, 활판 인쇄본

The oldest book with the title page specifying the name of the author, the title, the abstract and the printer for clear identification of the piece is Calendarium, a work by Joannes Regiomontanus of Augsburg, which was published by Erhard Ratdolt in 1476 in Venice. Its title page has woodcut decorations at the top and at each side, and at the bottom is printed two pieces of an ornamental pattern. The two pieces of the pattern, scaled down from articulated woodcuts into a small square form, are the prototype of the fleuron that would later be used by Giovanni and Alberto Alvise Brothers. The early title pages right after Schoeffer's Psalter in Latin functioned more as the dust jacket for inner pages, rather than to improve the communication with the readers. Whereas Erhard Ratdolt's title page contained the abstract with interesting decorations so that the book achieved success to the extent of being published in three languages and appearing in third editions. Later on, the adornment and typography of the title page came into fashion throughout the 16th century, a mirror to reflect the general taste of reading populations in the period from baroque and rococo to neoclassicism and art nouveau.

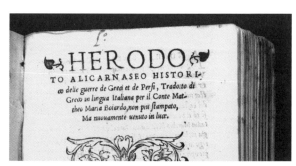

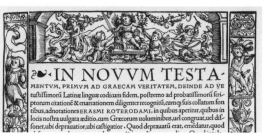

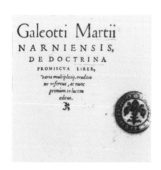

[5] (위쪽) 1502년 알디네 출판사에서 간행된 헤로도토스 표제지 / (아래) 1517년 프로벤이 간행한 신약성서
(up) The title page of Herodo (1502) published by Aldine Publisher / (down) Novum testamentum (1517) published by Froben

[6] 1532년 군주론 / 1548년 De Doctrina of Galeotti Martius에 사용된 삼엽 형태의 플러런과 세로 방향의 플러런
(left) Il Principe (1532) / (right) The trefoil and longitudinal fleuron used in De Doctrina of Galeotti Martius (1548)

등을 포함해 65가지의 판본이 제작되었다. 단
두 종류의 플러런만으로 다양하게 장식된 죽음의
기술의 지면들에서 플러런은 그림 4와 같이 글자와 함께
조판되어 제작의 효율성과 장식의 풍부함을 보여주었다.
같은 시기에 간행된 라트돌트의 아피안에 비해 장식의
형태적 복잡성이나 밀도가 상대적으로 단순했음에도
죽음의 기술이 상업적 성공을 거두면서 장식 활자의
새로운 시대가 시작된 것이다. 목판에서 금속 활자로
매개되는 과정에서 플러런은 오늘날의 디지털
글자체로도 살아남을 수 있게 되었다. [4]

5. 알두스의 알디네 잎사귀

오늘날 디지털 글자체에서의 플러런은 유니코드의
딩뱃 블록에서 찾을 수 있는데, 이 블록은 ITC 자프 딩뱃
시리즈 100을 기준으로 작성된 것으로, 유니코드의
U+2766(❦)과 U+2767(❧)에 가로와 세로 방향의 두
가지 플러런이 포함되어 있다. 이들은 알비세 형제가
최초로 사용했던 것에 비해 형태적으로 좀 더 단순하고
뚜렷한 이파리의 형태를 보이는데, 이는 알두스
마누티우스의 인쇄소에서 처음으로 사용된 것으로
그의 이름을 따서 종종 '알디네의 잎사귀'로 불린다.
알두스는 아라베스크 문양의 곡선을 단순화하여 금속
활자로 조각했으며 이것들을 문단의 시작을 알리는
지시자 또는 고깔 모양 문단의 끝을 마감하는 종결자로

4. The Origin of the Fleuron

The fleuron originates from the metal types
developed from Ratdolt's miniature woodcuts.
The oldest fleuron is used by Giovanni and Alberto
Alvise Brothers. On April 28, 1478, Ars Moriendi
was published and became a bestseller throughout
the 15th century, produced in at least 65 versions
including manuscripts, xylographs and presswork
until 1501. Ars Moriendi contains only two types of
fleurons. But the fleurons well decorate the pages
and are typeset with the letters so as to enhance
the efficiency of manufacturing and the richness of
the content. Compared to the Appian, published
in the same period, the decoration seems rather
simple and low in density, but the success of Ars
Moriendi started the new era for typographic
ornaments, enabling the fleuron to survive along
the passage from the woodblock printing through
metal types to the digital printing. [4]

5. The Aldine Leaf of Aldus Manutius

Today, fleurons are found in the dingbat block of
Unicode. This block is formulated based on ITC
Zapf Dingbat series 100, containing the longitudinal
and traverse fleurons and in U+2766(❦) and
U+2767(❧). As compared to the ones used by
Alvise Brothers, the present fleurons show simpler

[7] 1555년 단테의 신곡에서 지올리토가 사용한 복잡한 형태의 플러런들
Complicated fleurons used by Gabriel Giolito in Divina Commedia (1555)

24

사용했다. 1502년 알두스의 인쇄소에서 간행된 헤로도토스의 표제지 상단에 로만체 대문자의 제목과 함께 조판된 한 쌍의 플러런을 살펴볼 수 있다. [5 왼쪽] 이 작은 이파리 형태의 금속 활자는 처음 이탈리아에서는 'piccoli ferri'로 불렸으며, 후에 프랑스어로 'petits-fers'라고 불렸다. 작은 쇳조각이라는 의미의 'piccoli ferri'는 알디네 고전과 같이 광범위하게 복제되었으며 이탈리아에서뿐 아니라 바젤, 아우크스부르크, 리옹, 안트베르펜, 파리를 포함한 전 유럽으로 확산되었다.[3]

유럽의 많은 자모 조각가들이 알두스의 플러런을 복제해 사용하기 시작했는데, 특히 당시 이탈리아와 분쟁상태에 있던 프랑스에서 아라베스크 양식이 유행하면서 파리에서 활발하게 사용되었는데 그 시초는 앙리 에스티엔의 5개역 대조시편이었다. 다양한 플러런 중에서도 1517년 바젤의 프로벤이 신약성경의 표제지에 사용한 것이 오늘날 유니코드에 포함된 것과 거의 유사한 형태의 완성도를 보인다. [5 오른쪽] 이탈리아에서는 로마의 안토니오 블라도가 1532년경 마키아벨리의 군주론에서 '삼엽 형태의 플러런(trefoil)'을 사용했으며, 플로렌스의 로렌스 토렌티노는 1548년의 '마르티우스의 교리'에서 세로 방향의 플러런을 사용했다. [6] 그 후로 이탈리아에서는 같은 원천에서 파생된 더욱 복잡한 형태의 플러런들이 등장하는데,

<div style="text-align:right">3
앞의 책, 15쪽
Ibid., p. 15</div>

and clearer leaf shapes. The fleurons were first used at the printer of Aldus Manutius, often called "Aldine leaf (leaves)" after his name. Aldus carved a simplified form with arabesque curves into a metal type and used the type for the indication of the start of a new paragraph or the terminator of an inverted-triangle-shaped paragraph. As seen in figure 5, at the top of the title page of Herodotus, printed at Aldus's printer in 1502, appear a pair of fleurons typeset at each side of the Roman-letter title in upper case. The small leaf-shaped metal type was first called in Italy "piccolo ferri" and afterwards in France "petits-fers." The "piccolo ferri," which means the small metal piece, started to be copied and widespread along with the Aldine classics, not only within Italy but in many European cities including Basel, Augsburg, Lyon, Antwerp and Paris.[3]

Typesetters all over Europe imitated the Adine-style fleuron, especially those in France, the country which was battling with Italy and where the arabesque style came into fashion. Quincuplex Psalterium by Henri Estienne is one of the early examples. In Basel, Froben typeset the fleuron on the tile page of Novum Testamentum. The form of the fleuron nearly reached completion as seen in today's Unicode. [5] In Italy, Antonio

[8] (왼쪽) 1524년 베니스의 테두리 장식 / (오른쪽) 1537년 리옹의 테두리 장식
(left) The decorative frame used in Venice (1524) / (right) One used in Lyon (1537)

베니스의 가브리엘 지올리토가 사용한 복잡하고 다양한 형태의 플러런에서 이런 경향을 살펴볼 수 있다. [7] 이후 복잡한 형태의 플러런들은 쇠퇴하고 새로운 변화의 플러런이 리옹에서 시작되었다.[4]

6. 베르나르 살로몽의 목판 테두리 장식

16세기 초 플러런은 주로 독립적으로 사용되었으나 종종 반복되어 테두리 장식으로 사용된 사례 또한 발견된다. [8] 하지만 플러런을 단순하게 반복해 배치한 테두리 장식은 라트돌트의 아피안과 같은 목판 장식을 따라가기에는 완성도와 조형성이 많이 부족했다.

이에 16세기 중반 리옹에 위치한 장 드 투른의 인쇄소에서 조합 가능한 플러런들을 사용해 그 배열 방식에 따라 수백 가지의 새로운 조합이 가능하도록 만드는 혁신이 시작되었다. 파리에 조프루아 토리와 클로드 가라몽이 있었다면 리옹에는 베르나르 살로몽과 로베르트 그랑종이 있었던 것이다. 또한 파리는 소르본느대학의 신학자들로부터 간섭과 통제를 받았기 때문에 르네상스 인문주의를 마음껏 받아들이기 어려웠지만, 리옹은 중앙정부로부터의 거리가 상대적으로 멀었기 때문에 비교적 자유롭게 이탈리아의 아라베스크 양식을 받아들이고 더욱 발전시킬 수 있었다. 이 새로운 시도에 앞서 이를 가능케 했던

[4]
앞의 책, 19-20쪽
Ibid., pp. 19-20

Blado used the trefoil fleuron in the first edition of Il Principe of Machiavelli around 1532, and Laurence Torrentino from Florence used the longitudinal fleuron in De Doctrina of Galeotti Martius in 1548. [6] Then in Italy appeared more fleurons in more complex shapes from the same origin, as shown in the diverse versions of fleurons used by Gabriel Giolito. [7] The intricate-patterned ones declined subsequently as Lyon introduced another change.[4]

6. The Ornamental Woodcut Border of Bernard Salomon

In the early 1500s, the fleuron was used as a separate type but some examples show it was also used side by side as borders as seen in figure 8. But the fleurons simply put in a line lagged far behind the level of those printed in Appian in terms of completion and formativeness.

It was around the middle of the 16th century that the printer of Jean de Tournes developed the innovation to make hundreds of new compositions possible according to the arranging patterns of the fleurons. If there were Geofroy Tory and Claud Garamond in Paris, there were Bernard Salomon and Robert Granjon in Lyon. While the theologists in Sorbonne took control and ruled over the printing materials in Paris and made it difficult to

[9] (왼쪽) 1530년 La Fleur de la Science de Portraicture에 삽입된 펠레그리노의 아라베스크 장식 / (가운데) 1543년 Heures de la Vierge에 삽입된 토리의 장식 / (오른쪽) 1557년 오비드의 변형에 삽입된 살로몽의 장식
(left) The arabesque motif from La Fleur de la Science de Portraicture (1530) / (center) Tory's decoration from Heures de la Vierge (1543) / (right) Salomon's decoration from Metamorphoses of Ovid (1557)

베르나르 살로몽의 아라베스크 목판 테두리 장식에 관해 먼저 살펴보아야 할 것이다.

16세기 중반까지 투른 1세의 거의 모든 목판 장식을 조각했던 베르나르 살로몽은 1508년 리옹에서 태어났다. 그는 초기에 파리에서 공부했으나 1540년 투른 1세가 인쇄소를 차린 시점에 리옹으로 돌아와 이후 평생을 투른 1세를 위해 일했으며 그의 딸은 활자 조각가이자 제작자인 로베르트 그랑종과 결혼했다. 살로몽은 1560년에 일을 그만두고 1561년에서 1562년 사이에 타계했다.[5]

다양한 아라베스크 문양집 중에서도 꽃무늬 견본집(1530)에 삽입된 프란체스코 펠레그리노의 장식물이 조프루아와 토리에게 많은 영향을 주었으며 또한 16세기 중반 이미 상당히 유명했던 토리에게서 영향을 받았음을 짐작해볼 수 있다. 살로몽의 대표작 가운데 하나인 1557년의 오비드의 변신에서 보이는 섬세한 테두리 장식은 1543년 파리의 시몽 드 콜리네가 제작된 시간의 서 성모편에 삽입된 토리의 테두리 장식과 유사하며, 토리는 다시 펠레그리노의 장식으로부터 머리와 꼬리 부분의 영향을 받았음이 나타난다.[6] [9] 이런 관계를 성립시키는 공통적인 요소는 장식의 중앙부에 등장하는 작은 십자가 형태이다.

freely investigate humanism of the Renaissance, printers in Lyon, thanks to the fair distance from the central government, found it freer and easier to adopt the Italian arabesque style and develop it on their own. But to start with, the ornamental woodcut border of Bernard Salomon, the person who enabled the great renovation, has to be explored.

Bernard Salomon was born in 1508 in Lyon. He was the typesetter who carved almost all of the woodcut ornaments of Jean de Tournes until the middle of 16th century. He first practiced in Paris but came back to Lyon in 1540 when Jean de Tournes opened a printing house. Salomon worked for Jean for a lifetime and Salomon's daughter married a man called Robert Granjon, a typographer and a type producer. It was in 1560 when Salomon stopped working and he died between 1561 and 1562.[5]

Salomon's works seem to be influenced by those of Geofroy Tory, who was already very famous by the mid-1500s. Tory's works were inspired a lot from the arabesque ornaments of Francesco Pellegrino printed in La Fleur de la Science de Portraicture (1530), among others. Metamorphoses of Ovid, one of the representative works of Salomon, published in 1557, has delicate

5
앞의 책, 22-23쪽
Ibid., pp. 22-23

6
앞의 책, 26쪽
Ibid., p. 26

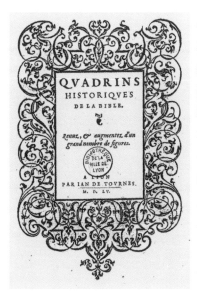
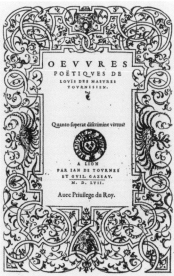
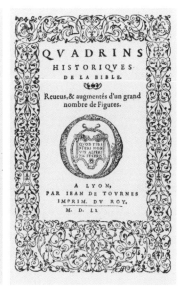

[10] 살로몽이 제작하고 투른이 간행한 책들에 공통적으로 사용된 표제지 장식 (왼쪽부터 1555년 , 1557년, 1560년)
Cover ornaments for books manufactured by Charlemagne and published by Tournes (from left 1555, 1557, 1560)

프랑스 국립도서관에서 제공하는 전자도서관 서비스 '갈리카(gallica.bnf.fr)'를 통해 16세기 당시 장 드 투른이 출판하고 살로몽이 장식했던 200여 권에 달하는 서적들에 대한 조사를 진행했다. 대부분의 서적들은 표제지를 중심으로 사례를 조사했고 살로몽의 대표작으로 일컬어지는 1557년 오비드의 변신은 그림책이었기에 모든 지면에 걸쳐 장식을 분석했다.

그림 10은 살로몽의 목판 장식들 중 투른 인쇄소에서 간행한 책들의 표제지 테두리 장식으로 사용된 세 가지 장식이다. 그림 10-1의 테두리 장식은 1554년, 1555년(8), 1556년(3), 1559년의 사례에서 발견되며, 총 6년에 걸쳐 13종류의 책에 사용되었다. 그림 10-2은 1555년(3), 1556년, 1557년(6), 1558년, 1560년의 사례에서 찾았으며, 총 6년에 걸쳐 12종류의 책에 사용되었다. 이 사례들은 투른이 간행한 모든 책의 사례는 아니며, 아라베스크와 삽화적인 양식이 혼합된 사례도 발견된다. 하지만 논문에서는 당시 르네상스를 풍미했던 아라베스크 양식을 순수하게 보여줄 수 있는 사례에 집중했다. 여기 마지막으로 그림 12의 한 가지 사례를 더 포함시켜야 할 것이다. 이 표제지는 프랑스 국립전자도서관에서는 찾을 수 없었으며, '스키너'라는 고미술품을 경매하는 웹사이트에서 발견했다. '갈리카'에서 그림 10-3의 장식물은 살로몽의 사후인 1588년 투른 2세가 간행한 파라독스에서 오직

ornamental borders very similar to those of Tory in Heures de la Vierge, the book manufactured by Simon de Clines in 1543. The head and tail of Tory's once again prove the influence from Pellegriono.[6] [9] What is common in three is the little cross shape at the middle of the adornment.

Through the online search service Gallica of French national library (BnF), I examined nearly two hundred books manufactured by Jean de Tournes and decorated by Salomon. Mainly the title pages of the books were looked into, and the aforementioned picture book Metamorphoses of Ovid was exceptionally examined from the first to the last page.

The figure 10 show the three types of title pages with Salomon's decorations published by the Tournes's printing company. The type of border as seen in figure 10-1 is discovered in books published between 1554 and 1559. Over six years, there were thirteen books with the pattern. The figure 10-2 type is shown in books published between 1555 and 1560, and there are twelve books in total containing the ornamental border. These are only part of the books printed by Jean, and there are some examples with patterns of arabesque motifs and some illustrations mixed. This study will focus only on those with arabesque

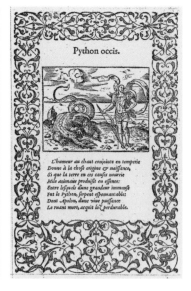

[11] 오비드의 변신 내지 목판 양각 아라베스크 장식들 중 일부. 살로몽은 이 그림책을 위해 총 19가지의 순수한 아라베스크 테두리를 조각했으며, 이 중 열 가지 장식이 양각으로, 나머지는 라트돌트의 아피안과 같이 음각으로 조각되었다.
Part of the arabesque decorative borders (woodcut in relief) contained in Metamorphoses of Ovid. For this sole picture book, Salomon carved 19 different arabesque frames. Ten of them were in relief, and the rest nine of them were engraved in sunken relief like those in Ratdolt's Appian.

한 차례 발견되었다. 가장 뒤늦게, 그리고 그의 타계 직전에 인쇄된 클로드 파라댕의 구약 성경의 1560년 판에 등장하는 이 표제지 장식은 그의 타계 시점을 감안할 때 살로몽의 유작이며 1557년의 오비드의 변신에서 먼저 내지의 테두리 장식으로 사용되었던 것이다. 아마도 오비드의 변신이 출판된 이후, 책에 포함된 수많은 아라베스크 장식들 가운데서도 그 조형적 아름다움이 뛰어났기에 3년 뒤 투른 출판사를 대표하는 장식으로 사용되었던 것으로 추측된다. 이 장식은 350년의 시간을 뛰어넘어 20세기 초 스탠리 모리슨을 비롯한 후대의 타이포그래퍼들이 르네상스 장인들의 진지함과 아름다움을 복원하기로 결정한 뒤 간행된 펠리컨출판사의 타이포그래피(1923)의 표제지 장식으로 사용되었다.

살로몽의 장인정신이 깃든 아름다운 책이 1557년 투른의 인쇄소에서 출판되었다. 이 책이 앞서 언급했던 오비드의 변신이다. 2장의 앞머리 그림, 표제지, 180쪽의 본문, 끝머리 그림의 순서로 총 185쪽으로 구성된 이 책은 표제지의 왼쪽 지면이 비어 있는 것을 빼고는 모든 지면이 목판 장식과 삽화를 포함하고 있다. 180쪽에 달하는 본문에서 살로몽은 총 27가지의 목판 테두리 장식을 번갈아가며 사용했다. 이 중 삽화적인 표현이 가미된 장식을 제외한 19가지의 모든 아라베스크 테두리 장식이 그의 손끝에서 탄생한 것이다.

patterns. Finally, the style shown in figure 10-2 is not from the gallica (BnF online service) but from Skinner, a website for ancient art auction. On gallica, the same pattern was discovered but only in one book, Paradoxe, published by Jean de Tournes, Jr in 1588, after the death of Jean de Tournes, Sr. The edition of Quadrins Historiques de la Bible published in 1560 [10-2] seem to be the posthumous work of Salomon and what was first used as the ornamental border for the inner pages of his Metamorphoses of Ovid. Assuming that the pattern is of such a beauty, after three years, it must have been used as a representative decoration of Tournes among other arabesque motifs. The frame was used in the beginning of 20th century, 350 years after it was first produced, by Stanley Morison and other typographers who decided to restore the beauty and sincerity of the artisan from the Renaissance period. It was placed on the title page of Typography (1923) published by Pelican Publisher.

In 1557, the books were published at the Tournes printing company which shows the craftsmanship of Salomon: Metamorphoses of Ovid. The volume contains the front-piece on page two, the title page, the body on page one hundred and eighty, and the end-piece. The 185-page copy

[12] 그랑종의 플러런 (왼쪽) 1596년 비밀의 책 면지 장식 / (오른쪽) 1610년 런던에서의 사례
Granjon's Fleuron. (left) the end paper of A Book of Secrets (1596) / (right) an example found in London (1610)

7. 그랑종의 플러런

오비드의 변신을 통해 보여준 수많은 목판 테두리를 조각하면서, 전체적으로는 다르지만 부분적으로는 반복되는 유사한 패턴의 아라베스크 문양을 반복적으로 조각하는 과정에서 살로몽은 당시 본문에 함께 조판되어 있던 플러런의 새로운 가능성에 대해서 생각해보았을 것이다. 또한 보다 작은 판형의 책에서 플러런을 반복적으로 사용해 테두리 장식을 만드는 사례가 이미 16세기 초반의 책들에서 발견된다. 이런 플러런들을 모듈화하여 다양하게 조합이 가능한 형태로 만든다면, 목판에 버금가는 우수한 품질의 테두리 장식을 훨씬 빠르고 효율적으로 생산할 수 있다. 결국 살로몽과 그랑종은 금속 활자로 된 8개의 모티프가 다양한 구성으로 재조합되면서 두리 장식, 머리띠, 꼬리 장식, 독립 장식 등 다양한 형태로 구현이 가능한 새로운 방식의 플러런을 창조했으며, 혁신을 가져왔다.[7] 당시 리옹의 인쇄가들은 표지 제본 과정의 수작업 공정에 도구 장식 표지를 도입하기 시작했는데, 이런 과정에서 본문에 사용되던 금속의 플러런들이 화려한 표지 장식을 위해 목판을 대체했음을 짐작할 수 있다.[8]

살로몽의 딸이 활자 제작인인 로베르트 그랑종과 결혼했다는 점, 그리고 이 플러런들의 조형적 완성도를

has the woodcut decorations and illustrations on every page except the opposite of the title page. In it, Salomon used 27 kinds of woodcut ornamental borders in all. Apart from those with illustration, the 19 arabesque decorations were created by Salomon himself.

7. Granjon's Fleuron

While engraving the numerous woodcut frames that are overall different from each other but partially similar in pattern in Metamorphoses of Ovid, Salomon must have thought about the possibility of novel fleurons typeset with the text in the body. In as early as the beginning of 16th century, the smaller sized books were made with the fleurons forming frames. If only the fleurons could be made into modules and composed in diverse ways, they would be used in producing as high-quality border decorations as made of woodblocks. So what Salomon and Granjon did in the end was to make a whole new set of eight metal-type motifs which could form borders, headbands, tail-pieces, and floating fleurons depending on how they were to be composed.[7] By then, the printers of Lyon started to introduce tooled binding in the process of binding the cover, and it is assumed that the metal fleurons replaced

7
앞의 책, 30쪽
Ibid., p. 30

8
앞의 책, 26쪽
Ibid., p. 26

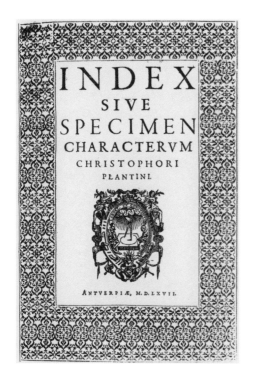

[13] (왼쪽) 가라몽의 플러런이 사용된 1567년의 가라몽 활자 견본 / (오른쪽) 1609년의 두에-라임스 성경
(left) Index Characterum (1567) / (right) Douai-Rheims Bible (1609)

통해 짐작해볼 때 그랑종이 최초의 조합 가능한
플러런을 조각했음을 알 수 있다. LTC(Lanston Type
Company)에서 디자인하고 P22에서 판매하고 있는
디지털 글자체의 이름은 '플러런 그랑종'이며, 존 라이더
또한 플러런 모음(1957)에서 이 플러런들을 '그랑종의
플러런'이라 부르고 있다. 또한 그는 그랑종이 플랑탱을
위해 언투배루펜에서 활동할 당시 이들이 '그랑종의
아라베스크'라 불렸다고 적고 있다. 이 그랑종의
플러런은 1554년 실비우스의 아라베스크 문양집에
처음으로 등장했으며, 1572년 이후로 실비우스가 계속
사용했다. 1590년 로마에서도 이 플러런이 사용되었고,
당시 그랑종이 로마에 있었음이 확인되므로 결국
살로몽의 말기에 그랑종에게 주었던 많은 영감들을
바탕으로 그랑종은 최초의 조합 가능한 플러런을
디자인했을 것이다.[9]

8. 가라몽의 플러런
그랑종의 플러런과 더불어 다른 종류의 플러런이 탄생해
현재까지 살아남았으며 그것은 1567년 안트베르펜에서
플랑탱이 인쇄한 가라몽 활자 견본에 클로드 가라몽의
로만체, 그랑종의 이탤릭체와 함께
포함되어 있었다. 그림 12의 가라몽 활자
견본은 그랑종과 유사하면서도 일부는
새로운 플러런을 포함하는데, 당시

the woodcut ones to be used on the lavish
book covers.[8]
 Judging by the fact that Salomon's daughter
married him and the completion of the set of
fleurons, Granjon seems to be the first person who
made the fleurons that are able to be composed.
The digitalized fleurons that LTC(Lanston Type
Company) designed and P22 sells now are called
Fleuron Granjon, and also John Ryder called
those fleurons 'Granjon's Fleuron' in his A Suite of
Fleurons (1957). The books also records that the
flower patterns were called 'Granjon's Arabesque'
when Granjon worked in Antwerp for Flantin.
'Granjon's Fleuron' first appeared in the arabesque
sampler published by Guillaume Silvius in 1554 and
was used on by Silvius since 1572. The patterns
were also used in 1590 in Rome (Granjon himself
was in Rome by then). In short, it was Granjon who
designed the composable fleurons based on the
inspiration he got from his father-in-law.[9]

8. Fleurons in Index Characterum
Along with Granjon's fleuron, there was another
type of fleuron created in the same period and
has survived until today. The pattern is included
in Index Characterum published by Plantin in 1567
in Antwerp with the Roman of Claud Garamond

9
앞의 책, 26쪽
Ibid., p.26

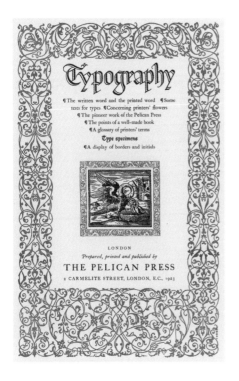

[14] 1923년 펠리칸출판사에서 간행한 타이포그래피의 표제지와 내지
The title page and the inside front cover of Typography (1923) published by Pelican Publisher

그랑종이 플랑탱과 함께 일했다는 사실에서 그랑종의 것과 흡사한 부분은 그랑종이 디자인한 것으로 추측할 수 있다. 하지만 그랑종의 것과 다른 새로운 플러런에 대해서는 잭 사봉을 생각해야 한다. 사봉은 리옹에서 태어났으며 투른 2세 및 그 지역의 다른 인쇄가들과 마찬가지로 종교 개혁의 추종자로서 종교 박해를 피해 프랑크푸르트로 이주했다. 그랑종이 로마로 떠나자 플랑탱은 그의 활자 및 플러런의 공급을 위해 다른 인재를 찾을 수밖에 없었는데 사봉이 그 물망에 오른 것이다.[10] 그러므로 플랑탱의 <u>가라몽 활자 견본</u>에서 보이는 플러런들은 잭 사봉과 로베르 그랑종을 통해 탄생한 것이다. 다만 사봉은 펀치 조각가가 아니라 활자 제작자였기에 누가 가라몽의 플러런을 실제로 조각했는지의 여부는 확실치 않다.

9. 소멸과 복원
이 그랑종과 가라몽의 조합가능한 플러런들이 활자 견본에 포함된 이후, 활자 견본에 장식용 활자들을 함께 싣는 것은 관습화되었다. 이후 프랑스의 루이 루스와 피에르 시몽 푸르니에, 지암바티스타 보도니, 윌리엄 캐슬론, 존 배스커빌에 이르기까지 모든 활자 견본에 장식용 활자의 일부로 플러런이 포함되었으나 이 조합 가능한 플러런들은 알두스의 플러런 — 알디네의

and the Italic of Granjon. As shown in Figure 12, Index Characterum contains the fleurons, some of which are similar to Granjon's and some others of which are new. Assuming that Granjon worked with Plantin, the similar ones would have been designed by Granjon himself. But in the different ones, Jacques Sabon must have been involved. Sabon was born in Lyon. As a supporter of the Reformation, he moved to Frankfort like other local printers including Tournes Jr. When Granjon went to Rome, Plantin need another person to design his types and fleurons. Sabon was good enough for the task.[10] Therefore, it were Jacques Sabon and Robert Granjon who created the fleurons in <u>Index Characterum</u>. Yet, Sabon was not a typesetter but a letter manufacturer so it is not certain who actually engraved those fleurons in the sampler.

9. Disappearance and Restoration
After the fleurons of Granjon and Garamond were included in Index Characterum, it became a kind of custom to include ornamental types in type samplers. All the samplers by Louis Luce, Pierre Simon Fournier, Giambattista Bodoni, William Caslon, and John Baskerville contained fleurons as part of decorative types. However, those composable fleurons lived relatively shorter than

10
앞의 책, 32쪽
Ibid., p. 32

[15] (왼쪽) 1984년 제럴드 점퍼가 인쇄한 <u>ATF 뉴스레터</u>의 표지 / (오른쪽) 플러런 학회지 중 중요한 논문을 묶어 재인쇄한 1973년의 플러런 선집의 표지 각각 그랑종과 사봉의 플러런이 사용되었다.
Respectively using the fleuron of Granjon and Sabon / (left) the cover of <u>ATF Newsletter</u> (1984) printed by Gerald Giampa (right) <u>Fleuron Anthology</u> (1973) in which the important literature published in The Fleuron

잎사귀 — 에 비해 그 수명이 상대적으로 짧았으며, 보도니가 배스커빌의 예제들을 따르기 시작하면서 서서히 사라져가기 시작했다. 특히 19세기 초 석판 인쇄 발명과 함께 인쇄와 제본 과정이 출판사에 의해 통합된 이후 장식물이 표제지가 아닌 표지에 위치하게 되면서 장식물은 더 이상 활자와 함께 조판되지 않았고 플러런의 소멸은 가속화되었다.

플러런은 한 세기의 시간을 뛰어넘어 19세기 말 넘쳐나던 저열한 석판 인쇄 장식에 염증을 느낀 스탠리 모리슨을 비롯한 영국의 타이포그래퍼들에 의해 복원되었다. 결국 그랑종의 플러런은 스탠리 모리슨, 프레드릭 가우디, 브루스 로저스가 활동했던 1920년 경의 모노타입에서 가우디의 손을 통해 복원된 것이다. 스탠리 모리슨은 1923년 프랜시스 메이넬 등과 함께 '플러런'이라는 이름의 학회를 설립했으며, 학회의 주된 연구 대상은 플러런을 포함한 고전적 타이포그래피였다. 같은 해 펠리컨 출판사에서 간행한 타이포그래피는 살로몽의 테두리 장식을 복원해 표제지를 장식했고, 가라몽의 플러런으로 내지의 테두리 장식을 조판했다. [16] 그리고 부록을 통해 앞서 살펴본 살로몽과 라트돌트의 테두리 장식을 복원해 수록했다.

10. 디지털 시대의 플러런
제럴드 점퍼는 1983년 랜스턴 모노타입을 인수하면서

'Aldine Leaf' and slowly disappeared as Bodoni followed the samples of Baskerville. Especially after the invention of lithography in the 19th century and the integration of printing and binding by publishers, the decorative types appeared not on the title page but on the cover of a book. For this reason, the decorative types were no more printed in samplers with ordinary types and this tendency accelerated the extinction of fleurons.

About a century later, fleurons were restored by Stanley Morison and other British typographers who felt tired of the lithographic decorations in the late 19th century. Around 1920, at Lanston Monotype Company, where Stanley Morison, Frederic Goudy and Bruce Rogers worked at the same time, Goudy revived Granjon's fleuron. Stanley Morison founded the academy called The Fleuron in 1923 with Francis Meynell and others, and their main subjects of study included the fleuron and classic typography. In the same year, Pelican Publisher published Typography with the title page framed by Salomon's decorative border and the inside front cover framed by Garamond's fleuron. [16] The frames designed by Salomon and Ratdolt are supplemented at the end of the volume.

[18] (왼쪽) 1928년 프레데릭 워드의 인쇄 오너먼트 표제지 / (오른쪽) 1934년 브루스 로저스가 디자인한 토머스 모어의 유토피아 표제지
(left) Printers Ornaments published by Frederic warde (1928) / (right) the title page of Utopia designed by Bruce Rogers (1934)

프레드릭 가우디의 활자들을 손에 넣게 되었고, 그 뒤로 모노타입 조판기에서 사용되었던 글자체들을 디지털 글자체로 복각하기 시작했다. 제럴드 점퍼는 디지털 글자체 회사인 LTC를 설립해 1988년부터 2004년까지 운영했으며, 2009년 그가 타계한 이후 LTC는 P22에서 인수해 현재까지 그가 남긴 디지털 글자체를 판매하고 있다. 결국 제럴드 점퍼의 손끝에서 디지털 글자체로 매개된 이후 그랑종과 사봉의 아름다운 플러런들이 영속적인 생을 누리게 된 것이다. 현재 P22에서 판매하고 있는 70종의 글자체 가운데 20종이 장식용 글자체이며, 그중 '플러런 가라몽'과 '플러런 그랑종'라는 두 글자체가 그랑종과 가라몽의 플러런이다. [17]

11. 결론

고전적 타이포그래피에 대한 연구는 바우하우스와 거의 동시에 이루어졌지만 오늘날 한국에서는 상대적으로 주목받지 못하고 있다. 다만 '작은 르네상스'라는 챕터를 통해 그래픽 디자인의 역사 한 구석에 자리하고 있을 뿐이다. 하지만 이를 통해 플러런뿐 아니라 비어트리스 워드의 개러몬드에 대한 연구를 비롯해 이상적인 이탤릭체 및 손글씨체에 대한 연구들이 진행되었음을 감안한다면, 근간을 찾고 기본에 집중하려는 노력은 오히려 현재의 한글 타이포그래피에서도 시의적이다. 따라서 본 논고의 목적은 '이렇게 좋은 것을 모르고 있었으니, 오늘날에라도 되살려 열심히 사용하자.'라는 것이 아니라 오늘날 만약 좀 더 새로운 시도를 하고자 한다면 오히려 옛것을 차분히 되짚어 다양한 관점에서 바라보자는 것이다.

인간은 기계와 달리 쓸데없는 움직임이 많다. 장식도 그중 하나일 것이다. 오늘날 우리의 목을 뻐근하게 만드는 사용자 중심의 인터페이스가 인간적인 인터페이스인지 되물어볼 필요가 있다. 12세기 아일랜드 지역의 필사본 장식이 후대의 표제지들을 무색하게 하는 밀도와 완성도를 보이는 것처럼, 인간의 쓸데없는 행동을 무시하기보다는 어떻게 의미 있게 반영할지 고민해야 한다.

참고 문헌

남종국, 지중해 교역은 유럽을 어떻게 바꾸었을까?, 민음인, 2011
필립 B.멕스, 그래픽 디자인의 역사, 황인화 옮김, 미진사, 2002
오웬 존스, 세계문양의 역사, 김선숙 외 옮김, 다빈치, 2010
로베르 마생, 글자와 이미지, 김창식 편역, 미진사, 1994
Joanna Drucker and Emily McVarish, Graphic Design History: A Critical Guide, Pearson

10. The Fleuron of Digital Era

Gerald Giampa bought Lanston Monotype Company in 1983 to acquire Frederic Goudy's types and reprinted the types used by Monotype compositer typesetters in digital types. He founded the Lanston Type Company, a digital type company, and managed it from 1988 to 2004 and after his death in 2009, LTC is taken over by P22. The digital types he left are on sale until now. Giampa did bridge the fleurons produced by Granjon and Sabon onto the digital types and gave the patterns permanent life. Twenty of seventy types currently sold by P22 are ornamental, and two of them are Fleurons Garamont and Fleurons Granjon. [17]

11. Conclusion

The study on classic typography was started almost at the same time as Bauhaus, but today the field is not buoyant and less so in South Korea. It is one small chapter called the Small Renaissance in the The History of Graphic Design. There was research going on by Beatrice Warde about Garamond and ideal italics and handwritings. These studies were focusing on basics and are timely not only for those interested in fleurons but for other typographers. The aim of this study is not to say 'let's use the good old things in present times' but to urge to gain diverse perspectives by looking back to old accomplishments if you want to make new attempts in your field.

Unlike machines, humans move inefficiently. Decorations could be an example of this. But we should ask if it's really humane to use those 'user-centered' interfaces that makes our necks stiff. As the manuscript from 12th Century Ireland has the title page so absolutely and perfectly completed that any modern title pages look clumsy in comparison, we are not to ignore those human behaviors apparently wasteful but to find ways to use them meaningfully.

Reference

A Natural History of Printers' Flowers, Seibundo Shinkosha, 2010
Christopher Plantin, Index Charactereum, facsimile reprint by Douglas C. McMurtrie, 243th copy, 1924
Geofroy Tory, Champ Fleury, trans. by George B. Ives, Dover Publications, 1967
Harold Berliner's Typefoundry, A Garden of Printers' Flowers, Harold Berliner's Typefoundry, 1982
Harry Carter, A View of Early Typography, reprinted by James Mosely, Hyphen Press, 2002

Prentice Hall, 2009
Stanley Morison and Francis Meynell, The Fleuron Vol. I-VII, Fleuron, 1923-1930.
———, Printers' Flowers and Arabesques, The Fleuron Vol. I, 1923
Philip Gaskell, A New Introduction to Bibliography, Oak Knoll Press, 1972
S. H. Steinberg, revised by John Trevitt, Five Hundred Years of Printing, Oak Knoll Press and The British Library, 1996
Typography, The Pelican Press, 1923
John Ryder, A Suite of Fleurons, Charles T. Branford, 1957
Harold Berliner's Typefoundry, A Garden of Printers' Flowers, Harold Berliner's Typefoundry, 1982
Mark Arman, Traditional Designs for Printers: A Specimen of Printers' Flowers of the 16th, 17th, 18th, 19th and 20th Centuries, The Workshop Press, 1994.
Christopher Plantin, Index Charactereum, facsimile reprint by Douglas C. McMurtrie, 243th copy, 1924
A Natural History of Printers' Flowers, Seibundo Shinkosha, 2010
Geofroy Tory, translated by George B. Ives, Champ Fleury, Dover Publications, 1967
Harry Carter, A View of Early Typography, reprinted by James Mosely, Hyphen Press, 2002

↗

Joanna Drucker and Emily McVarish, Graphic design history: a critical guide, Pearson Prentice Hall, 2009
John Ryder, A Suite of Fleurons, Charles T. Branford, 1957
Mark Arman, Traditional Designs for Printers: A Specimen of Printers' Flowers of the 16th, 17th, 18th, 19th and 20th Centuries, The Workshop Press, 1994
Nam Jongguk, How did Mediterranean Trade Altered Europe?, Minumin, 2011
Owen Jones, The Grammar of Ornament: A Unique Collection of Over 2,350 Classic Patterns Included, trans. by Kim Seonsuk, Davinchi, 2010
Philip B. Meggs, The History of Graphic Design, trans. by Hwang Inhwa, 3rd edition, Mijinsa, 2002
Philip Gaskell, A New Introduction to Bibliography, Oak Knoll Press, 1972
Robert Massin, La lettre et l'image, trans. by Kim Chansik, Mijinsa, 1994
S. H. Steinberg, Five Hundred Years of Printing, revised by John Trevitt, Oak Knoll Press and The British Library, 1996
Stanley Morison and Francis Meynell, The Fleuron Vol. I-VII, Fleuron, 1923-1930
———, Printers' Flowers and Arabesques, The Fleuron vol. I, 1923
Typography, The Pelican Press, 1923

↗

불경 언해본과 한글 디자인

The Korean Translation of Joseon Dynasty Era Buddhist Scripture and Hangeul Typeface Design

안상수, 노민지, 노은유
ag타이포그라피연구소, 한국

Ahn Sang-soo, Noh Min-ji, Noh Eun-you
ag Typography Lab, Korea

요약

1443년(세종 25) 한글을 멋짓고 나서, 1446년(세종 28) 그 사용법을 설명한 훈민정음이 반포된 뒤, 세종의 첫 사업 중 하나는 한문 서책을 한글로 풀어내는 것이었다. 당시 한글은 유신들의 반대로 공식 문서에는 쓸 수 없었고, 언문이라 부르며 천시하는 경향이 있었다. 그리하여 세종은 그들의 관심이 적은 불경을 먼저 언해하면서 한글을 활용할 기회를 갖고자 했다. 조선의 불경 언해본 간행은 한글을 통한 불교문화의 대중화를 시도한 것이며, 조선 말기까지 약 400년 동안 한글꼴을 발전시키는 데 중요한 역할을 했다. 오늘날 알려진 조선 시대의 불경 언해본은 총 45종으로 이때 간행된 한글 문헌(총 299종)의 약 15%에 해당한다. 이 중 한글꼴의 특성이 두드러지는 불경 언해본 11종을 대상으로 한글 창제 원형을 계승하고 발전시킨 불경 언해의 시작기(1449-), 국가의 주관으로 활발한 간행이 이루어진 불경 언해의 부흥기(1461-), 지방 사찰을 중심으로 확산되기 시작한 불경 언해의 확산기 (1517-)로 나누어 각 시기에 만들어진 한글꼴의 종류와 특징을 파악했다.

Abstract

King Sejong in 1443 (25th year of reign) announced a new writing system called Hangeul, also published a manual on it's proper usage called the Hunminjeongeum in 1446(28th year of reigh). With this manual he set about translating numerous Chinese literature written in Chinese into Korean. The reformists of that era would not allow Hangeul to be used in official documents or records, and down played the translation efforts by referring to them as 'eonmun', a derogatory term of that period. Buddhist scripture was chosen to defer such criticism and thought to raise the least attention with the translation efforts and accounted for the development of Hangeul types for 400 years. Today 45 translated texts from the Joseon period can be found, which amounts to roughly 15% of the total 299 Korean texts recorded. Of the text, we have chosen 11 Korean Buddhist Scripture which are representative of the Hangeul used at that time and have divided them into three periods: Inception of Korean Buddhist Scriptures (1449-), Development of Korean Buddhist Scriptures (1461-), and Expansion of Korean Buddhist Scriptures (1517-) based on the variety, and characteristics of the Hangeul used at the time as well as the influences on Hangeul type design and Buddhist culture in general.

주제어

타이포그래피, 글자체, 한글, 불경언해본

Keywords

Typography, Font, Hangeul, Buddihst Scripture

→

번역: 박경식 Translation: Fritz K. Park

1. 들어가며

1443년 한글을 창제하고 그 사용법을 상세히 설명한 훈민정음(訓民正音, 1446)이 반포된 뒤 한글을 이용한 세종의 첫 번째 사업 중 하나는 한문으로 전해 오던 수많은 서책을 언해[1]하는 것이었다. 그 종류는 경서류(經書類), 문학류(文學類), 사서류(史書類), 종교류(宗敎類) 등 매우 다양했으며, 이는 학문과 지식을 널리 보급하는 데 크게 이바지했다. 하지만 언해 사업이 처음부터 순탄했던 것만은 아니다. 당시 한글은 유신들의 반대로 공식적인 문서에는 쓸 수 없었고, 언문(諺文)이라 부르며 천시하는 경향이 있었다. 그리하여 그들의 관심이 적은 불경을 먼저 언해하면서 한글을 활용할 기회를 갖고자 했다. 세종의 명을 받은 수양대군은 석가모니의 일대기를 모은 글을 한글로 번역하고, '석보상절 전용 놋쇠 활자체'를 주조해 최초의 한글 불경이자 한글 놋쇠 활자본인 석보상절(釋譜詳節, 1449)을 간행했다.

오늘날 알려진 조선 시대의 불경 언해본은 총 45종으로 이때 간행된 한글 문헌(총 299종)[2]의 약 15%에 해당한다. 이 중 한글꼴의 특성이 두드러지는 불경 언해본 11종을 대상으로 불경 언해의 시작기(1449-), 불경 언해의 부흥기(1461-), 불경 언해의 확산기(1517-)로 나누어 각 시기에 만들어진 한글꼴의 종류와 특징을 파악하고, 불교 문화가 한글꼴 디자인에 미친 영향에 대해 살펴보고자 한다.

2. 불경 언해본에 쓰인 한글꼴
2.1. 불경 언해의 시작기 (1449-)

불경 언해의 시작은 석보상절이 간행된 1449년이며, 이 시기를 '불경 언해의 시작기'라 부르고자 한다. 이때 나타난 한글꼴은 석보상절 등에 쓰인 '석보상절 놋쇠 활자체'와 월인석보(月印釋譜, 1459) 등에 쓰인 '월인석보 목판 글자체'이다.

❶ 석보상절 놋쇠 활자체 [1]

수양대군은 세종의 명으로 석보상절을 간행했다. 이 책은 다른 불경 언해본에 비해 문장이 유려해 당시 국문학을 대표하는 작품으로 꼽힌다.

이때 쓰인 한글꼴은 '석보상절 놋쇠 활자체(이하 석보체)'이며, 본문으로 쓰인 큰 글자와 한자의 발음을 표기하거나 주석으로 쓰인 작은 글자로 이루어져 있다. ⓐ 줄기는 가로, 세로의

[1]
'언해'는 조선 시대 한문으로 된 글을 한글로 번역하는 일을 말한다.
'Unhae' refers to Korean translations of Chinese text

[2]
김무봉, 불전언해의 몇 가지 문제, 불교학연구 제9호, 불교학연구회, 2004 / 문화관광부, 한글 옛 문헌 정보 조사 연구, 문화체육관광부, 2001
Kim Mu-bong, A Few Issues With Buddhist Scripture-eonhae, Buddhist Studies Vol. 9, Buddhist Studies Organization, 2004 / Korea Ministry of Culture & Tourism, Old Hangeul Literature Information Research Studies, Korea Ministry of Culture & Tourism, 2001

1. Introduction

King Sejong in 1443 announced a new writing system called Hangeul, also published a manual on it's proper usage called the Hunminjeongeum (1446). With this manual he set about translating numerous literature written in Chinese into Korean[1]. Among those translations were sacred, literary, historicla, religious, and other various texts, resulting in a mass outpour of knowledge and teaching to a wider readership. However, this translation project was not without difficulties. The reformists would not allow Hangeul to be used in official documents or records, and down played the translation efforts by referring to them as eonmun, a derogatory term of that period. Buddhist scripture was chosen to defer such criticism and thought to raise the least attention with the translation efforts. Under command from King Sejong, Grand Prince Suyang (Sejo) translated the life of Buddha, forged the 'Seokbosangjeol brass font, and printed the first Korean Buddhist scripture, as well as the first brass font for Seokbosangjeol in 1449.

Today 45 translated texts from the Joseon period can be found, which amounts to roughly 15% of the total 299 Korean texts recorded.[2] Of the texts, we have chosen 11 Korean Buddhist Scripture which are representative of the Hangeul used at that time and have divided them into three periods: Inception of Korean Buddhist Scriptures (1449-), Development of Korean Buddhist Scriptures (1461-), and Expansion of Korean Buddhist Scriptures (1517-) according to the variety, and characteristics of the Hangeul used at the time as well as the influences on Hangeul type design and Buddhist culture in general.

2. Hangeul Type Used in Korean Buddhist Scripture
2.1. Inception of Korean Buddhist Scriptures (1449-)

The Korean translation of Buddhist scripture began with Seokbosangjeol published in 1449, heralding the beginning of translations of Buddhist scripture into Korean. The Hangeul type used in this period were found in Seokbosangjeol called 'Seokbosangjeol brass type' and 'Wolinseokbo Woodcut' found in Wolinseokbo (1459).

❶ Seokbosangjeol Brass Type [1]

The Grand Prince Suyang (Sejo) was commanded by King Sejong to publish the Seokbosangjeol in 1449. This text, compared to other Korean

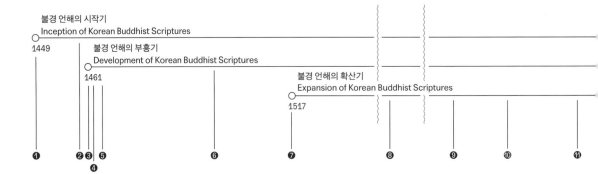

불경 언해의 시작기
Inception of Korean Buddhist Scriptures
1449

불경 언해의 부흥기
Development of Korean Buddhist Scriptures
1461

불경 언해의 확산기
Expansion of Korean Buddhist Scriptures
1517

❶ ❷❸❺ ❹ ❻ ❼ ❽ ❾ ❿ ⓫

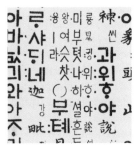

❶ 석보상절 놋쇠 활자체, 석보상절,
1449
Seokbosangjeol brass type,
Seokbosangjeol, 1449

❷ 월인석보 목판 글자체, 월인석보,
1459
Wolinseokbo woodcut,
Wolinseokbo, 1459

❸ 강희안 놋쇠 활자체,
능엄경언해(활자본), 1461
Kangheeahn brass type,
Neungeomgyeong-eonhae
(metal type), 1461

❹ 간경도감 목판 글자체,
능엄경언해(목판본), 1462
Gangyeongdogam woodcut,
Neungeomgyeong-eonhae
(woodcut), 1462

❺ 정난종 놋쇠 활자체, 원각경구결,
1465
Jeongnanjong brass type,
Wongakgyeong-gugyeol, 1465

❻ 인경 나무 활자체, 시식권공언해,
1496
Ingyeong wood type,
Shishikkwongong-eonhae, 1496

❼ 경서 목판 글자체 계열,
몽산법어언해, 1517
Gyeongseo woodcut group,
Mongsanbeop-eonhae, 1517

❽ 염불보권문 목판 글자체,
염불보권문언해, 1704
Yeombulbogwonmun woodcut,
Yeombulbogwonmun-eonhae,
1704

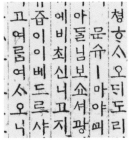

❾ 교서관 목판 글자체 계열,
지장경언해, 1762
Gyoseogwan woodcut group,
Jijangkyeong-eonhae, 1762

❿ 중간진언집 목판 글자체,
중간진언집, 1777
Jungganjineonjip woodcut,
Jungganjineonjip, 1777

⓫ 부모은중경 목판 글자체,
부모은중경언해, 1796
Bumo-eunjungyeong woodcut,
Bumo-eunjungyeong-eonhae,
1796

굵기가 비슷하며 민부리 글자체로 분류할 수 있다. ⓑ 낱자는 대체로 좌우대칭을 이루며 ⓒ ㅅ, ㅈ, ㅊ은 윗점 갈래3의 형태이다. ⓓ ㅇ, ㅎ은 정원을 유지한 채 모임꼴에 따라 크기만 달라지며 ⓔ 소리점과 아래아 또한 정원으로 되어 있다. ⓕ 글자체의 틀은 큰 글자는 정네모, 작은 글자는 세로로 긴 네모이다. ⓖ 너비는 큰 글자는 전각, 작은 글자는 반각을 유지하고 ⓗ 글줄은 낱자의 가운데로 흐른다.

석보체는 훈민정음에 쓰인 '훈민정음 목판 글자체(이하 정음체)'와 같이 기하학적인 형태이지만, 곁줄기가 점에서 선으로 변하는 등 더욱 읽기 편하게 보정하고, 세로로 긴 비례의 작은 글자로 내용을 분리한 점이 돋보인다.

❷ 월인석보 목판 글자체 [2]

세조는 석보상절과 월인천강지곡 (月印千江之曲, 1449)을 고치고 엮어 월인석보를 간행했다. 월인석보 간행은 세종 말에서 세조 초까지 양대에 걸쳐 이룩된 사업이며, 당시의 글자나 말을 그대로 나타내고 있어 국어학적으로 귀중한 문헌이다.

이때 쓰인 한글꼴은 '월인석보 목판 글자체'(이하 월인석보체)이며, 본문으로

Buddhist Scripture is generally viewed to be more elegant and representational of Korean literature in this period.

The Hangeul type used is 'Seokbosangjeol brass type' (Seokboche) and consists of large letters for the main text and small letters for Chinese pronunciations or footnotes. ⓐ The vertical and horizontal strokes both have the same weight and are classified as sans-serif letterforms. ⓑ Individual letters are generally symmetrical. ⓒ The ㅅ (shi-ot), ㅈ (jiut), ㅊ (chi-ut) have a upper cross stroke3 configuration. ⓓ The ㅇ (e-ung) and ㅎ (hiut) maintain a circle with slight alteration in size according to the syllables it's configured in, ⓔ while the phonetic symbols and araea (·) also retain a circle form. ⓕ The frame of the large letters is close to a square, while the small letters have tall rectangular frames. ⓖ The large letters is of unified width while the small letters are a half-width, (much like the em and en of Western typography). ⓗ The baseline flows in the center of each letter.

'Seokboche' follows the form of the 'Hunminjeongeum woodcut' used in the Hunminjeongeum itself, while geometric in shape, the side strokes have developed from dots to stroke to enhance readability as well as to separate the tall small letters from the main text.

3
윗점 갈래(ㅅ)는 시옷, 지읒, 치읓의 갈래가 윗점에서 시작되는 모양을 말한다.
The upper cross stroke refers to the start of the right stroke starting at the apex of the letters ㅅ, ㅈ, ㅊ.

		형태 Form		큰 글자 Large letters	작은 글자 Small letters		구조 Structure		큰 글자 Large letters	작은 글자 Small letters
[1] 석보상절 놋쇠 활자체의 조형적 특징 Characteristics of Sukbosangjul brass type		줄기 Stroke	ⓐ				틀 Frame	ⓕ		
		모양 Shape	ⓑ				너비 Width	ⓖ		
			ⓒ				글줄 Baseline flow	ⓗ		
			ⓓ							
			ⓔ							

쓰인 큰 글자와 한자 발음을 표기하거나 주석으로 쓰인 작은 글자로 이루어진다. ⓐ 줄기의 시작점과 맺음에 붓의 흔적이 남아 뾰족하게 돌출되어 있다. ⓑ 낱자는 좌우대칭에서 살짝 벗어난 모습이며 ⓒ ㅅ, ㅈ, ㅊ은 윗점 갈래의 형태이다. ⓓ ㅇ, ㅎ은 정원을 유지한 채 크기만 달라지며 ⓔ 소리점과 아래아는 정원이 아닌 길쭉한 내리점의 형태이다. ⓕ 글자체의 틀은 큰 글자는 정네모, 작은 글자는 세로로 긴 네모이다. ⓖ 너비는 큰 글자는 전각, 작은 글자는 반각이며 ⓗ 글줄은 낱자의 가운데로 흐른다.

월인석보체는 한글 창제 초기의 기하학적인 구조를 유지하면서도 붓의 움직임과 강약이 미세하게 드러나면서 부리의 초기 형태를 관찰할 수 있으며, 석보체보다 한층 더 안정감 있는 균형을 보인다.

2.2. 불경 언해의 부흥기 (1461-)
1461년 세조에 의해 간경도감이 설치되면서 불경 언해가 활발하게 이루어지게 되는데 이 시기를 '불경 언해 부흥기'라 부르고자 한다. 이때 나타난 한글꼴은 능엄경언해(楞嚴經諺解, 1461) 활자본 등에 쓰인 '강희안 놋쇠 활자체', 간경도감에서 발행한 불경 언해본에 쓰인 '간경도감 목판 글자체', 원각경구결(圓覺經口訣, 1465) 등에 쓰인 '정난종 놋쇠 활자체', 시식권공언해(施食勸供諺解, 1496) 등에 쓰인 '인경(印經) 나무 활자체'이다.

❷ Wolinseokbo Woodcut [2]
Sejo also took it upon himself to combine the Seokbosangjeol with another text called Wolincheongang-jigok (1449) and titled it Wolinseokbo (1459), which was started during the reign of King Sejong and continued on to the early years of Sejo's reign, an important scene in the Korean language history: it records the letters, words and writing of the times.

The font used then was 'Wolinseokbo woodcut' (Wolinseokboche) and consists of large letters for the main text and small letters for Chinese pronunciations or footnotes. ⓐ The start and ends of the strokes have calligraphic tendencies with sharp edges. ⓑ Individual letters are slightly off-center. ⓒ The ㅅ, ㅈ, ㅊ have a upper cross stroke configuration. ⓓ The ㅇ, ㅎ maintain a circle with slight alteration in size according to the syllables it's configured in, ⓔ while the phonetic symbols and araea have a long downstroke form. ⓕ The frame of the large letters is close to a square, while the small letters have tall rectangular frames. ⓖ The width of the large letters is of unified width while the small letters are a halfwidth. ⓗ The baseline flows in the center of each letter.

'Wolinseokboche' follows the form of the Hunminjeongeum geometric shape with minute

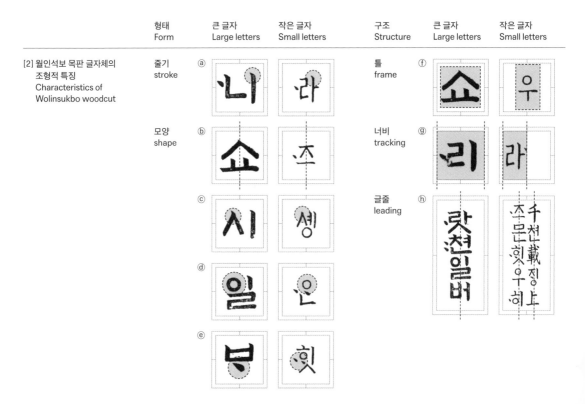

	형태 Form	큰 글자 Large letters	작은 글자 Small letters	구조 Structure	큰 글자 Large letters	작은 글자 Small letters
[2] 월인석보 목판 글자체의 조형적 특징 Characteristics of Wolinsukbo woodcut	줄기 stroke ⓐ	니	라	틀 frame ⓕ	쇼	우
	모양 shape ⓑ	쇼	조	너비 tracking ⓖ	리	라
	ⓒ	시	셩	글줄 leading ⓗ	랏쳔일버	千쳔載문화셩우히
	ⓓ	일	언			
	ⓔ	보	횟			

40

❸ 강희안 놋쇠 활자체 [3]

1461년 세조는 능엄경(楞嚴經)의 번역을 완료해 활자본으로 간행했는데, 이것이 능엄경언해 활자본이다. 이때 쓰인 한글꼴은 조선 전기 서화가인 강희안(姜希顔, 1417-1464)의 글자본으로 주조된 '강희안 놋쇠 활자체(이하 강희안체)'이다.

　　강희안체는 작은 글자로 이루어져 있으며, 본문, 한자의 발음 표기, 주석 등에 쓰였다. ⓐ 줄기는 예리하게 뾰족한 형태를 띠고 있는 것을 볼 수 있다. ⓑ 낱자는 좌우대칭에서 살짝 벗어났으며 ⓒ ㅅ, ㅈ, ㅊ은 윗점 갈래와 가운뎃점 갈래[4]가 섞여 있다. ⓓ ㅇ, ㅎ은 정원에서 점차 벗어나고 있으며 ⓔ 소리점과 아래아는 내리점의 형태이다. ⓕ 글자체의 틀은 받침글자는 대체로 세로로 긴 네모틀, 민글자는 왼사다리틀이다. ⓖ 너비는 반각을 유지하며 ⓗ 글줄은 낱자의 가운데로 흐른다.

　　강희안체는 석보체와 월인석보체에 비해 각 줄기의 공간 조정으로 글자체의 틀이 네모틀에서 벗어나기 시작했다는 점에서 의미가 깊다.

❹ 간경도감 목판 글자체 [4]

간경도감은 1461년부터 1471년 (성종 2년) 폐지되기까지 11년간 불경

[4]
가운뎃점 갈래(ㅅ)는 시옷 지읒, 치읓의 갈래가 줄기의 중간에서 시작되는 모양을 말한다.
The mid-cross stroke refers to the start of the right stroke starting at the mid-section of the letters ㅅ, ㅈ, ㅊ.

movement and force. Early signs of a serif can be noticed as well as a more stable balanced form than 'Seokboche'.

2.2. Development of Korean Buddhist Scriptures (1461-)

In 1461, Sejo established the Gangyeongdogam to further the translation of Buddhist scripture into Korean. We will call this period the Development of Korean Buddhist scripture. The type developed during this time was the 'Kangheeahn brass type' used in Neungeomgyeong-eonhae (1461), 'Gangyeongdogam woodcut' manufactured by the same name, the 'Jeongnanjong brass type' used in the Wongakkyung-gugyul (1465) and the 'Ingyeong wood type' used in the Shishikkwongong-eonhae (1496).

❸ Kangheeahn Brass Type [3]

In 1461, Sejo completed the translation for Neungeomgyeong and committed it to print. This is called the Neungeomgyeong-eonhae print plate. The font used here is taken from the lettering of skilled calligraphist Kang Hee-ahn (1417-1464) and was made into type called 'Kangheeahn brass type' (Kangheeahnche).

　　This font consists of only small letters for main

[3] 강희안 놋쇠 활자체의 조형적 특징 Characteristics of Kangheeahn brass type	형태 Form				구조 Structure			
	줄기 Stroke	ⓐ	니	디	틀 Frame	ⓕ	날	시
	모양 Shape	ⓑ	똑	부	너비 Tracking	ⓖ	뗑	
		ⓒ	시	스	글줄 Leading	ⓗ	부몬데보비논	
		ⓓ	욷	샹				
		ⓔ	이	훙				

한문본 31종, 언해본 9종을 간행했다. 간경도감에서 처음 펴낸 불경 언해본은 능엄경언해(1462)로 여기에 쓰인 한글꼴은 '간경도감 목판 글자체'(이하 간경도감체)이다.

간경도감체는 강희안체와 마찬가지로 작은 글자로 이루어져 있으며, 본문, 한자의 발음 표기, 주석 등의 기능으로 쓰였다. ⓐ 줄기의 끝에서 목판 새김의 흔적으로 삼각형의 돌기를 관찰할 수 있다. ⓑ 낱자는 좌우대칭에서 살짝 벗어났지만 대체로 창제 초기의 기하학적 성격은 남아 있다. ⓒ ㅅ, ㅈ, ㅊ은 윗점 갈래의 형태이다. ⓓ ㅇ과 ㅎ은 정원을 유지하며 크기만 달라지고 ⓔ 소리점과 아래아는 내리점의 형태이다. ⓕ 글자체의 틀은 세로로 긴 네모틀을 유지하며 ⓖ 너비는 반각을 유지한다. ⓗ 글줄은 낱자의 가운데로 흐른다.

간경도감체는 불경을 간행하기 위해 만들어진 한글꼴로 조선 시대에 가장 많은 불경언해본을 간행하는 데에 쓰였다. 간경도감체는 강희안체에 비해 네모틀에 더 가까우며, 창제 초기의 기하학적인 형태의 모습을 닮아 있는 점이 돋보인다.

❺ 정난종 놋쇠 활자체 [5]

1465년 세조는 원각경(圓覺經, 1380)에 구결을 달아 원각경구결을 간행했다. 이때 쓰인 한글꼴은 서예가 정난종(鄭蘭宗, 1433-1489)의 글자본으로 주조된 '정난종 놋쇠 활자체'(이하 정난종체)이다.

text, Chinese pronunciations and footnotes. ⓐ The strokes are sharp and pointed. ⓑ Individual letters are slightly off-center. ⓒ The ㅅ, ㅈ, ㅊ have an upper and middle cross stroke[4] configuration. ⓓ The ㅇ, ㅎ are slowly moving away from a circle, ⓔ while the phonetic symbols and araea have a long downstroke form. ⓕ The frame is tall with the final consonant syllable, while others have a left slanted frame. ⓖ The width are a half-width, ⓗ The baseline flows in the center of each letter.

Comparing 'Kangheeahnche' with 'Seokboche', and 'Wolinseokboche', the syllables are moving away from a square frame due to the spacing between the letters.

❹ Gangyeongdogam Woodcut [4]

The Gangyeongdogam during it's 11 year existence from 1461 to 1471 (2nd year of King Songjong's reign) produced 31 Chinese Buddhist publications and 9 translated Korean Buddhist scriptures. The first publication published was the Korean Buddhist Scripture Neungeomgyeong-eonhae (1462) and the font used was the 'Gangyeongdogam woodcut' (Gangyeongdogamche).

The 'Gangyeongdogamche', like the 'Gangheeahnche' consists of small letters for the main text, Chinese pronunciations and footnotes.

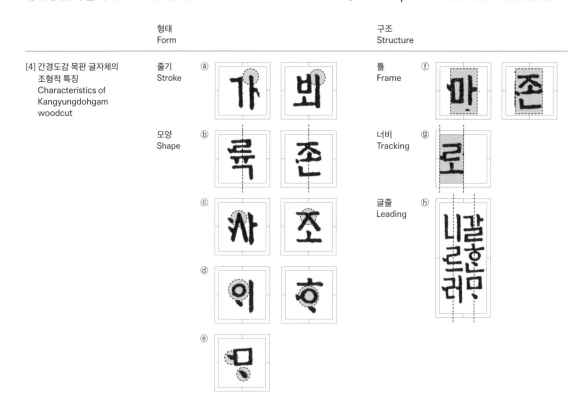

[4] 간경도감 목판 글자체의 조형적 특징
Characteristics of Kangyungdohgam woodcut

	형태 Form			구조 Structure		
	줄기 Stroke	ⓐ		틀 Frame	ⓕ	
	모양 Shape	ⓑ		너비 Tracking	ⓖ	
		ⓒ		글줄 Leading	ⓗ	
		ⓓ				
		ⓔ				

정난종체는 강희안체, 간경도감체와 같이 작은 글자로 이루어있으며, 한자의 발음 표기, 주석 등의 기능으로 쓰였다. ⓐ 줄기는 대체로 부리가 거의 없는 형태이며 ⓑ 낱자는 대칭을 이룬다. ⓒ ㅅ, ㅈ, ㅊ은 윗점 갈래의 형태이다. ⓓ ㅇ, ㅎ은 정원에서 조금 벗어난 모습을 보이며 ⓔ 소리점과 아래아는 내리점의 형태이다. ⓕ 글자체의 틀은 세로로 홀쭉한 긴 네모틀이며 ⓖ 너비는 반각을 유지하고 ⓗ 글줄은 가운데로 흐른다.

정난종체는 목판으로 새겨진 간경도감체에 비해 글자의 줄기가 가늘고 예리하며, 다른 반각 글자체에 비해 가장 너비가 좁은 점이 특징이다.

❻ 인경 나무 활자체 [6]
간경도감이 폐지된 이후에는 자성대비, 인수대비, 정현대비 등의 주관과 지원으로 불경 언해본이 간행되었다. 특히 인수대비의 명으로 간행된 불경 언해본에는 '인경(印經) 나무 활자체'(이하 인경체)가 만들어져 쓰였다.

인경체는 큰 글자와 작은 글자로 이루어져 있다. 큰 글자는 본문으로 쓰이고, 작은 글자는 한자의 발음을 표기하거나 주석으로 쓰였다. ⓐ 줄기에서 나무 새김의 뾰족한 삼각 형태의 부리를 관찰할 수 있다. ⓑ 낱자는 좌우 대칭에서 벗어나고 있으며 ⓒ ㅅ, ㅈ, ㅊ은 대체로 윗점 갈래이나 부분적으로 시작점이 어긋나는 모습을

ⓐ The tips of the stroke have a triangular finish due to the wood cutting process. ⓑ Individual letters are slightly off-center but generally retain the geometric shape of the original Hangeul letterforms. ⓒ The ㅅ, ㅈ, ㅊ have upper cross stroke configuration. ⓓ The ㅇ, ㅎ are generally a circle, slightly of different in size ⓔ and the phonetic symbols and araea have a long downstroke form. ⓕ The frame is a tall rectangular shape, ⓖ The width are a half-width, ⓗ The baseline flows in the center of each letter.

The 'Gangyeongdogamche' was the most widely used type of this period. Compared to the 'Kangheeahnche' it is closer to a square frame and generally retain the geometric shape of the original Hangeul letterforms.

❺ Jeongnanjong Brass Type [5]
In 1465, Sejo included grammatical connectors called gugyeol to the Wongakgyeong (1380) and renamed it Wongakgyeong-gugyeol. The type used for this publication took it's roots from the reknowned calligraphist Jeong Nanjong (1433-1489) and was named 'Jeongnanjong brass type (Jeongnanjongche)'.

Like 'Kangheeahnche' and 'Gangyeongdogamche' the 'Jeongnanjongche'

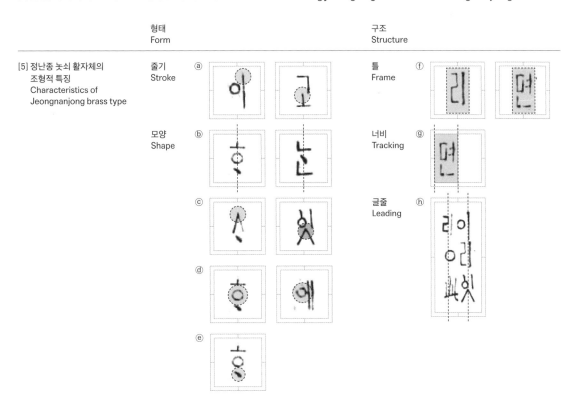

[5] 정난종 놋쇠 활자체의 조형적 특징
Characteristics of Jeongnanjong brass type

형태 Form		구조 Structure	
줄기 Stroke ⓐ		틀 Frame ⓕ ⓑ	
모양 Shape ⓑ		너비 Tracking ⓖ	
ⓒ		글줄 Leading ⓗ	
ⓓ			
ⓔ			

보인다. ⓓ 이전까지 정원을 유지했던 ㅇ, ㅎ은 위치에 따라 비례가 달라지면서 타원화가 시도되었고 ⓔ 소리점과 아래아는 내리점의 형태이다. ⓕ 글자체의 틀은 모임꼴에 따라 다양하게 나타나며, 이전의 한글꼴에 비해 자소 사이의 공간 조정이 활발히 이루어져 네모틀에서 탈피하려는 모습이 보인다. ⓖ 너비는 큰 글자는 전각, 작은 글자는 반각을 유지하며 ⓗ 글줄은 대체로 낱자의 가운데로 흐르지만, 미세하게 오른쪽으로 이동한 것을 볼 수 있다.

인경체는 창제 초기의 기하학적인 모습에서 벗어나 낱자의 형태에서 붓의 영향이 조금씩 나타나고 한층 부드러운 표정이다. 또한 글줄의 흐름이 미세하게 오른쪽으로 이동하면서 이전의 글자체과 이후의 글자체를 연결하는 과도기적 성향을 보이고 있다.

2.3. 불경 언해의 확산기 (1517-)

1500년대 이후 국가의 주관으로 간행되던 불경 언해본은 지방 사찰을 중심으로 확산되기 시작했는데 이 시기를 '불경 언해 확산기'라 부르고자 한다. 이전의 불경 언해본에 쓰인 한글꼴은 대부분 불경을 간행하기 위해 만들어진 것이었다면, 이 시기의 한글꼴은 불경뿐 아니라 경서류, 문학류 등과 함께 쓰였다.

이때 나타난 한글꼴은 몽산법어언해(蒙山法語諺解, 1517) 등에 쓰인 '경서 목판 글자체 계열',

consists of small letters for the main text, Chinese pronunciations and footnotes. ⓐ The strokes are generally without any serif. ⓑ Individual letters are symmetrical. ⓒ The ㅅ, ㅈ, ㅊ have an upper cross stroke configuration. ⓓ The ㅇ, ㅎ are slowly moving away from a circle, ⓔ while the phonetic symbols and araea have a long downstroke form. ⓕ The frames are tall and rather narrow. ⓖ The width is a half-width. ⓗ The baseline flows in the center of each letter.

The 'Jeongnanjongche', unlike the woodcut 'Gangyeongdogamche', have thin sharp strokes throughout, and compared with other half-width (en) type is probably the most condensed.

❻ Ingyeong Wood Type [6]

When the Gangyeongdogam was closed, Empress Jasung, Empress Insoo, Empress Jeonghyeon took on the responsibility of translating the Korean Buddhist Scriptures. Korean Buddhist Scripture decreed under the command of Empress Insoo was set with what was named 'Ingyeong wood type' (Ingyeongche).

The type consists of both large and small letters. The large letters for the main text and small letters were used for Chinese pronunciations or footnotes. ⓐ Sharp triangular serif can be seen

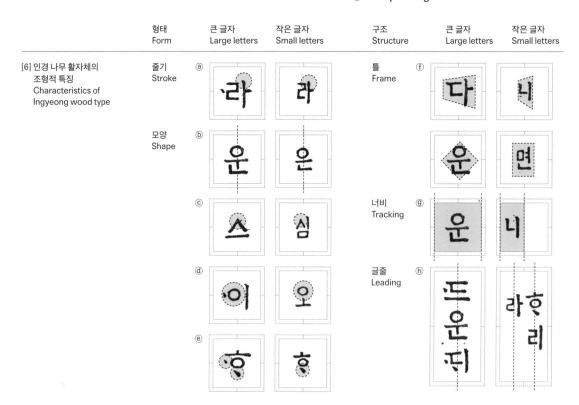

	형태 Form	큰 글자 Large letters	작은 글자 Small letters	구조 Structure	큰 글자 Large letters	작은 글자 Small letters
[6] 인경 나무 활자체의 조형적 특징 Characteristics of Ingyeong wood type	줄기 Stroke	ⓐ 라	라	틀 Frame	ⓕ 다	니
	모양 Shape	ⓑ 운	온		운	면
		ⓒ 스	심	너비 Tracking	ⓖ 운	니
		ⓓ 이	오	글줄 Leading	ⓗ 띠운뜌	라ㅎ리
		ⓔ ㅎ	ㅎ			

44

염불보권문언해(念佛普勸文諺解, 1704)에 쓰인 '염불보권문 목판 글자체', 지장경언해(地藏經諺解, 1762) 등에 쓰인 '교서관 목판 글자체 계열', 중간진언집(重刊眞言集, 1777)에 쓰인 '중간진언집 목판 글자체', 부모은중경(父母恩重經, 1796)에 쓰인 '부모은중경 목판 글자체'이다.

❼ 경서 목판 글자체 계열 [7]

16세기 무렵에는 대학언해(大學諺解, 1590)와 같은 유교 경서를 언해하는 사업이 활발히 이루어졌다. 이때 주로 쓰인 한글꼴 중 하나가 '경서 놋쇠 활자체'이다. 비슷한 시기 이와 비슷한 형태적 특징을 갖는 목판 글자체들이 개발되었는데 이를 모두 통틀어 '경서 목판 글자체 계열(이하 경서체 계열)'이라 부르고자 한다.

경서체 계열이 쓰인 언해본은 대표적으로 몽산법어언해 고운사판이 있다. 여기에 쓰인 경서체 계열은 큰 글자와 작은 글자로 이루어져 있으며, 큰 글자는 한자의 발음을 표기하기 위해 작은 글자는 본문, 한자의 발음 표기, 주석 등으로 쓰였다. ⓐ 줄기에 붓의 움직임과 강약이 강하게 드러나는 것을 볼 수 있다. ⓑ 낱자는 좌우 대칭에서 완전히 탈피했으며 ⓒ ㅅ, ㅈ, ㅊ은 윗점 갈래와 가운뎃점 갈래가 섞여 있다. ⓓ ㅇ, ㅎ은 모임꼴에 따라 다양한 형태로 나타난다. ⓔ 소리점과 아래아는 내리점의 형태이고 ⓕ 글자체의

on the strokes due to the wood cuts. ⓑ Individual letters are slightly off-center. ⓒ The ㅅ, ㅈ, ㅊ have an upper cross stroke configuration with slight inconsistencies of the starting points. ⓓ The ㅇ, ㅎ retain a circular form, but take on an oval shape according to the placement within a syllable. ⓔ The phonetic symbols and araea have a long downstroke form. ⓕ The frame changes according to syllable configuration, and compared with previous Hangeul letterforms, an active effort for proper spacing between the vowels and consonants is apparent, trying to break away from the square frame. ⓖ Both large and small letters are half-width. ⓗ The baseline generally flows in the center of each letter, with a minute lean toward the right.

'Ingyeongche' has broken away from the original geometric and symmetrical form of Hangeul toward a more calligraphic, organic form. Also with it's slight lean to the right, this typeface serves as a transitional letterform to define the prior and post Korean typeface designs.

2.3. Expansion of Korean Buddhist Scriptures (1517-)

In the 1500's the translation of Korean Buddhist Scripture was undertook on a national level, this

	형태 Form	큰 글자 Large letters	작은 글자 Small letters	구조 Structure	큰 글자 Large letters	작은 글자 Small letters
[7] 경서 목판 글자체 계열의 조형적 특징 Characteristics of Gyeongsu woodcut group	줄기 Stroke	ⓐ 함	읜	틀 Frame	ⓕ 동	즁
	모양 Shape	ⓑ 목	믈		하	다
		ⓒ 심	셩	너비 Tracking	ⓖ 동	빌
		ⓓ 하	히	글줄 Leading	ⓗ 동숨함	목인들 뜬엇뎨
		ⓔ 깨	ㄹ			

틀은 네모틀에서 벗어나 다양한 틀이 등장한다.
ⓖ 너비는 큰 글자는 전각, 작은 글자는 반각을 유지하며
ⓗ 글줄은 가로모임꼴의 받침이 홀자의 기둥 쪽으로
정렬되면서 전체적으로 살짝 오른쪽으로 흐른다.

　　이전의 불경에 나타난 한글꼴이 정음체의 영향으로
기하학적 성격이 뚜렷했다면 경서체 계열은 서예가
고유의 필법이 드러난다는 점에서 확연한 차이를 보인다.

❽ 염불보권문 목판 글자체 [8]

1600년대 후반 박진희(朴震禧)가 지은 두창 치료
의서인 두창경험방(痘瘡經驗方)에 목판으로 새겨진
새로운 한글꼴이 등장한다. 이후 이와 비슷한 형태의
한글꼴이 나타나는데 염불보권문언해 용문사판에
쓰인 '염불보권문 목판 글자체'(이하 염불보권문체)가
대표적이다.

　　염불보권문체는 큰 글자로 이루어져 있으며,
본문으로 쓰였다. ⓐ 세로 줄기에 부리가 뚜렷이
관찰되므로 부리 글자체로 분류할 수 있다. ⓑ 낱자는
왼쪽으로 살짝 기울어졌으며 ⓒ ㅅ은 가운뎃점 갈래,
ㅈ은 꺾임 ㅈ5으로 표현했다. 특히 시옷은 내림이
수직으로 떨어진 독특한 형태이다. ⓓ ㅇ, ㅎ은 목판
새김의 특성이 반영되어 삼각형으로 되어 있고 ⓔ
아래아는 내리점의 형태이다. ⓕ 글자체의 틀은 다양한
틀이 나타나며 네모틀에서 상당히 벗어난 모습을 볼

period is called the expansion period. During this
period, other texts were translated such as holy
writings and literature.

　　The type developed during this period is
of the 'Gyeongsu woodcut group' found in the
Mongsanbeop-eonhae (1517) among others, the
'Gyosugwan woodcut group', the 'Gyeongsu
woodcut group', the 'Yeombulbogwonmun
woodcut' used in the Yeombulbogwonmun-
eonhae (1704) 'Gyosugwan woodcut group' used in
Jijangkyung-eonhae (1762), the 'Jungganjineonjip
woodcut' used in the Jungganjineonjip (1777) and
'Bumo-eunjungyung woodcut' used in the Bumo-
eunjunggyeong (1796).

❼ Gyeongsu Woodcut Group [7]

In the 16th century, holy writings such as the
Confucius writing Daehak-eonhae (1590) were
actively translated into Korean. One of the most
widely used Korean type of this period was the
'Gyeongsu brass type'. Similar woodcuts were also
developed during this time and have been grouped
together as the 'Gyeongsu wood type group'
(Gyeongsu group).

　　The text most widely associated with the
Gyeongsu group is probably the Mongsanbeop-
eonhae Gowunsa edition. The type used here

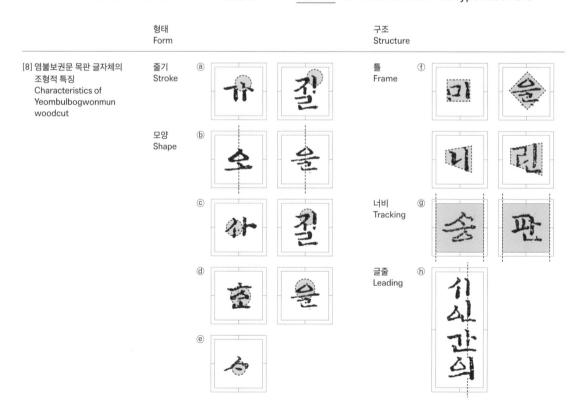

	형태 Form			구조 Structure		
[8] 염불보권문 목판 글자체의 조형적 특징 Characteristics of Yeombulbogwonmun woodcut	줄기 Stroke	ⓐ		틀 Frame	ⓕ	
	모양 Shape	ⓑ				
		ⓒ		너비 Tracking	ⓖ	
		ⓓ		글줄 Leading	ⓗ	
		ⓔ				

수 있다. ⑨ 너비는 전각을 유지하며 ⓗ 글줄은 홀자의 기둥을 따라 오른쪽으로 흐른다.

염불보권문체는 목판이 갖는 낱자 형태의 특징이 잘 드러났으며, ㄹ의 맺음이 오른쪽으로 길게 뻗은 모습, 홀자의 곁줄기와 기둥이 비스듬한 내리점의 형태인 점 등은 보다 개성 있는 한글꼴의 모습을 보이고 있다.

❾ 교서관 목판 글자체 계열 [9]
1600년대 후반 교서관(校書館)에서 중국 명나라로부터 수입해온 명판인본(明板印本)을 자본으로 인쇄 전용 한자 활자체인 '교서관 인서체자'가 개발되었다. 이 활자체와 함께 쓰인 한글꼴은 1700년대부터 나타나는데 이를 '교서관 무쇠활자체'라 한다. 이후 이와 비슷한 형태의 목판본이 개발되어 불경 언해본에 쓰였는데, 이를 통틀어 '교서관 목판 글자체 계열'(이하 교서관체 계열)이라 부르고자 한다.

교서관체 계열은 큰 글자로 이루어져 있으며, 본문으로 쓰였다. ⓐ 줄기는 시작과 끝에서 예리한 삼각 형태를 관찰할 수 있다. ⓑ 낱자는 대체로 대칭에서 벗어났으며 ⓒ ㅅ, ㅈ, ㅊ은 대체로 가운뎃점 갈래로 나타난다. 특히 시옷의 삐침은 왼쪽으로 시원하게 뻗고, 내림은 오른쪽으로 단정하게 내려오거나

5
꺾임 ㅈ은 가로줄기와 삐침이 꺾여 이어진 모양의 ㅈ을 말한다.
The down-turned ㅈ refers to the ㅈ that has a vertical stroke connecting with the left downward stroke.

appeared both in large and small letters, for the main text and small letters were used for Chinese pronunciations or footnotes respectively.

ⓐ The start and ends of the strokes have calligraphic tendencies, making sharp edges. ⓑ The individual letters are asymmetrical. ⓒ The ㅅ, ㅈ, ㅊ have both an upper and middle cross stroke configuration. ⓓ The ㅇ, ㅎ have a different form according to configuration. ⓔ The phonetic symbols and araea have a long downstroke form. ⓕ The frame is inconsistent and have totally broken away from the square frame syllable composition. ⓖ The width of the large letters is of unified width while the small letters are a half-width. ⓗ The baseline is overall slightly leaning to the right with the lower consonants aligning with the vertical columns of the syllables without lower consonants.

Prior Buddhist scriptures followed the original geometric Hangeul type of the Hunminjeongeum, but the renowned 'Gyeongsu group' calligraphist styles differ from the previous typefaces.

❽ Yeombulbogwonmun Woodcut [8]
In the later 1600s a new woodcut used in a medical text for a small pox treatment by Park Jin-hee called Duchang-gyeongheombang

	형태 Form				구조 Structure			
[9] 교서관 목판 글자체 계열의 조형적 특징 Characteristics of Gyosugwan woodcut group	줄기 Stroke	ⓐ	이	셰	틀 Frame	ⓕ	이	닙
	모양 Shape	ⓑ	보	을			을	보
		ⓒ	쇼	시	너비 Width	ⓖ	쇼	꽝
		ⓓ	이	을	글줄 Baseline flow	ⓗ	보상졔	
		ⓔ	쪼					

왼쪽으로 꺾어지기도 한 점이 돋보인다. ⓓ ㅇ, ㅎ은 모임꼴에 따라 다양한 형태가 나타나며 ⓔ 아래아는 내리점으로 표현했다.

ⓕ 글자체의 틀은 다양한 틀을 보이며 ⓖ 너비는 전각을 유지하고 ⓗ 글줄은 홀자의 기둥을 따라 가지런하게 오른쪽으로 흐른다.

교서관체 계열은 닿자의 크기가 작아지고 홀자의 줄기가 시원하게 뻗어 이전 활자체에 비해 공간 조정이 활발히 이루어지고 보다 균형 잡힌 모습을 보이고 있다.

❿ 중간진언집 목판 글자체 [10]

1777년 여러 종류의 부처의 말을 범어(산스크리트어), 한자, 한글로 함께 수록한 중간진언집(重刊眞言集) 만연사판이 간행되었다. 이때 사용된 한글꼴이 '중간진언집 목판 글자체'(이하 중간진언집체)이다.

중간진언집체는 큰 글자로 이루어져 있으며, 본문으로 쓰였다. ⓐ 줄기의 시작점이 뾰족하게 꺾여 있으며, ㅎ의 꼭지와 홀자의 곁줄기를 비스듬하게 내려서 표현한 점이 돋보인다. ⓑ 낱자는 비스듬하게 기울어졌으며 ⓒ ㅅ, ㅈ, ㅊ은 가운뎃점 갈래로 표현했고 ⓓ ㅇ, ㅎ은 모임꼴에 따라 다양한 형태로 나타난다. ⓔ 소리점과 아래아는 내리점으로 표현했고 ⓕ 글자체의 틀은 다양하게 나타난다. ⓖ 너비는 전각을 유지하고 ⓗ 글줄은 오른쪽으로 가지런하게 흐른다.

is found. Later similar typefaces are found in various text such as the 'Yeombulbogwonmun woodcut' (Yeombulbogwonmunche) used in the Yeombulbogwonmun-eonhae Yongmunsa edition.

The Yeombulbogwonmunche consists of large letters, used in the main text. ⓐ The serif is clearly distinguishable in the strokes and can be classified as such. ⓑ Individual letters are slightly leaning toward the left. ⓒ The ㅅ has a middle cross stroke, and the ㅈ has an angled stroke.[5] Of note is the downstroke of ㅅ which is quite unique in form. ⓓ The ㅇ, ㅎ have wood cut characteristics and is triangular in shape, ⓔ while the phonetic symbols and araea have a long downstroke form. ⓕ The frame is inconsistent and have totally broken away from the square frame syllable composition. ⓖ The width of the letters maintain a unified width. ⓗ The baseline is aligned with the vertical columns, and so are to the right.

This type clearly retains the characteristics often found in woodcut type, with the terminal of the ㄹ extending far to the right, and syllables with double strokes and columns having angled downstrokes being prominent characteristics of this typeface.

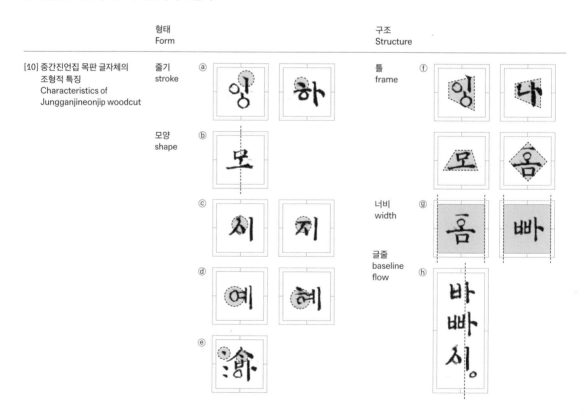

	형태 Form			구조 Structure		
[10] 중간진언집 목판 글자체의 조형적 특징 Characteristics of Jungganjineonjip woodcut	줄기 stroke	ⓐ	잉 하	틀 frame	ⓕ	잉 나
	모양 shape	ⓑ	모			모 옴
		ⓒ	시 지	너비 width	ⓖ	옴 빠
		ⓓ	예 혜	글줄 baseline flow	ⓗ	바 빠 싱
		ⓔ	兪			

48

중간진언집체는 붓의 강약과 움직임이 반영됨과 동시에 곁줄기와 줄기의 끝에 목판 새김의 느낌이 도드라졌으며 다른 책에서 볼 수 없는 다양한 합자를 시도해서 개성 있는 모습을 보이고 있다.

⑪ 부모은중경 목판 글자체 [11]

1796년 부모은중경언해(父母恩重經諺解) 용주사판이 간행되었다. 이 언해본은 1500년대부터 이미 몇 차례 간행된 바 있지만, 그중에서도 용주사판을 특별한 언해본으로 여긴다. 정조(正祖)는 부모의 은혜를 기리는 뜻에서 이 언해본을 개간하도록 명하고 김홍도(金弘道, 1745-1806)로 하여금 삽화를 그리도록 했다. 이때 쓰인 한글꼴이 궁체 계열의 '부모은중경 목판 글자체'(이하 부모은중경체)이다.

부모은중경체는 큰 글자와 작은 글자로 이루어져 있으며, 큰 글자는 주로 본문, 작은 글자는 주로 주석으로 쓰였다. ⓐ 줄기는 붓의 영향을 그대로 받아 시작점이 꺾여 있는 모습을 볼 수 있다. 또한 ㅎ, ㅊ의 꼭지가 내리점으로 되어 있는 점이 돋보인다. ⓑ 낱자는 왼쪽으로 살짝 기울어져 있고, ⓒ ㅅ, ㅈ, ㅊ은 가운뎃점 갈래로 통일되었다. ⓓ ㅇ, ㅎ은 정원을 유지한 채 크기만 달라지고 있으며 ⓔ 소리점은 사라지고, 아래아는 내리점의 형태이다. ⓕ 글자체의 틀은 다양한 형태로 나타난다. ⓖ 너비는 큰 글자는 전각, 작은 글자는 반각을

❾ Gyoseogwan Woodcut Group [9]

In the later 1600s the Gyosugwan imported type named Myeongpaninbon from the Ming empire and used them as the matrices for a set of printing types called 'Gyosugwan Insucheja'. The type developed to accompany this was introduced in the 1700s and was suitably named 'Gyosugwan cast-iron type'. Later a woodcut was developed based on this typeface and was also named 'Gyosugwan woodcut group' (Gyosugwanche group).

'Gyosugwan group' consists of large letters, used in the main text. ⓐ The start and ends of the strokes have triangular sharp edges. ⓑ The individual letters are slightly asymmetrical, ⓒ The ㅅ, ㅈ, ㅊ generally have a middle crossstroke configuration. The lower stroke of shi-ot extends long to the lower left, and the right stroke is neat and reserved or angled to the left. ⓓ The ㅇ, ㅎ have a different form according to configuration. ⓔ The araea has a downstroke form. ⓕThe frame is inconsistent and have totally broken away from the square frame syllable composition. ⓖ The width of the letters maintains a unified width. ⓗ The baseline is aligned with the vertical columns, and so is to the right.

The first consonants are smaller, the syllables with no final consonants have long extended

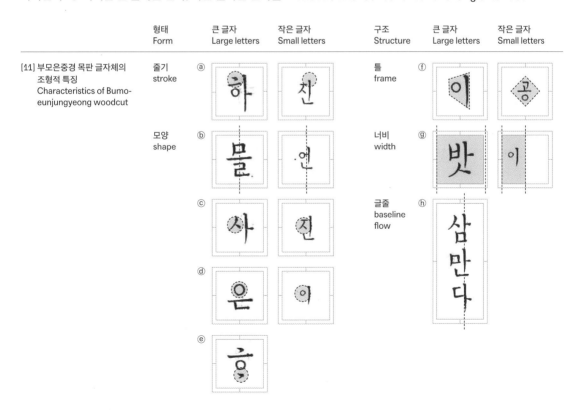

	형태 Form		큰 글자 Large letters	작은 글자 Small letters	구조 Structure		큰 글자 Large letters	작은 글자 Small letters
[11] 부모은중경 목판 글자체의 조형적 특징 Characteristics of Bumo-eunjungyeong woodcut	줄기 stroke	ⓐ	하	친	틀 frame	ⓕ	이	공
	모양 shape	ⓑ	물	연	너비 width	ⓖ	밧	이
		ⓒ	사	진	글줄 baseline flow	ⓗ	삼 만 다	
		ⓓ	은	이				
		ⓔ	ㅎ					

유지하며 ⓗ 글줄은 홀자의 기둥을 따라 가지런하게 흘러
보다 읽기 편해진 모습을 보인다.

부모은중경체는 이전까지 불경 언해본에 쓰이지
않았던 궁체 계열의 한글꼴이 쓰였으며, 자유롭고 유려한
붓글씨체의 모습을 보이고 있다.

3. 나가며

조선의 불경 언해본 간행은 한글을 통한 불교 문화의
대중화를 시도한 것으로 조선 말기까지 꾸준히
진행되었다. 한글 창제 이후 약 400년 동안 불교는
한글을 활용함으로써 한글꼴을 발전시키는 데 중요한
역할을 한 것이다.

불경 언해 시작기(1449-)의 '석보상절 놋쇠
활자체'와 '월인석보 목판 글자체'는 한글 창제의 원형인
'훈민정음 목판 글자체'를 계승하고 발전시킨 형태로서
의미가 깊다. 불경 언해 부흥기(1461-)의 '강희안
놋쇠 활자체'와 '간경도감 목판 글자체', '정난종 놋쇠
활자체'는 가로 너비가 큰 글자의 절반인 작은 글자를
중심으로 발전했다. 불경 언해의 확산기(1517-)의
한글꼴인 '경서 목판 글자체 계열', '염불보권문 목판
글자체', '교서관 목판 글자체 계열', '중간진언집 목판
글자체', '부모은중경 목판 글자체'는 창제 초기의
기하학적인 구조에서 벗어나 글자 줄기에서 강약이
느껴지는 손글씨의 영향을 받은 글자체로, 세로쓰기에
맞추어 균형이 오른쪽으로 이동했으며, 다양한 형태의
한글꼴이 등장했다. 이렇듯 불경 언해본은 한글꼴 발달
역사의 형태적, 구조적 연구 자료로서 큰 가치가 있다.

오늘날 우리가 주로 쓰는 한글꼴은 조선 시대
선조들이 써온 전통 한글꼴과는 뼈대를 달리한다.
1990년대 이후 원도 활자를 바탕으로 다수의 디지털
글자체가 개발되었지만, 비슷한 형태와 구조로 다양한
표정의 글자체에 대한 필요성이 늘 대두되었다.
불경언해본을 포함한 선조들의 다양한 언해본을 잘
살펴보고, 이를 현대화하여 쓰임에 맞게 재탄생시킨다면
불교 문화뿐 아니라 한글꼴 역사에 새로운 바람을
불러일으킬 수 있을 것이라 기대한다.

참고 문헌

김무봉, '불경언해의 국어사적 의의',
한국불교학결집대회 제1집, 한국불교학결집대회
조직위원회, 2002
———, '조선 시대 간경도감 간행의 한글 경전 연구',
한국사상과 문화 제23집, 한국사상문화학회, 2004
———, '불전언해의 몇 가지 문제', 불교학연구 제9호,
불교학연구회, 2004
김진평, '한글 활자체 변천의 사적 연구', 출판연구 1.1,
한국출판연구소, 1990

strokes and more attention to spacing is apparent
leading to a more balanced form of type.

❿ Jungganjineonjip Woodcut [10]

In 1777 a compendium of Buddha's sayings in
Sanskrit, Chinese and Korean were compiled into
a single text called the Jungganjineonjip
Manyeonsa edition. The type used was
'Jungganjineonjip woodcut' (Junggganjineonjipche).

'Junggganjineonjipche' consists of large letters
and is used in the main text. ⓐ The start of
the stroke is sharp and angled, the knob of ㅎ
and the double side strokes of the vowels have
been angled. ⓑ Individual letters are slanted.
ⓒ The ㅅ, ㅈ, ㅊ generally have a middle
crossstroke configuration. ⓓ The ㅇ, ㅎ have
a different form according to configuration. ⓔ The
phonetic symbols and araea has a downstroke
form. ⓕ The frame is inconsistent and have totally
broken away from the square frame syllable
composition.
ⓖ The width of the letters maintains a unified
width. ⓗ The baseline is aligned to the right.

This typeface reflects the movement and
pressure of a calligraphic brush while showing
hints of woodcut at the edges and tips of the
strokes and sidestrokes while attempting unique
syllable compositions unseen in previous texts.

⓫ Bumo-eunjungyeong Woodcut [11]

In 1796 the Bumo-eunjungyeong-eonhae Yongjusa
edition was completed. This translation was
one of many versions leading up to the 1500s.
However, the Yongjusa edition is considered as the
definitive Korean edition. In showing honor to his
parents, King Jeongjo had this edition printed with
illustrations by the reknowned artist Kim Hongdo.
The type used in this edition is of a palace type and
was called 'Bumo-eunjungyeong woodcut' (Bumo-
eunjungyeongche).

'Bumo-eunjungyeongche' and consists of large
letters uesd for the main text and small letters
for footnotes. ⓐ The stroke is indicative of the
calligraphic brush with the starting point angled.
the knob of ㅎ and ㅊ are downstrokes. ⓑ Individual
letters are aligned to the left. ⓒ The ㅅ, ㅈ, ㅊ are
unified with a middle cross stroke configuration.
ⓓ The ㅇ, ㅎ retained a circular form, but take on
different sizes according to the placement within
a syllable. ⓔ The phonetic symbols has
disappeared and araea has a downstroke form.
ⓕ The frame change according to syllable
configuration. ⓖ The width of the large letters is

문화관광부, 한글 옛 문헌 정보 조사 연구,
　　문화체육관광부, 2001

안상수, 한재준, 이용제, 한글 디자인 교과서, 안그라픽스,
　　2009

최윤곤, '간경도감의 실체와 불전 간행 사업',
　　인문사회과학논문집 제31집, 광운대학교
　　인문사회과학연구소, 2002

한국타이포그라피학회, 타이포그래피 사전, 안그라픽스,
　　2012

↗

of unified width while the small letters are a half-width. ⓗ The baseline is aligned to syllables without a final consonant, making it easier to read.

'Bumo-eunjungyeongche' uses a form of type used only in the palaces which has not been seen in previous Korean Buddhist Scriptures also showing free-form calligraphic styles as well.

3. Closing

The Korean translation efforts of the Buddhist Scriptures served to introduce Buddhist culture to the general public well into the late Joseon period. For 400 years after the inception of Hangeul, Buddhism used Hangeul in its teaching and served to develop it and establish it as a writing system.

During the Inception of Korean Buddhist Scriptures (1449-) period 'Seokbosangjeol brass type' and 'Wolinseokbo woodcut' are prominent as they developed the basic form of the original 'Hunminjeongeum woodcut'. During the Development of Korean Buddhist Scripture period (1461-) 'Kangheeahn brass type', 'Gangyeongdogam woodcut', 'Jeongnanjong brass type' developed the half width small letters of Hangeul. And during the Expansion of Korean Buddhist Scripture period (1517-), Gyeongsu woodcut group', 'Yeombulbogwonmun woodcut', 'Gyosugwan woodcut group', 'Jungganjineonjip woodcut', and 'Bumo-eunjungyeong woodcut' broke away from the geometric base shape of Hangeul to a form influenced by movement and pressure in handwriting, aligning to the right, and generally taking on unique shapes. As it stands the Korean Buddhist Scripture is a vital resource in understanding the development of Hangeul type as well as a source for research in form and structure.

The typefaces we use today are generally different in origin from what our ancestors used during this period. Since 1990 much effort has been put in digitizing typeface masters, alluding to the need for diversity in form and structure. The Korean Buddhist Scriptures as well as other translation texts of this period offer a viable alternative in diversifying as well as modernizing these Hangeul fonts for wider use.

Reference

Ahn Sang-soo, Han Jae-joon, Lee Yong-je, Hangeul
　　Design Textbook, Ahn Graphics, 2009

Choi Yun-gon, 'Substance of Gangyeongdogam
　　and the publication of Buddhist classics',

Journal of The Institute of Humanities & Social Sciences Vol. 31, Institute of Humanities & Social Sciences Kwangwoon University, 2002

Kim Jin-pyung, 'A Historical Study on Changes of Hangeul Typeface', Publication Study 1.1, Korea Publication Lab, 1990

Kim Mu-bong, 'The Korean Translation of Buddhist Scriptures in the history of Korean Language', Korean Conference of Buddhist Studies Vol. 1, Korean Conference of Buddhist Studies's Official Documentary, 2002

———, 'A study on Korean Scriptures published by the Gangyeongdogam in Joseon Dynasty Era', Korean Thought and Culture Vol. 23, The Society of Korean Thought and Culture, 2004

———, 'Several Issues of Buddhist Scriptures', Journal of Buddhist studies No. 9, The Korean Society for Buddhist Studies, 2004

Korean Society of Typography, A Dictionary of Typography, Ahn Graphics, 2012

Ministry of Culture, Sports and Tourism, A Study on Information about the Ancient Korean References, Ministry of Culture, Sports and Tourism, 2001

↗

강조 및 인용 표시를 위한 한글 글자체 디자인

Hangeul Font Design for Emphasis and Quotation

정영훈
국민대학교 대학원, 한국

Jung Young-hun
Graduate School of Kookmin University, Korea

요약

영문을 국문으로 번역할 경우 문장부호를 많이 사용하게 되는데, 이는 로만 알파벳 폰트 중 이탤릭 글자체에 상응해 사용할 수 있는 한글 폰트가 없는 탓이다. 본 연구는 한글 폰트에서 로만 알파벳의 이탤릭에 상응하는 가족체 디자인 방법을 연구한다. 한글에서 로만 알파벳의 이탤릭과 같이 손글씨의 형태적 특징이 담겨 있는 글자체를 찾고, 찾아낸 글자체에서 골격을 축출한다. 이 골격을 토대로 글자체 디자인 방법을 연구하고, 정자체와 함께 섞어서 본문 조판을 시도한다. 국립국어원의 문장부호 개정안의 사례와 출판 업계에서 관행적으로 이어지는 문장부호 활용 사례를 비교해 어떤 차이점이 있는지를 파악한다. 이를 토대로 중복된 기능이나 반드시 필요한 문장부호를 분류하고, 중복된 기능은 한글 이탤릭 글자체로 대체하고, 반드시 필요한 문장부호 또한 대체 가능성을 검토한다. 한글 이탤릭 글자 가족 디자인 방법을 연구하고, 실제로 디자인한 뒤에 정자체와 함께 섞어서 본문 조판을 시도해 시각적 우려함을 유지하고 변별력을 갖추고 있는지 검증한다. 본 연구는 한글 폰트에서 강조 및 인용을 표시하기 위해 로만 알파벳의 이탤릭 글자체에 상응하는 한글 이탤릭 글자체 디자인 방법을 제안한다.

Abstract

Punctuation marks that are used in the typography of Korean & English or Korean translated texts are more frequently used in Korean texts than in English texts. This is because there is no italic font in Korean when typesetting English so they replace it with punctuation marks. This study is to research the possibility of a Korean italic font like the Roman alphabet italics. This is also a further study of font design and an attempt in designing italics in Korea. After driving out the frame of handwritten fonts such as italics of the Roman alphabet in Korean, we will study the ways to design fonts and try mixed typesetting of Korean italics and Korean normal fonts using to designed fonts. We are to figure out differences among the cases of adapting the Revision of Punctuation Marks made by the National Institute of Korean Language and the independent manuals of the open books. We will categorize the punctuation marks that are necessary and that have overlapped functions when using punctuation marks, attempting to replacing them with italics and maintaining visual refinement when mix-typesetting Korean normal fonts and Korean italics, lastly we will test if they are discriminable. This study is to suggest ways to design Korean italic fonts that are equivalent to italics in the Roman alphabet to indicate emphasis and citation in Korean fonts.

주제어
한글, 문장부호, 글자체, 흘림체, 이탤릭

Keywords
Hangeul, Punctuation, Font, Cursive, Italic

→

1. 서론

번역서 또는 국문과 영문을 함께 조판할 경우 국문에서 문장부호가 더 많이 쓰이는데, 이는 로만 알파벳의 이탤릭체에 상응하는 글자체가 한글에는 없기 때문이다. 여러 문장부호가 쓰이다 보면 그에 따라 기능이 세분되고 복잡해지기 마련인데, 그렇기에 국립국어원에서는 문장부호의 기능을 정의해 알리고 있다. 하지만 문장부호의 실제 쓰임을 보면 국립국어원에서 정의한 지침을 따르지 않고, 출판사에서 독자적으로 매뉴얼을 만들거나 디자이너의 의도대로 사용하는 등 혼란이 일어나는 상황이다. 모든 문장부호가 반드시 필요한 것일까? 그리고 로만 알파벳의 이탤릭체에 상응하는 글자체가 한글 글자체에는 없는 것일까?

이런 의문을 바탕으로 본 연구를 시작했다. 국립국어원 문장부호 개정안[1]과 다르게 사용되는 경우를 비교하기 위해 열린책들 출판사에서 출간한 열린책들 편집 매뉴얼(이하 편집 매뉴얼)의 강조 및 인용을 표기하기 위한 문장부호와 비교했다. 편집 매뉴얼은 문장부호의 쓰임을 정의해 책으로 출간하고 있어 서점에서 손쉽게 구매할 수 있다. 또한 매년 새로이 문장부호의 기능을 정의하기 때문에 가장 체계적으로 정리된 사례로 판단해 본 연구에 활용했다. 국립국어원 문장부호 개정안과 편집 매뉴얼의 문장부호에서 강조 및 인용 등의 표기 방법을 비교하고 중복된 기능을 제거한 뒤 문장부호를 반드시 써야만 하는 경우를 찾아내어, 여러 문장부호를 한글 이탤릭체로 대체해 본문을 조판하고 변별력과 유사성 두 측면을 모두 만족시킬 수 있는 한글 글자체 디자인 방법을 연구한다.

[1]
국립국어원의 문장부호 개정안은 아직 시행되지 않은 개정안이고, 개정안 발표 시기를 명확히는 알 수 없으나, 앞으로 개정될 표준을 제시하기 때문에 본 연구에 활용했다. 앞으로 정식으로 발표될 개정안은 본 논문에 쓰인 내용과는 다소 다를 수 있음을 밝힌다. The Revised Punctuation Marks of National Institute of the Korean Language has not been implemented, nor has there been a specified date for this revision. However, as this revision will set the standard for the future, this article will reference the revised standard. As such, the actual revision standards may be slightly different from those stated in this article.

1. Introduction

Punctuation marks that are used in the typography of Korean & English or Korean translated texts are more frequently used in Korean texts than in English texts. This is because there is no italic font in Hangeul so they replace the equivalent with punctuation marks. As a variety of punctuation marks are used to fulfill essentially the same function, it is natural that the usage of each symbol would become more detailed and complex, that's why the National Institute of the Korean Language has tried to define each symbol and it's proper use. However, instead of following the guidelines set out by the National Institute of the Korean Language, many publishers choose to define these symbols in their own way and set guidelines based on their own personal preference. Do we really need all of these punctuation marks?

Also, is there a Korean letterform that could correspond to the Western italic font? These question form the basis of this study. To address the difference in usage, the Revised Punctuation Marks of National Institute of the Korean Language[1] has been chosen to compare with the Open Books Editorial Manual (OB Editorial Manual), published by the Open Books Editorial Department, as this manual is available to the general public and relatively easy to acquire. Also, with a revised edition being released each year it is viewed as the most reliable and current of editing style manuals available today. Comparing the emphasis and quotation marks usages of both the Revised Punctuation Marks and the OB Editorial Manual, discarding identical usages and defining those that must absolutely retain it's function this study seeks to find an alternative method for punctuation marks based on similarity and uniqueness to coincide with the Western italic for Korean type design.

번역: 박경식 Translation: Fritz K. Park

2. 국립국어원 문장부호 사례
2.1 문장부호 개정안과 편집 매뉴얼 강조 및 인용 표기법 비교

[a] 문장부호 개정안과 편집 매뉴얼의 강조 및 인용 표기법 비교

	문장부호 개정안	편집 매뉴얼
큰따옴표	• 대화를 표시할 때 쓴다. • 말이나 글을 직접 인용 할 때 쓴다. • 책의 제목을 나타낼 때 쓴다.	• 글 가운데 직접 대화. • 남의 말 인용. • 각주, 참고 문헌에서 로마자 논문 제목을 표시할 때, 저자, 책 제목.
작은따옴표	• 인용한 말 가운데 다시 인용한 말이 들어갈 때 쓴다. • 마음속으로 한 말이나 독백을 나타낼 때 쓴다. • 문장에서 특정부분을 따로 드러내 보이고자 할 때 쓴다. • 작품의 제목, 가게 이름 등 고유한 이름을 나타낼 때 쓴다.	• 따온 말 가운데 다시 따온 말이 들어 있을 때 쓴다. • 마음속으로 한 말을 적을 때 쓴다. • 문장에서 중요한 부분을 두드러지게 하기 위해 드러냄표 대신에 쓰기도 한다.
소괄호	• 주석이나 보충적인 내용을 덧붙일 때 쓴다. • 한자어나 외래어의 원어를 보일 때 또는 외국어를 음차한 말과 해당 외국어를 함께 보일 때 쓴다. • 우리말 용어와 외국어를 함께 보일 때 쓴다. • 조건에 따라 형태가 달라지는 말에서 생략될 수 있는 요소임을 나타낼 때 쓴다. • 희곡 등 대화를 적은 글에서 동작이나 분위기, 상태를 드러낼 때 쓴다. • 내용이 들어갈 빈자리임을 나타낼 때 쓴다. • 항목 부호 등 기호적인 기능을 하는 숫자나 문자에 쓴다.	• 원어, 연대, 주석, 설명 등을 넣을 적에 쓴다. • 특히 기호 또는 기호적인 구실을 하는 문자, 단어, 구에 쓴다. • 빈자리임을 나타낼 적에 쓴다. • 한자와 일본어를 밝힐 때 쓴다. • 일본어나 중국어의 한자는 한국어의 한자 발음과 다르더라도 소괄호를 쓴다.
중괄호	• 여러 단위를 동등하게 묶어서 보일 때 쓴다. • 나열된 항목 중 어느 하나가 자유롭게 선택될 수 있음을 보일 때 쓴다.	• 여러 단위를 동등하게 묶어서 보일 때 쓴다.
대괄호	• 묶음표 안의 말이 바깥말과 음이 다를 때 쓴다. • 음가를 나타낼 때 쓴다.	• 묶음표 안의 말이 바깥말과 음이 다를 때 쓴다. • 묶음표 안에 또 묶음표가 이을 때 쓴다.
드러냄표	• 문장 내용 중에서 주의가 미쳐야 할 곳이나 중요한 부분을 특별히 드러내 보일 때 쓴다. • 드러냄표 대신 밑줄을 치기도 한다.	• 문장 내용 중에서 주의가 미쳐야 할 곳이나 중요한 부분을 특별히 드러내 보일 때 쓴다. • 드러냄표 대신 밑줄을 치기도 한다.
홑꺽쇠표	• 작품의 제목 등 고유한 이름을 나타낼 때 쓴다. • 겹꺽쇠표와 홑꺽쇠표를 구별하기 어렵거나 따로 구별할 필요가 없을 때는 홑꺽쇠표 하나를 대표로 쓴다.	• 인용구일 때 쓴다. • 강조할 땐 원서에서 이탤릭체로 된 부분을 표기할 때 쓴다. • 마음속으로 한 생각을 나타낼 때 쓴다. • 간접 인용. • 따온 말은 홑낫표를, 그중 다시 따온 말에 쓴다. • 문장에서 중요한 부분을 두드러지게 하기 위해 드러냄표 대신에 쓰기도 한다. • 강조할 때 쓴다. • 홑낫표 안에 또 홑낫표를 써야 하는 경우엔 홑낫표 대신 꺾은괄호를 쓴다.
겹꺽쇠표	• 책, 신문 등의 제목을 나타낼 때 쓴다.	• 인용 속에 강조. • 강조 속에 강조.
홑낫표	• 작품의 제목 등 고유한 이름을 나타낼 때 쓴다. • 겹낫표와 홑낫표를 구별하기 어렵거나 따로 구별할 필요가 없을 때는 홑낫표 하나를 대표로 쓴다.	• 글 가운데서 직접 대화를 표시할 때 쓴다. • 간접 인용일 경우에 쓴다. • 책의 형태가 아닌 인쇄물(신문), 그 자체로 책이 되기 어려운 작품(중편소설, 단편소설), 논문, 영화, 연극, 오페라, 노래, 교향곡, 음반명, 미술작품, 전시회 이름 등을 표시할 때 쓴다.
겹낫표	• 책, 신문 등의 제목을 나타낼 때 쓴다.	• 책의 형태로 볼 수 있는 것, 즉 단행본, 장편소설, 소설집, 희곡집, 잡지(주간, 월간 계간, 부정기 간행물 등)를 표시할 때 쓴다.

2. The National Institute of the Korean Language Punctuation Mark Examples
2.1 Comparison of Emphasis and Quotation Methods of the <u>Revised Punctuation Marks</u> and the <u>OB Editorial Manual</u>

[a] Comparison of Emphasis and Quotation Methods of the <u>Revised Punctuation Marks</u> and the <u>OB Editorial Manual</u>

	Revised Punctuation Marks	OB Editorial Manual
Double Quotation Marks	• For conversation • Quote words or text • Book titles	• Conversation between the text • Quoting other's words • English thesis titles, author, book title in footnotes, references
Quotation Marks	• A quotation within a quotation • Thoughts or for monologue • Used to emphasize important parts in a text. • Unique names such as work titles, store names etc.	• A quotation within a quotation • Thoughts expressed • Used to emphasize important parts in a text, used instead of emphasis mark
Parentheses	• Footnotes or supplementary materials • Differentiate other languages such as Chinese and Japanese, or to discern the Korean pronunciation with the corresponding foreign word. • Show Korean and other languages together • In other instances to discern omitted parts of a word. • In playwrite denotes action, atmosphere, or condition within a given dialogue. • Space for words to be filled in. • Used with letters or numbers in a given list or group.	• Original language, date, footnote, supplement material • Symbols or letters, words or segments that act as symbols • Indicate empty space • Show Chinese and Japanese • Even if Japanese or Korean Chinese pronunciations differ, use parentheses to differentiate with Korean pronunciation
Braces	• Grouping many units together • Multiple selection options	• Grouping many units together
Square Brackets	• When inside and outside words in parenthesis are pronounced differently • Show phonetic value	• When inside and outside words in parenthesis are pronounced differently • Inside parenthesis or when connecting parenthesis
Emphasis Mark	• Part of a sentence that needs attention or is important or special • Ues underline in place of an emphasis mark	• Part of a sentence that needs attention or is important or special • Ues underline in place of an emphasis mark
Single Angle Brackets	• Work title or other unique names • When it is difficult to distinguish between double angle brackets and single angle brackets or is not needed to do so, use the single angle brackets	• Use for quotations • For emphasis, use when the original language text uses italics • Expressing thoughts • Indirect quotations • Quotes should be in single corner brackets, quotes within those should use angle brackets • Used in place of emphasis mark for emphasis • For emphasis • When using a single corner brackets within another single corner bracket use the angular quote brackets in place of single corner brackets
Double Angle Brackets	• For book or newspaper titles	• Emphasis within a quote • Emphasis within an emphasis

비교한 문장부호의 기능을 더 간단히 비교할 수 있도록 대화, 인용, 고유명사 등으로
요약했다.

[b] 문장부호 개정안과 편집 매뉴얼의 강조 및 인용 표기법 요약

	문장부호 개정안	편집 매뉴얼
큰따옴표	• 대화 • 인용 • 고유명사	• 대화 • 인용 • 고유명사
작은따옴표	• 인용구에 인용 • 독백 • 강조	• 인용구에 인용 • 독백 • 강조
소괄호	• 주석 및 보충 • 외래어 음차 • 국문과 외래어 혼용 • 생략 • 희곡 등 대화 글 동작 및 분위기 • 빈자리 • 기호	• 주석 및 보충 • 기호 • 빈자리 • 한자 및 일본어 • 외래어 음차
중괄호	• 단위를 동등하게 묶음 • 나열된 항목 선택	• 단위를 동등하게 묶음
대괄호	• 음이 다를 때 • 음가	• 음이 다를 때 • 묶음표 안에 묶음표
드러냄표	• 강조	• 강조
홑꺽쇠표	• 고유명사 • 겹꺽쇠표와 홑꺽쇠표의 구분이 어려울 때	• 인용 • 강조 • 원서의 이탤릭 • 독백 • 간접 인용 • 따온말에 따온말 • 강조 • 홑낫표 안에 홑낫표 사용할 때
겹꺽쇠표	• 고유명사	• 인용 속 강조 • 강조 속에 강조
홑낫표	• 고유명사 • 겹낫표 홑낫표 구분이 어렵거나 구문이 불필요할 때	• 대화 • 간접 인용 • 책의 형태가 아닌 인쇄물에 고유명사
겹낫표	• 고유명사	• 책의 형태로 볼 수 있는 인쇄물에 고유명사

2.2 문장부호 개정안에서 강조 및 인용의 기능을 하는 문장부호 요약

앞에서 살펴봤듯이 문장부호 개정안과 편집 매뉴얼에서 정의한 문장부호의 기능은 달랐고,
문장부호 개정안에서 정의한 강조 및 인용 등을 표시하기 위한 문장부호의 기능이 서로
중복되는 경우가 있었다. 반드시 문장부호를 사용해야 하는 경우와 중복되는 기능을
제외한 나머지를 문장부호를 남겨놓는 방식으로 정리했고, 대부분 기능이 로만 알파벳의
이탤릭체의 기능과 유사하다고 판단했다. 간추린 문장부호 개정안의 강조 및 인용을
표시하기 위한 문장부호의 기능은 다음과 같다.

Single Corner Brackets	• Work title or other unique names • When using both double corner brackets and single corner brackets or is not needed to do so, use the single corner brackets	• Used for dialogue in text • Indirect quotation • Print matter other than books (newspaper), printed matter difficult to be classified as a book (mid or short stories), thesis, movies, plays, opera, songs, symphony, album titles, art work, exhibitions etc.
Double Corner Brackets	• Book or newspaper titles	• Printed material in book form: books, novels, anthologies, plays, periodicals (weekly, monthly, quarterly, irregular)

I simplified function of compared punctuation marks using conversation, quotation, and proper noun.

[b] Summary of Punctuation Marks Used For Emphasis and Quotation in the Revised Punctuation Marks and the OB Editorial Manual

	Revised Punctuation Marks	OB Editorial Manual
Double Quotation Marks	• dialogue • quotation • proper noun	• dialogue • quotation • proper noun
Quotation Marks	• quotation within a quotation • monologue • emphasis	• quotation within a quotation • monologue • emphasis
Parentheses	• footnote & supplement • foreign language • Korean & other language mix • delete • script dialogue, action or setting • space • symbols	• footnote & supplement • symbols • space • Korean and Japanese • Korean & other language mix
Braces	• grouping many units together • multiple selection options	• grouping many units together
Square Brackets	• different phonetics • phonetic value	• different phonetics • Parentheses within a parenthesis
Emphasis Mark	• emphasis	• emphasis
Single Angle Brackets	• proper noun • When difficult to distinguish double angle brackets and angle brackets	• quotation • emphasis • Italic font in original book • monologue • Indirect quotation • Quotes from the quoted word • emphasis • Using single corner bracket within single corner bracket
Double Angle Brackets	• proper noun	• Emphasis within a quote • Emphasis within an emphasis
Single Corner Brackets	• pronoun • When difficult to distinguish double corner brackets and single corner brackets or when it is not needed	• dialogue • Indirect quotation • Proper noun in printed matter except format of a book
Double Corner Brackets	• proper noun	• Proper noun in format of a book

2.2 Summary of Punctuation Marks Used For Emphasis and Quotation in the Revised Punctuation Marks

As we see above, the Revised Punctuation Marks and OB Editorial Manual define punctuations and it's usages differently, and in many cases in the Revised Punctuation of the National Institute of the Korean Language definitions of emphasis

큰따옴표	대화/인용/고유명사
작은따옴표	인용구에 인용/독백/강조/고유명사
소괄호	주석 및 보충/외래어 음차/기호/국문과 외래어 혼용/생략/빈자리/희곡 등 대화글 동작 및 분위기
중괄호	단위를 동등하게 묶음/나열된 항목 선택
대괄호	음이 다를 때/음가
드러냄표	강조
홑꺾쇠표	고유명사/겹꺾쇠표와 홑꺾쇠표의 구분이 어려울 때
겹꺾쇠표	고유명사
홑낫표	고유명사/겹낫표와 홑낫표 구분이 어렵거나 구분이 불필요할 때
겹낫표	고유명사

중복되는 용도와 반드시 문장부호를 사용해야하는 경우를 제거한 나머지는 표 f와 같다.

[d] 문장부호 개정안의 강조 및 인용 표기법 요약 2

큰따옴표	대화/인용/고유명사
작은따옴표	인용구에 인용/독백
소괄호	주석 및 보충/외래어 음차/국문과 외래어 혼용/희곡 등 대화글 동작 및 분위기
중괄호	
대괄호	음이 다를 때/음가
드러냄표	강조
홑꺾쇠표	겹꺾쇠표와 홑꺾쇠표의 구분이 어려울 때
겹꺾쇠표	
홑낫표	겹낫표와 홑낫표 구분이 어렵거나 구분이 불필요할 때
겹낫표	

문장부호를 요약했는데도 여전히 기능이 많아서 쓰임이 복잡하다. 위에 나열한 문장부호의
기능은 로만 알파벳의 이탤릭체와 기능이 유사하다.[2]

[e] 로만 알파벳의 이탤릭체 표기법 요약

이탤릭	대화/인용/고유명사/주석 및 보충/외래어 음차/국문과 외래어 혼용/희곡 등 대화 글 동작 및 분위기/인용구에 인용/독백/음이 다를 때/음가/겹꺾쇠표와 홑꺾쇠표의 구분이 어려울 때/겹낫표와 홑낫표 구분이 어렵거나 구분이 불필요할 때

2
조엡 풀런,
글자 분수, 타센,
2011, 39쪽

and quotations are often repeated. We organized the symbols into essentials and symbols that have not been repeated, we found that the majority of the punctuation marks serve a similar purpose to italics.

[c] Summary of Punctuation Marks Used For Emphasis and Quotation in the Revised Punctuation Marks 1

Double Quotation Marks	dialogue / quotation / proper noun
Quotation Marks	quotation within a quotation / monologue / emphasis / proper noun
Parentheses	footnote & supplement / foreign language / symbols / Korean & other language mix / delete / space / script dialogue, action or setting
Braces	grouping many units together / multiple selection options
Square Brackets	different phonetics / phonetic value
Emphasis Mark	emphasis
Single Angle Brackets	proper noun / When difficult to distinguish double angle brackets and angle brackets
Double Angle Brackets	proper noun
Single Corner Brackets	proper noun / When difficult to distinguish double corner brackets and single corner brackets or when it is not needed
Double Corner Brackets	proper noun

The rest are the same as table f except for repeated usage and essential punctuation marks.

[d] Summary of Punctuation Marks Used For Emphasis and Quotation in the Revised Punctuation Marks 2

Double Quotation Marks	dialogue / quotation / proper noun
Quotation Marks	quotation within a quotation / monologue
Parentheses	footnote & supplement / foreign language / Korean & other language mix / script dialogue, action or setting
Braces	
Square Brackets	different phonetics / phonetic value
Emphasis Mark	
Single Angle Brackets	When difficult to distinguish double angle brackets and angle brackets
Double Angle Brackets	
Single Corner Brackets	When difficult to distinguish double corner brackets and single corner brackets or when it is not needed
Double Corner Brackets	

The use is overly complicated even though punctuation has been revised. The punctuation marks shown in the upper may be used in place of italics.[2]

[e] Summary of features in italics

Italics	conversation / quotation / proper noun / footnotes or supplements / foreign pronunciation / Korean and other language mix / plays, script action or movement / quote within a quotation / monologue / different phonetics / phonetic value / Difficult to distinguish double angle brackets and angle brackets / Difficult to distinguish double corner brackets and single corner brackets or when it is not needed

2
Joep Pohlen,
Letter Fountain,
TASCHEN, 2011,
p. 39

흘림체 cursive	이에 관한 영구 븣야가 따로 생겼을 정도로	
탈네모틀	이에 관한 연구 분야가 따로 생겼을 정도로	
우사체 right italic	이에 관한 연구 분야가 따로 생겼을 정도로	
좌사체 light italic	이에 관한 연구 분야가 따로 생겼을 정도로	
볼드 Bold	이에 관한 **연구 분야가** 따로 생겼을 정도로	
밑줄 underline	이에 관한 <u>연구 분야가</u> 따로 생겼을 정도로	
그림자 shadow	이에 관한 **연구 분야가** 따로 생겼을 정도로	

[1] 강조 및 인용 부분을 표시할 수 있는 일곱 가지 한글 글자체
Seven methods for emphasis and punctuation in Hangeul letters

이에 관한 영구 븣야가 따로 생겼을 정도로

이에 관한 영구 븣야가 따로 생겼을 정도로

이에 관한 영구 븣야가 따로 생겼을 정도로

[2] 정자체와 골격의 유사성, 변별력을 갖춘 흘림체
Cursive, similar in structure and distinction with regular letters

MCST Batang	이에 관한 연구 분야가 따로 생겼을 정도로
MCST Cursive	이에 관한 연구 븣야가 따로 생겼을 정도로
골격 Structure	이에 관한 연구 분야가 따로 생겼을 정도로 이에 관한 영구 븣야가 따로 생겼을 정도로
같은 두께 Same weight	이에 관한 연구 분야가 따로 생겼을 정도로 이에 관한 영구 븣야가 따로 생겼을 정도로
조합 Composition	이에 관한 영구 븣야가 따로 생겼을 정도로

[3] 문화체육부 바탕체와 문화체육부 쓰기 흘림체 비교
Comparison of MCST Batang and MCST Cursive

이에 관한 영구 븣야가 따로 생겼을 정도로

[4] 문화체육부 쓰기 흘림체의 가로쓰기와 세로쓰기의 중심축
Baseline for vertical and horizontal typesetting of the MCST Cursive

3. 강조 및 인용 부분을 문장부호 이외에 표시할 수 있는 한글 글자체 연구

정자체와 구분해서 사용할 수 있는 한글의 구조로 흘림체, 탈네모틀, 우사체, 좌사체, 볼드, 밑줄, 그림자 이렇게 일곱 가지로 구분했고, 각 글자체들의 골격을 추출했다. [1]

　일곱 개의 한글 글자체와 정자체를 섞어서 조판해 각각의 유사성과 변별력 정도를 평가했을 때, 탈네모틀 글자체는 변별력보다 유사성이 떨어져 보였으며, 우사체와 좌사체는 같은 골격의 글자체를 기울였기 때문에 유사성은 있지만, 변별력은 떨어져 보였다. 볼드체는 형태적으로 강조되어 보이기 때문에 쓰임이 강조만으로 국한될 수 있고, 밑줄과 그림자 또한 강조되어 보이기 때문에 볼드체와 같이 쓰임이 국한될 수 있다. 흘림체는 앞에서 언급한 여섯 개의 글자체보다 유사성과 변별력에서 더 확실하며, 로만 알파벳의 이탤릭체에 상응하는 글자체 디자인의 골격으로 삼기에 적합했다. [2]

　흘림체는 정자체와 골격의 유사성을 지니면서도 변별력을 갖추고 있으며 탈네모틀, 우사체, 좌사체보다 글자 골격에서 정자체와 유사하다. 정자체와 흘림체는 모두 같은 뿌리인 붓글씨에서 이어져왔다. 흘림체는 정자체와 골격의 유사성을 지니면서도 형태가 달라 변별력을 갖추고 있다

4. 문화체육부 바탕체와 문화체육부 쓰기 흘림체 사례 조사

문화체육부(현 문화체육관광부) 바탕체와 문화체육부 쓰기 흘림체는 1991년에 총 9종으로 개발되었다. 각 9종의 글자체는 제목용, 본문용 등 용도에 따라 기능을 분류해 개발되었다. 문화체육부 바탕체와 문화체육부 쓰기 흘림체는 같은 골격으로 두 글자체가 디자인되어서 본 연구의 조사 대상이 되었다. [3]

　문화체육부 바탕체는 가로쓰기에 적합하게 제작되었다. 하지만 문화체육부 쓰기 흘림체는 글자의 중심축이 오른쪽으로 치우쳐 있어서 가로쓰기보다 세로쓰기에 적합하다. 문화체육부 쓰기 흘림체는 골격과 형태가 펜글씨와 유사한데, 펜글씨의 골격이 붓글씨에 기본을 두고 있기에 가로쓰기가 아닌 세로쓰기에 적합한 것이다. 현재 대부분의 조판을 세로쓰기로 하지 않기 때문에 가로쓰기에 적합한 골격으로 조정이 필요하다. 앞서 언급한 바와 같이 문화체육부 바탕체와 문화체육부 쓰기 흘림체는 형태의 유사성이 적어 가족체라고 하기에는 무리가 있다. 두 글자체를 가족체로 활용하기 위해서는 가로쓰기에 적합하게 중심축이 중앙으로 이동해야 한다. [4]

3. Hangeul Fonts Suitable for Emphasis and Quotation

Type of Korean fonts to use with regular letterforms are cursive, non-square frame, oblique, reverse oblique, bold, underline, and drop shadow fonts. Of these seven I've extracted the basic structure of each type. [1]

　The above seven types were then mixed with regular type text and set, then evaluated according to similarity and uniqueness. Non-square frame was rated low in similarity, oblique and reverse oblique were basically the same letters only forced slanted so was evaluated low in uniqueness but high in similarity. Bold set apart the word drastically and so should be reserved for that purpose, along with underlines and drop shadows. Cursive rated highest in both evaluation categories and also retains a structural design method that can be associated with italics. [2]

　As cursive is both similar in form and structure, but also unique enough to be differentiated from its roman counterpart as well as being associated with roman letters than non-square frame, oblique, and reverse oblique fonts. Both roman and cursive stem from the same method of writing; with a brush. Cursive retains the same structure as roman while being different enough to be distinguished.

4. Samples of the Batang Font of MCST and the Cursive

The 'Ministry of Culture & Athletics (now Ministry of Culture, Sports and Tourism, MCST) Batang' and 'MCST Cursive' was developed as a 9 type family in 1991. Each weight was given a specific task such as display or body text and designed accordingly. Both MCST Batang and MCST Cursive were designed from the same structure and has been chosen for this study. [3]

　MCST Batang is ideal for horizontal typesetting. However, the center alignment of the MCST Cursive is toward the right and therefore suitable for vertical typesetting. MCST Cursive is similar to penmanship writing in both structure and form, making it suitable for vertical writing rather than horizontal typesetting. As the majority of text is set horizontally an adjustment is needed for this type of letterform.

　As was mentioned above MCST Batang and MCST Cursive are too drastically different in design as to be considered of one family group. As a way of joining the two as a family, the center angle should be aligned for horizontal typesetting. [4]

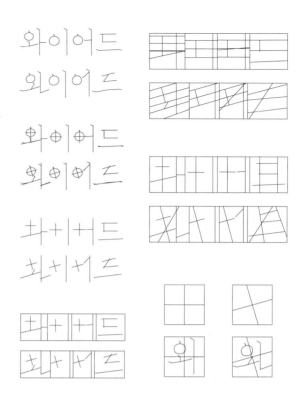

[5] 흘림체의 이음선과 기울기
 Cursive continuous lines and slanted angles

[7] 흘림체의 이음선과 기울기를 정자체의 골격과 비교
 Comparison of cursive continuous lines and slanted angles
 with regular letter structures

[6] 정자체에 흘림체의 골격 비교
 Comparison of regular and cursive structures

외 외 외 외

Yoon Myeongjo 310 Barun Batang Nanum Gothic

후자의 개정판은 와이어드가 발행했다.
후자의 개정판은 와이어드가 발행했다.

후자의 개정판은 와이어드가 발행했다.
후자의 개정판은 와이어드가 발행했다.

[8] 흘림체의 이음선과 기울기를 적용한 글자체와 정자체 혼용 조판
 Mixed typesetting with cursive continuous lines with
 slanted angles and regular letters

5. 한글 흘림체의 골격과 형태적 특징 조사 및 실험

획의 이음선과 각도 등 한글 흘림체의 두드러진 특징에 대해 골격과 형태적 특징을 실험했다. 실험을 통해 흘림체의 특징은 이음선과 기울기라고 판단했다. 정자체의 골격에 흘림체의 특징인 이음선과 기울기를 적용해 정자체와 유사한 흘림체의 기울기를 추출했다. [5-8]

6. 한글 흘림체 네모틀 골격을 이용해 흘림체의 형태 특성을 적용한 글자체 디자인

한글 흘림체의 골격을 토대로 흘림체의 세부 형태 특성 적용했다. [9-13]

7. 결론

한글에서 강조 및 인용을 표시하기 위해 대부분 문장부호를 사용하고, 로만 알파벳은 이탤릭체를 사용한다. 한글에는 아직 이탤릭체가 없으므로 로만 알파벳에 비해 더 많은 문장부호를 써야 하고, 문장부호의 기능이 복잡하다. 국립국어원에서 문장부호의 기능을 정의했지만, 현재 출판 업계에서 발행하는 여러 편집물과는 차이점이 많다. 본 연구는 위와 같은 상황에 대한 의문에서 출발했다. 이를 해결하는 방법으로 한글 이탤릭 디자인을 제안하고, 그에 따른 디자인 방법을 개발해 흘림체를 디자인했다. 로만 알파벳 폰트는 이탤릭을 하나의 가족체로 둔다. 한글 흘림체 또한 독립된 글자체가 아닌 가족체로서의 역할을 할 것이며, 대부분 문장부호로 대체하는 본문 조판에서 표현의 다양성을 넓히는 데 이바지할 것으로 예상한다. 또한 문장부호를 사용했을 때보다 조형성과 시각적 유려함이 더욱 높아질 것으로 기대한다.

참고 문헌

국립국어원, www.korean.go.kr/09_new/data/report_list.jsp

김진평, 한글의 글자표현, 미진사, 2001

김학성, 레터링 디자인, 조형사, 1991

박병천, 조선 시대 한글 서간체 연구, 다운샘, 2007

――――, 한글 궁체 연구, 일지사, 1983

세종대왕기념사업회, www.sejongkorea.org/sub/sub05_03.php

심우진, '한글 타이포그래피 환경으로서의 문장부호에 대하여', 글짜씨 3권 2호, 한국타이포그라피학회, 2011

열린책들 편집부, 열린책들 편집 매뉴얼 2012, 열린책들 편집부, 2012

이용제, '한글에서 문장부호 '.'와 ','의 문제, 글짜씨 2권 1호, 한국타이포그라피학회, 2010

5. Structural & Form Research Tests Based on Hangeul Cursive

We tested the structural attributes of Hangeul cursive based on strokes and stems and directional angles. The result was that cursives are best identified with stems and directional angles. Using the power of deduction, we chose the cursive type letterforms that best match the roman font in terms of structure as well as stem connectors and angles. [5-8]

6. Type Design Applying the Formal Attributes of Cursive Using the Square Frame of Hangeul Cursive

Applied cursive form details based on structure of Hangeul Cursive. [9-13]

7. Conclusion

In Hangeul, punctuation marks are used to denote emphasis or quotations while Latin alphabets rely mainly on italics. As italics do not exist in Korean writing, punctuation marks serve a much larger function than they do in the Latin alphabet, and are therefore more complex. Although the National Institute of the Korean Language has a set definition of all the individual punctuation marks, it differs in usage and meaning from other publishers. This paper started off with this inquiry. To rectify this situation, a recommendation to design a Korean italic was suggested, and as a design approach cursive was selected as a viable option. Italics are a part of a Latin alphabet family. Likewise, Hangeul cursive should also be considered as an intricate part of designing fonts in Hangeul, allowing for a widened form of expression other than the punctuation marks currently in use when setting type. Also, it is expected that a more visual as well as compositional typesetting will be possible than from when using punctuation marks.

Reference

Joep Pohlen, Letter Fountain, TASCHEN, 2011

Lee Ji-won, 'The Making of a Hangul Typeface: Barun Jiwon', LetterSeed Vol. 4 No. 1, Korean Society of Typography, 2012

Lee Yong-je, 'The Issue of '.' and ',' Punctuation Marks in Hangeul', LetterSeed Vol. 2 No. 1, Korean Society of Typography, 2010

National Institute of the Korean Language, www.korean.go.kr/09_new/data/report_list.jsp

Sim Wu-jin, 'Punctuations as an Environment of Hangeul Typography', LetterSeed Vol. 3 No. 2, Korean Society of Typography, 2011

ㄱ ㄴ ㄷ ㄹ ㅁ
ㅂ ㅅ ㅇ ㅈ ㅊ
ㅋ ㅌ ㅍ ㅎ

가 나 다 라 마
바 사 아 자 차
카 타 파 하

각 난 닫 랄 맘
밥 삿 앙 잦 찾
칵 탄 팝 항

가나다라마
바사아자차
카타파하

각난닫랄맘
밥삿앙잦찾
칵탄팝항

[9] 흘림체의 기울기를 적용한 네모틀 글자체 1
Cursive continuous lines and slanted angles applied to
square frames 1

[10] 흘림체의 기울기를 적용한 네모틀 글자체 2
Cursive continuous lines and slanted angles applied to
square frames 2

미 시
마 사 마 바
차 파 사 파
밥 각 밥 찾
 각 삿

[11] 흘림체 이음선을 적용한 글자체 1
Continuous lines applied to letters 1

난 맘 삿 찾 칵 팜
가나다라마바사아자차카타파하
각난닫랄맘밥삿앙잦찾칵탄팝항
뉴요커 프래드릭 가우디
알파벳 찬미자
레터링의 기본 타이포로지아
타이포그래피카 타이포그래피와
글꼴 디자인을 위한 팸플릿 아즈
타이포그래피카 뉴욕 말보로 지역
빌리지 출판사 나는 타임이다
타임이 말한다 나는 타이트하다

[12] 흘림체의 이음선을 적용한 글자체 2
Continuous lines applied to letters 2

66

유지원, '라틴 알파벳의 이탤릭체와 한글의 흘림체 비교
연구', 글짜씨 1권 1호, 한국타이포그라피학회,
2009
이기성, 한글 디자인 해례와 폰트 디자인, 한국학술정보,
2009
이기성, 한글 타이포그래피, 한국학술정보, 2007
이지원, '바른지원체', 글짜씨 4권 1호,
한국타이포그라피학회, 2012
태을출판사 편집부, 종합 한글 펜글씨 교본, 태을출판사,
2012
한국정신문화연구원 장서각, 아름다운 글자 한글,
이회문화사, 2004
Joep Pohlen, Letter Fountain, 타센, 2011

Yu Jiwon, 'A Comparative Study on Italic of the
Latin Alphabet and Cursive of Hangeul',
LetterSeed Vol. 1 No. 1, Korean Society of
Typography, 2009
김진평, 한글의 글자표현, 미진사, 2001
김학성, 레터링 디자인, 조형사, 1991
박병천, 조선 시대 한글 서간체 연구, 다운샘, 2007
———, 한글 궁체 연구, 일지사, 1983
세종대왕기념사업회, www.sejongkorea.org/sub/
sub05_03.php
열린책들 편집부, 열린책들 편집 매뉴얼 2012,
열린책들 편집부, 2012
이기성, 한글 디자인 해례와 폰트 디자인, 한국학술정보,
2009
이기성, 한글 타이포그래피, 한국학술정보, 2007
태을출판사 편집부, 종합 한글 펜글씨 교본, 태을출판사,
2012
한국정신문화연구원 장서각, 아름다운 글자 한글,
이회문화사, 2004

↗

↗

1933년에 발행된 뉴요커 지는 프레드릭 가우디를 알파벳 찬미자라고 소개했다. 가우디는 알파벳, 레터링의 기본, 타이포로지아 를 비롯한 수많은 글, 팸플릿, 책을 썼으며, 124 개의 글꼴을 디자인했다. 또한 그는 본인의 미학 사상을 소개하는 내용을 담은 타이포그래피카: 타이포그래피와 글꼴 디자인을 위한 팸플릿과 아즈 타이포그래피카를 창간했다. 이러한 간행물은 자신의 활동을 알림으로써 인쇄소에 글꼴을 팔기위한 목적으로 발행한 것이지만, 나중에는 이것이 모여 가우디의 학업과 비평의 원천이 되었다. 가우디는 1903년부터 1939년까지 뉴욕 말보로 지역의 빌리지 출판사를 소유했는데, 여기서 자신의 저서와 작은 기념품들을 직접 조판하고 인쇄했다. 나는 타일이다는 일명 타일이 말한다라고도 불린다. 이 글은 가우디가 글자의 화신이 되어 인쇄와 디자인에 타입이 차지하는 높은 위상에 대해 성직자의 어투로 역설한다. 이 글을 발표하고 수년 뒤, 가우디는 나는 타이트하다라는 패러디 제목으로 크리스마스 카드를 만들어 발송하기도 했다. 가우디의 글은 날카롭고 예리하면서도 유머를 잃지 않는다. 그는 동료가 자신이 세운 기준을 따라와 주길 바랐지만, 그의 글을 읽는 사람들은 가우디의 생각을 어떤 규칙으로 읽기보단 의문을 제기하는 내용으로 받아들였다.

[13] 필자가 디자인한 흘림체와 산돌고딕네오 1 Thin의 혼용 조판
Mixed typesetting with author's cursive and Sandol Gothic Neo 1

좌담　　　　　　　Talk

돌아온 오너먼트

크리스 로, 이병학, 유지원, 전종현, 이재민(진행)

2014년 4월 10일 목요일 저녁 8시
클로리스 카페, 서울

The Return of the Ornament

Chris Ro, Lee Byoung-hak, Yu Jiwon, Harry Jun, Lee Jae-min(host)

8 pm Thursday 10 April 2014
Café Chloris, Seoul

주제어
장식, 오너먼트, 컴포지션

→

Keywords
Decoration, Ornament, Composition

1. 배경

이재민: 안녕하세요. 바쁘신 가운데 참석해주셔서 감사합니다. 오늘 이 자리에서 다루게 될 내용은 '오너먼트'입니다. 국어로는 대체할 정확한 단어가 언뜻 떠오르지 않습니다. 임의로 '장식'이라고 하겠습니다. 사실 오너먼트나 장식, 혹은 데코레이션이라는 용어의 정의도 이 기회를 통해 정리할 수 있으면 좋겠습니다. 아무튼 최근에 등장하는 작업들, 또 논의되는 이야기 사이에서 오너먼트 또는 장식 개념이 자주 보입니다. 그런 흐름과 더불어 유지원 선생님이 국민대학교 3학년 수업에서 진행한 타이포그래피 챕터 99: 장식 컴포지션이나 이병학 선생님의 박사학위 논문, 크리스 로 선생님과 전종현 기자님이 기획하신 월간 디자인 3월호 특집 기사인 '디지털 크래프트 그래픽스' 등에 주목하게 됩니다. 오늘은 모던 타이포그래피 이후 폐기된 것처럼 여겨졌던 '장식' 개념이 최근에 다시금 대두된 현상과 그 배경 등을 자유롭게 이야기했으면 합니다.

전종현: 철학, 예술, 디자인 등 학문의 분야별, 미국, 유럽, 아시아 등 지역별로 변화가 전파되는 상대성을 염두에 두는 태도가 필요한데요, 특히 한국은 독특한 성격을 지니고 있습니다. 권위주의 정권 하에 한정된 채널로만 정보를 들여오는 게 만연화돼 있었죠. 그래서 해외 여행이 자유화된 1989년은 특별한 해입니다. 이 시기를 기점으로 한국인들은 멀리서 전해 듣거나, 번역을 통해 습득하던 것들을 실제로 체험하게 됩니다. 이건 감각의 차원이 달라지는 순간인데요, 예를 들어 1980년대라면 지금처럼 디지털 공예 그래픽스를 추구하는 마리안 반티예스나 제시카 히쉬를 동시대에 인식하긴 어려웠을 겁니다. 하지만 지금은 정신없을 정도로 정보가 실시간으로 쏟아지고, 물리적인 거리와 시차만 있을 뿐 지구 반대편과 동시대적인 삶을 공유합니다. 여기서 한 가지 짚고 넘어가야 하는 점이 동시대성이 마냥 좋은가 하는 의문입니다. 문화에는 오랜 경험을 통해 쌓이는 정반합의 규칙이 있습니다. 단순히 정보를 통해 얻은 지식으로 역량이 채워지는 것은 표면적인 것이죠. 갑자기 밀어닥친 동시대성을 제대로 소화할 수 있는 우리의 내적 역량을 확인할 필요가 있습니다. 어쩌면 우리는 그들의 겉모습만 베끼고 있는 걸지도 모르니까요. 예컨대 오랜 토의와 논쟁을 기반으로 각 시대의 취향과 성향의 변화를 인지하는 서구와 달리, 자본주의적 성격이 강한 미국의 디자인을 해방 이후 그대로 받아들인 한국에서 객관적인 가치 판단이 애당초 불가능한 것일지도 모릅니다.

이병학: 빠르게는 17세기에 이미 시민 혁명을 경험했던 나라들에 비해 20세기 후반에 근대화를 이룩한

1. Background

Lee Jae-min: Good evening, everyone. Thank you for taking time off from your busy schedules to join us. Tonight, we will talk about ornament. I cannot think of an exact Korean alternative for this word. Perhaps we can use the word jangsik. In fact, it will be a great chance for us today to discuss the definition of the terms ornament, jangsik (Korean), and even decoration. Anyhow, we can easily find the words ornament and jangsik among recent works or discussions. And in light of such trends, we can note the following works: Typography Chapter 99: Ornament Composition, a lecture by Ms. Yu at Kookmin University; Ms. Lee's doctoral dissertation; and Digital Craft Graphics, a special feature for the March issue of Monthly Design by Professor Ro and Mr. Jun. In today's talk, we hope to freely discuss how the concept of ornament, which seems to have been discarded after modern typography, has resurfaced in recent days.

Harry Jun: I believe we should first consider how changes travel across different academic fields — such as philosophy, art, and design, and across regions — like America, Europe, and Asia. In Korea's case, it's pretty unique: information usually travels through limited channels, due to the restrictions of authoritative regime. That is why the year 1989 was so special — when overseas trips were liberalized. From this point on, Koreans experience in person things that they only have heard of or acquired from translated texts. It was a moment of change in the dimension of senses. For example, we are currently familiar with contemporary digital craft artists Marian Bantjes or Jessica Hische, but such would have been difficult back in the 80s. We now have floods of information flowing in real-time, and other than the physical differences in distance and time, we are sharing the same period with those on the opposite side of the globe. However, the question here is this: Is this all boon and no bane? In culture, we have the principle of thesis-antithesis-synthesis, which is usually acquired after many experiences. The capability consisting of common knowledge from easy-to-get information is only superficial. We must evaluate our inner capabilities — capabilities to fully digest the sudden influx of contemporariness. Perhaps we are merely imitating their superficial images. For instance, while Western countries recognized the changes in preferences of each

번역: 임유나 Translation: Im Yoona

대한민국이 1980-1990년대 당시의 외국과 동일한 맥락의 해체주의를 경험하기는 힘들었을 겁니다. 인터넷도 없던 시절에 따라가기만 해도 대단한 것이지요. 저는 디자인 모험의 주된 맥락인 1980-1990년대의 관습에 대한 도전이 이제 한국에서 시작되는 것이 아닌가 하는 생각이 듭니다. 물론 국제적인 흐름에 충분히 동시성을 가진 디자이너들도 많습니다만, 수용자의 관점에서 볼 때 매체를 통해서 접하는 현재의 그래픽 디자인들이 형식화되는 경향이 일정 수준 드러나고 있는 것처럼 보이기 때문입니다. 그 책에서 읽었던 "일반 대중을 보호하기 위해 많은 규칙이 필요하지 않다."라는 구절이 생각나네요.

전종현: 조심스럽게 말하자면 한국의 문화와 관련이 깊다고 봅니다. 동북아 3국을 비교하면 중국은 거대하고 화려하며, 일본은 디테일에 천착하는 태도와 다도 문화에서 유래된 소박함이 혼재합니다. 그렇다면 한국은 어떻게 정의할 수 있을까요? 우리가 자주 듣는 한국의 미의 중에 '고졸미'가 있습니다. 소박하고 질박한 외형에 숨겨진 고아하고 세련된 중용의 미학인데요, 이런 정의가 우리 발목을 잡고 있습니다. 고졸미의 원류를 따지면 백제의 예술을 묘사한 '검이불루(儉而不陋) 화이불치(華而不侈)', 즉 '검소하지만 누추하지 않고, 화려하지만 사치스럽지 않다'는 말을 꺼내게 되는데요, 실제 백제와 신라 시대의 장신구, 고려 시대의 청자와 불화를 보면 화려함과 세련된 느낌의 조화가 확연합니다. 하지만 지금 우리가 접할 수 있는 대부분의 전통 문화가 유교 사상이 지배하던 조선 시대이다 보니 사람들이 자신의 정체성을 조선 시대의 미학에 가두는 경향이 있습니다. 마치 달항아리가 우리 문화의 전부인 것처럼요. 하지만 조금만 관심을 기울여보면 일제 강점기 직전까지만 해도 궁중과 사대부의 공예품에는 우리가 상상하지 못하는 오너먼트의 아름다움이 풍성합니다. 시대가 달라지고 사회를 지배하는 정신이 바뀌어도 우리에게는 화려함, 세련됨, 오너먼트에 대한 욕구가 있었습니다. 그 표현 방식을 얼마나 노골적으로 드러내느냐의 차이였죠. 그러나 일제 강점기 이후 이런 공예의 맥이 끊기고 전쟁으로 피폐해진 무력한 상황에서 먹고 사는 문제보다 오너먼트에 관심을 갖는 것은 어찌 보면 죄악에 가까웠을지도 모르는 일입니다.

이재민: 게다가 대한민국은 특이하게도 근대화 과정에서 문화적으로 '잃어버린 고리'가 존재한다고 봅니다. 그런 불연속성 때문에 지금 우리가 말하는 장식적인 것을 찾으려면 너무 옛날로 되돌아가야 합니다. 효율과 속도를 강조한 근대화 과정에서 자연스럽게 이어지고 계승되어야 할 것들이 많이 사라져버렸어요.

period through long discussions and disputes, Korea simply accepted the rather capitalistic American designs soon after liberation. Perhaps that is why it had been impossible to set any values objectively in Korea from the beginning.

Lee Byoung-hak: Considering that Korea's modernization occurred in the latter half of the 20th century, which is three decades after the revolutions in other countries, I believe it was difficult for Korea to experience the kind of deconstructivism that other countries had already gone through during the 80s and 90s. It was great progress, given that we didn't even have the internet back then. Sometimes I wonder that perhaps the challenge against the conventions from the 80s and 90s, which is the core of "adventures in design," is only beginning now in Korea. Of course there are many Korean designers who are indeed contemporary with global trends, but the current graphic design that consumers meet through media tends to be formalized to a certain degree. This reminds me of the passage from the book: "We do not need many rules to protect the general public."

Harry Jun: Carefully speaking, it is closely related to the characteristics of the Korean culture. Let me compare it to the other two Northeastern countries. China enjoys grand and magnificent designs, and Japan is fixated on simplicity — originated from the tea drinking culture — and details. Then how can we define Korea's culture? We often speak of Korean aesthetics as antique and rather rough. The Korean aesthetics of moderation can be defined as elegance and sophistication hidden beneath a plain and simple appearance. But such definitions are holding us back. This all began from the description of the artworks from Baekje: Simple but never humble, magnificent but never luxurious. In fact, you can find such harmony of magnificence and sophistication from the ornaments from Baekje and Silla or the celadon and the Buddhist paintings from Goryeo. But since most of the traditional cultures that we see today are from Joseon Dynasty, people have the tendency to limit their own identities to the aesthetics of Joseon. We would think that the Moon Jar is everything there is about our culture. But if we take a closer look, even right before the Japanese colonial era, craftworks from the palace and noble families are full of ornaments that we couldn't imagine. Though times and societal values

크리스 로: 제가 한국 시각 문화 역사 전체를 아울러 장식 문화에 대해 말씀드리기는 어렵습니다. 하지만 한국이 근대화를 통해 질보다 양을 중요시하게 되면서 장식은 번거롭고 없어도 문제가 되지 않는 것으로 여겨진 듯합니다. 여기에 한국의 '빨리빨리' 문화가 더해지면서 우리는 자연스럽게 꾸밈을 멀리하게 된 것 같습니다. 또 한국인들의 작품을 평가하는 태도도 큰 영향을 끼친 듯합니다. 제가 보기에는 한국의 디자이너, 클라이언트, 소비자 모두에게 디자인에는 이유, 혹은 의미가 있어야 한다는 강박이 있습니다. 장식은 '경험하는 것'인데 말이죠. 결국 오너먼트는 그런 평가의 벽을 넘기 힘들었고, 결국 범죄 취급을 받게 된 것 같습니다.

전종현: 개인의 취향을 표출하는 것이 자유로워지면서 장식에 대한 욕구가 살아나는 건 분명합니다. 디자이너는 자신의 작업 스타일이 있을지 모르지만, 클라이언트가 장식을 향한 욕구가 분명하다면 결국 세상은 장식에 점점 더 너그러워지게 되는 거죠. 동시에 디자이너 스스로가 느끼는 장식의 문턱도 낮아지는 거고요. 실제 2007년 이후부터 디자이너들이 장식을 과감히 사용하는 경향이 있는 것 같습니다. 멀리서 예를 들 것도 없이 여기 계시는 이재민 선생님이나 크리스 로 선생님도 굉장한 디테일과 공력이 들어가는 타이포그래피, 혹은 그래픽 작업을 클라이언트 작업으로 보여주고 계시죠. 그런데 여기서 짚고 넘어가야 할 게 하나 있습니다. 보통 소비자라고 불리는 대중은 디자이너보다 화려함을 추구하는 경향이 있습니다. 이는 다른 이유가 아니라 디자이너가 학교를 다닐 때 작업의 가이드라인이 '이것만 지켜라'는 포지티브 방식에 가까웠기 때문입니다. '이것만 하지 말고 무엇이든지 해보라'는 네거티브의 태도로 접근했다면 실제 사람들과 창작자가 느끼는 장식에 대한 생각이 지금처럼 크게 벌어지지는 않았을 겁니다. 이건 제가 강남 근처를 지나다가 찍은 건물 사진인데요,

[1] 강남의 한 웨딩홀 건물
A wedding hall building in Kang-nam area, Seoul

changed, we have always desired for magnificence, sophistication, and ornaments. The only difference was how much we expressed such desires. But as the lineage of the craftsmanship was cut off and postwar impoverishment and helplessness became prevalent, it might have been considered sinful to become interested in ornaments more than survival.

Lee Jae-min: Moreover, Korea had this unique missing link during its modernization. And because of such discontinuity, we have to go too far back to the past in order to find what we now call something "ornamental." We have lost much that should have been naturally continued and inherited during modernization, which focuses on efficiency and speed.

Chris Ro: Honestly, it might be difficult for me to tell you about the culture of ornaments in line with the overall history of Korean visual culture. But I can tell you that ornaments were considered redundant and unnecessary as Korea went through modernization, in which quantity was considered more important than quality. On top of that, people began valuing speed and naturally distanced themselves from ornaments. Also, attitudes in evaluating artistic works had great influence, too. In my opinion, Korean designers, clients and consumers are all under this constraint that design must have a reason or a meaning. But ornaments are purely experiential. In the end, ornaments couldn't overcome the obstacle of such evaluations and were considered something sinful.

Harry Jun: Desire for ornaments does become alive when people show personal preferences more openly. Though designers have always had their own style, when clients are clear about their desire for ornaments, the world will become more and more tolerant towards them, too. And at the same time, the thresholds for the designers themselves on ornaments get lower as well. In fact, designers did begin using more ornaments after 2007. We don't have to look far: Professors Lee and Ro here have done some typographic or graphic works with significant amount of details and craftsmanship for their clients. But we have to make one thing clear here. Normally, the public — also known as consumers — tend to pursue more showiness than designers do. This is because when designers are trained in school, their guidelines are close to a positive method of 'At least follow this.'

이렇게 기능도 족보도 없는 소위 버네큘러 예식장 양식을 보면 아돌프 로스가 1세기 전 "장식은 범죄다."라고 말한 게 백번 이해됩니다. [1] 하지만 그는 필요 없는 장식을 피하자는 뜻이었지, 장식 자체를 부정한 것이 아닙니다. 지금은 과한 장식의 극치로 여기는 아르누보 시대를 생각해보면, 재미있게도 어원은 '새로운 예술'입니다. 아르누보가 추구했던 장식에 대한 열망이 그 당시에 과연 범죄였을까요? 또 한 가지 재미있는 사실은 반(反)장식의 대표 주자처럼 보이는 국제 타이포그래피 양식이 대두된 1960년대에 앤디 워홀의 첫 전시가 시작됐다는 것입니다. [2] 미국 가정에서 흔히 쓰는 브릴로 비누 박스를 화이트 큐브에 가져다놓은 작품 브릴로 상자를 본 미국의 미학자 아서 단토는 '예술의 종말'을 외쳤습니다. 규범으로 정의할 수 있던 예술의 시대는 가고, 이제 작가의 생각과 의도가 중요해지는 다원주의가 현대 미술의 견인차가 된 거죠. 장식이냐, 반장식이냐 하는 외관에 상관없이 대체 네 의도가 무엇이냐고 줄기차게 물고 뜯던 그 시기에 디자인은 실상 장식과 가장 먼 곳에 있었다는 사실이 저는 무척 흥미롭습니다.

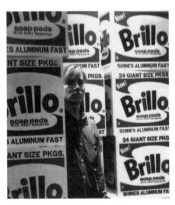

[2] 브릴로 상자와 앤디 워홀, 1964
Andy Warhol with Brillo boxes, 1964

이병학: 빈 여백에 무엇을 넣고 싶은 욕구는 모든 사람에게 있습니다. 사람의 기본적인 욕구죠. 장식 활자가 없던 초기 금속 활자 시대에 고깔무늬 문단이 딱 떨어지지 않아 콤마 세 개로 삼각형 형태의 조형 요소를 만들어 마무리하려고 했던 원시적인 도판을 본 적이 있습니다. 타의가 아니라 전적으로 자의에 의한 것이죠. 결국 크리스 로 선생님의 말씀처럼 이유를 설명하고 타인을 설득하기보다는 솔직한 자기 표현에 집중하는 것이 중요하지 않을까요? 몰입의 세계에서 저자성은 단순히 경험을 전달하는 과정에서 나아가 경험 자체를 구성하게 된다는 말이 있습니다.

크리스 로: 저는 2년 전부터 '그래픽 디자이너의 몰입'이라는 주제를 연구했습니다. 오늘날 그래픽

If they were shown negative guidelines of 'Don't just do that but try everything else,' preferences on ornaments of the public and creators might not have been so different. This is a picture of a building that I took when I was passing through Gangnam. [1] Looking at this vernacular design of a hall without any functions or genealogy, I can fully understand why Adolf Loos said "Ornaments are a crime" a century ago. But what he meant was that we should avoid unnecessary ornaments, not that we must deny ornament itself. Interestingly, the word Art Nouveau, which is considered the age of excessive ornaments, means 'new art'. Did people back then think the desire for ornaments of Art Nouveau was a crime? Another interesting fact is that the style of international typography — seemingly the forerunner of anti-ornament — was on the rise in the 60s, which is the same period when Andy Warhol held his first exhibition. [2] When the American aesthetician Arthur Danto saw Brillo Box, stacks of white cubes of commonly used Brillo soap boxes, he screamed that the end of art was near. The age of art that was defined by standards ended, and pluralism, which values the thoughts and intentions of artists, became the new driving force of modern art. In times when people endlessly disputed over the artists' intentions regardless of the argument over ornament versus anti-ornament, interestingly enough, design was actually furthest away from the actual ornament.

Lee Byoung-hak: Everyone has the urge to fill in the blanks. It is a fundamental urge. I have seen a highly primeval plate that used three commas to form a triangular shape in order to fill the cone-shaped paragraph when ornamental types have not yet been invented during the earliest stage of the metal type era. And such attempt was made purely voluntarily. Perhaps this means that, like Professor Ro has mentioned before, it is more important to focus on plainly expressing oneself rather than trying to explain and persuade others one's own intention. They say that in the world of immersion, authorship forms experience itself rather than simply transferring the experience.

Chris Ro: I have been studying the subject of 'the immersion of graphic designers' ('flow' as coined by Mihály Csíkszentmihályi) for the past few years. In modern times, most graphic designers use computers, and some say that such use hinders this 'flow' or immersion. Though it has been 30 years since the propagation of computers,

디자이너는 대부분 컴퓨터를 사용하는데, 컴퓨터가 몰입을 방해한다는 의견이 있습니다. 컴퓨터가 보급된 지 30년이 지났지만 아직도 디자이너들은 컴퓨터나 프로그램이 불편하다고 말합니다. 저는 여기에 동의할 수 없습니다. 최근에 제가 관심을 갖고 작업하는 부분이 바로 여기에서 왔는데요 , '디지털 공예'입니다. 그래픽 디자인 작업은 다른 분야에 비해 디자이너가 작업 과정의 많은 부분을 통제할 수 있고, 바로 이런 작업에서의 통제와 몰입 부분이 공예의 그것과 유사하다고 볼 수 있습니다. 만약 그래픽 디자이너가 컴퓨터를 음악가의 '악기'처럼 여긴다면, 컴퓨터를 자유자재로 사용하고 연주할 수 있을 것이고, 자연히 거기에 몰입하고 자유롭게 표현할 수 있게 된다고 생각합니다.

이재민: 손으로 만들었는데 굉장히 치밀한 크리스 로 선생님의 아키타입 프로젝트는 인상적이었습니다. [3]

이병학: 디지털 크래프트에 대해서 저도 많은 부분 공감하고 있습니다. 원래 저는 박사 학위 논문을 쓰면서 장식 활자를 자동 조판하는 인터페이스를 만들려고 했습니다. 실제로 플래시로 프로토타입을 만들었는데 컵라면을 발명한 것 같은 기분이었습니다. 시간만 단축시킬 뿐이지 별다른 의미가 없었습니다. 오히려 일일이 조판하는 과정에서 과거의 사람들이 어떤 생각을 했을지 궁금하더군요. 찾아보니 장식 활자 앞에 목판 장식이 있었습니다. 그 앞에 필사본이 있었고요. 점입가경이었습니다. 12세기에 책 한 권을 필사하는 데 20년이 걸렸다는 기록이 있습니다. 물론 전쟁으로 중단된 기간이 있긴 했지만 복제와 반복이 너무나 가볍게 느껴지는 오늘날 그런 장인 정신이 다시 주목받는 것 같습니다. 하지만 결과물의 밀도와 복잡성만으로 장인 정신을 판단할 수는 없지요. 극도로 복잡한 알고리즘 조형은 화폐 디자인에 사용되는 툴을 사용하면 비교적 손쉽게 생성되거든요. 곱게 개어야만 만들어지는 반듯한

many designers still complain that computers or programs are inconvenient to use. However, I cannot completely agree with this. My recent interest and works are actually centered around this area, and this is called 'digital craftsmanship.' Graphic design, compared to other fields, allows designers to control many parts of their work and process. I believe this control and immersion is similar to those found in crafts. If graphic designers can embrace their computers like a musician would embrace their instruments, they will be able to use and master computers at their own will. This might allow them to gain immersion in their works and express themselves freely.

Lee Jae-min: The handmade but highly elaborate archetype project by Professor Ro was indeed very inspiring. [3]

Lee Byoung-hak: I can relate to digital craftsmanship. Originally, I tried to create an interface that automatically typesets ornamental types when I was writing my doctoral dissertation. I actually created a prototype using flash, and I felt like I had invented cup ramen. It could only save time, but other than that, it was meaningless. Rather, during the process of typesetting each type, I was curious about what people had been thinking in the past. I looked it up and found out that there were wooden ornamental types before ornamental types. And before that, there were manuscripts. It was getting more and more interesting. One record says that it took twenty years to transcribe one book in the 12th century. Of course things had to pause due to the war, but I think such craftsmanship is resurfacing today while duplication and repetition seem so easy. However, we cannot evaluate craftsmanship

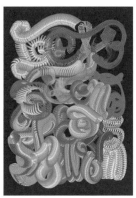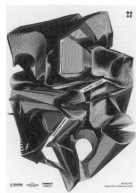

[3] 아키타입 프로젝트: 한동훈, 이윤영, 남윤지, 우승미 학생 작품, 2014
The Archetype Project: Student work from Han Dong-hoon, Lee Yun-young, Nam Yun-ji and Woo Seung-mi, 2014

노출 콘크리트를 모조 판넬로 발라버리는 것처럼 말이죠. 크리스 로 선생님께서 말씀하신 대로 결과보다는 그 작업에 몰입하는 과정이 중요하지 않나 생각됩니다.

2. 개념과 정의

이재민: 강의를 끝내고 합류하기로 한 유지원 선생님이 오셨습니다. 지금까지 타이포그래피에서 장식이 다시 대두하고 거론되게 된 원인에 대해 말씀이 오가고 있었습니다. 유지원 선생님 의견은 어떤지요?

유지원: 전 세계적으로 장식적 레터링, 장식적 활자체, 장식 글자 일러스트레이션, 장식 타이포그래피가 다양한 양태로 왕성하게 다시 눈에 띄는 것에 비하면 한국에서는 아직 소극적인 편이라고 보입니다. 한국의 타이포그래피 실무와 교육에서는 여전히 고전적 타이포그래피라던가 모던 타이포그래피의 강령이 지배적입니다.

타이포그래피에서 '모던'의 개념은 서로 다른 세 시기에 서로 다른 영역에서 나타났지만, 여기서 제가 지시하는 모던 타이포그래피라는 것은 1920년대 이후의 움직임을 뜻합니다. 우리는 당시의 사회적, 기술적 배경을 주목할 필요가 있습니다. 제1차 세계대전에서 패배한 1920년대 독일에서, 19세기 말에서 20세기 초에 나타난 윌리엄 모리스 및 이를 이어간 아르누보식 개념의 아름다운 책과 글자를 만든다는 부르주아 취향은 호사스럽게 여겨졌을 것입니다. 또한 초기 기계 시대였던 당시에는 대량생산에 필요한 아이디어의 기술적 구현에 여러 제약이 있었습니다. 사회적, 기술적 정황에 적합하지 않은 비용과 시간에 맞서 효율적인 방식을 찾아가려 한 태도는 지식의 민주적 보급과도 관련 있습니다.

오늘날은 당시와는 비교도 되지 않을 정도로 매체가 다양해지고 발전했습니다. 장식에 드는 시간과 비용이 대폭 줄게 된 것입니다. 그러면서 왕성한 표현 욕구를 가진 예술가들이 장식을 굳이 배제할 이유가 없어진 것입니다. 그들은 구태의연한 낡은 장식을 답습하는 것이 아니라 새로운 시대에 맞는 새로운 형상을 찾아가고 있습니다. 이런 맥락에서 저는 플렉시블 디스플레이가 펼쳐낼 형태의 미래에 관심이 큽니다. 디스플레이의 해상도는 더욱 정교해지고 그 틀도 사각형이나 정육면체를 벗어나게 될 겁니다. 정보를 담는 디바이스는 머리카락처럼 얇아지고 펼친 면적은 넓어지되 둘둘 말거나 여러 방식으로 접어서 원하는 부피의 입체 형태로 담을 수 있겠죠. 디바이스가 말거나 펼쳐지며 움직이는 가느다란 옆면의 정교한 유기적 곡선 형태가 미래의 조형이 될 것입니다. 해상도는 기본 유니트가 '나노 단위'로 정교해져서 둔중한 산세리프 아닌 정교한 활자가

solely based on the density and complexity of the finished work. You can easily create extremely complicated algorithmic models by using tools for currency designs. And the same goes for how you paste mock panels over exposed concrete made by finely ground materials. As Professor Ro had said, I believe being immersed in the work is more important than the results.

2. Concept and Definition

Lee Jae-min: Now we have Ms. Yu here, she was scheduled to join us a little late after finishing her class at a school nearby. We have been talking about the reason why ornament in typography resurfaced and was discussed. Ms. Yu, what do you think?

Yu Jiwon: Ornamental lettering, ornamental types, ornamental letter illustration, and ornamental typography are coming into view again in many aspects across the world; however, things are not as active here in Korea.

Doctrines on classic typography or modern typography are still dominant in Korea's businesses and education in the field. The concept of 'modern' in typography appeared in three different periods and areas, but the modern typography I am bringing up now is the movement that occurred after the 1920s.

We should focus on the social and technical background at the time. In the 1920s Germany, after losing the World War I, it might have been considered luxurious to have bourgeoisie tastes of creating beautiful books and letters under the concept of William Morris between the late 19th and early 20th century as well as its successor, Art Nouveau. Moreover, the time being the early machine age restricted technical realization of ideas needed for mass production. The attitude of seeking efficient methods in order to fit time and cost into the social and technical circumstances is related to civic dissemination of knowledge.

Today, media have diversified and developed significantly compared to the time then. It now costs much less time and money to create ornaments. And artists with so much passion for expression no longer had reason to rule out ornaments in their works. Rather than following old and obsolete ornaments, they are pursuing new forms that are suitable for the new age. Therefore, I am highly interested in the future of the form created by flexible displays. The resolution of the

유기적 곡선형 장식과 맞물려 유행할 것이고, 무한한 깊이의 공간을 향하는 확장적 장식이 부활할 것입니다. 조금 더 시간이 흘러 20세기초를 돌아보면 무디고 죽은 나무토막의 형상을 가진 시대로 보일 수도 있겠습니다.

이병학: 유지원 선생님의 말씀대로 매체의 한계와 오너먼트는 관계가 있습니다. 초기의 금속 활자는 무게로 인한 사용성 때문에 72포인트가 가장 큰 글자였습니다. 가장 작은 판형이었던 옥타보 판형의 경우 72포인트로도 적절한 구성이 가능했기에 과거에도 테두리 장식이 등장하지 않습니다만, 콰르토 이상의 넓은 판형의 경우엔 테두리 장식이 등장합니다. 필사본에 비해 작은 글씨로도 충분히 가독성을 확보할 수 있었던 반면 판형, 즉 매체 자체에는 별다른 변화가 없었기 때문에 이 간극을 메우기 위한 장치로 장식이 사용되었다고 볼 수 있겠습니다.

전종현: 기술의 발전과 장식을 연결할 수 있는 가장 쉬운 예가 요즘 열풍처럼 번지는 3D 프린팅입니다. 사실 뉴스에서 말하는 '모든 것을 대체하는 제조 혁명으로서의 3D 프린팅'과 대중이 접할 수 있는 데스크톱 3D 프린팅의 간격은 상당합니다. 3D 프린터가 주목받는 이유는 물체를 구현할 때 밖에서 깎는 것이 아니라, 안에서부터 쌓는 적층 방식이기 때문인데요. 디지털 파일로 형상을 완성하면 불세출의 장인도 불가능하던 복잡하고 세밀한 형태가 구현 가능합니다. 다만 디자이너의 상상력을 '마음 먹은 만큼 충분히 구현'하는 건 최소 가격이 억 단위를 넘어가는 산업용 3D 프린팅에서 구현된다는 게 맹점이죠. 하지만 결과만 봤을 때 산업용 3D 프린팅 기술을 활용해 만든 작업들은 놀랄 정도로 아름답고 경이롭습니다. 혹시 관심이 있으시다면 MIT 미디어 랩의 교수인 네리 옥스만의 작업을 한번 찾아보세요. 그녀가 신화 속 동물을 변형해 현실에 구현한 일련의 오브제들은 본능적인 경이를 선사합니다.

유지원: 조금 뒤늦은 언급이지만, 저는 이 자리에 계신 이병학 선생님의 박사 논문, 크리스 로 선생님과 전종현 기자님의 월간 디자인 특집, 그리고 국민대학교 학생들과 제가 함께 진행한 타이포그래피 챕터 99: 장식 컴포지션 책자 작업이, 장식이라는 주제를 둘러싸고 각각 서로 다른 관점을 갖고 있다는 점에 대해 한번 정리하고 넘어가고자 합니다. 같은 시기에 같은 소재를 서로 다른 위치에서 서로 다른 시각과 방식으로 서로 모른 채 진행해나갔다는 다양성이 고무적이라고 생각합니다. 사실 장식은 더 다양하게 다루어질 수 있는 잠재력을 가진 주제입니다. 우선 이병학 선생님은 특히 16세기 아라베스크 문양을 중심으로 한 오너먼트의 역사를 체계적으로 정리하면서, 현대적 수용의 현황을 진단하고

display will become more elaborate, and its frame will no longer be restricted to rectangle or cube shape. The device storing information will become thin — like a strand of hair — and wide, so that it can be rolled up or folded into whatever form or volume you want. The elaborate and organic curves of the thin sides that move as the device is rolled or opened will become the formative of the future. The standard unit of the resolution will become more elaborate to a nanoscale; therefore, elaborate types and organic curve ornaments will become the new trend rather than the dull san serif, and ornaments that expand to infinite depth and space will make a comeback. Perhaps when we look back into the early 20th century later on, the period might resemble a blunt, dead block of wood.

Lee Byoung-hak: Just like what Ms. Yu said, ornaments and the limits of media are closely related. The biggest size of early metal types was 72 points, due to their practicality by weight. In case of octavos, there was no border ornaments in the past since 72-point types were sufficient for proper composition, but border ornaments were found in case of quarto and bigger.

Harry Jun: The easiest example of technology development that can be related to ornaments is the up-and-coming 3-D printing. There is actually a huge gap between what the news media calls '3-D printing, the revolution of manufacture that can replace anything' and the desktop 3-D printing that the public can access. 3-D printers are receiving the spotlight because it laminates layers from the inside rather than carving from the outside. Once a form is completed in a digital file, the most complicated and elaborate design can be materialized — something that not even extraordinary craftsman can possibly do. The loophole here is that in order for the designer's imagination to be 'materialized as pleased,' it will cost up to at least one hundred million won using commercial 3-D printers. But looking at the results, the works done by commercial 3-D printing technology are surprisingly beautiful and extraordinary. If you are interested, please look up the works done by the MIT media lab's Professor Neri Oxman. Her objet, materialization of mythical animals, is an instinctive wonder.

Yu Jiwon: It might seem a little late for me to bring this up, but I would like to point the different

그 응용 방식 제안하셨습니다. 크리스 로 선생님은 미하이 칙센트미하이가 저서 몰입의 즐거움에서 제안한 몰입의 개념을 성찰하고 응용하셨지요. 너무 까다롭지도 너무 단조롭지도 않은 적정 수준의 성취 속에서 몰입의 행복이 가능하다고요. 그와 함께 아키타입 프로젝트를 통해 디지털 툴을 사용하는 시대에 크래프트맨십의 의미를 화두로 던지셨습니다.

저는 체계적인 컴포지션의 방법론에 주안점을 둡니다. 장식 컴포지션은 타입 컴포지션, 즉 좁은 개념으로서 타이포그래피와는 다른 방법론입니다. 즉 레터링이나 장식적인 타입을 디자인하는 것과는 궤를 달리한다는 점을 강조하기 위해 '장식 타이포그래피'가 아닌 '장식 컴포지션'이라는 용어을 사용합니다. 이때 꼭 복잡하고 화려한 오너먼트를 사용할 필요는 없습니다. 아주 단순한 엘리먼트를 수집하고, 그것을 컴비네이션으로 조합한 뒤, 컴포지션의 작품으로 지면 위에 완성해냅니다.

[5] fnt, JTBC 브랜드 아이덴티티, 2013
fnt, Brand Identity for JTBC, 2013

perspectives on the subject of ornament among the doctoral dissertation of Ms. Lee, the featured article from Design by Professor Ro and Mr. Jun, and the booklet 'Ornament Composition' by myself and the students of Kookmin University. I think it is inspiring that all of us made progress using different methods and from perspectives and positions to work on the same subject at the same time. In fact, ornament is a field that has potential to grow even bigger.

First of all, Ms. Lee systematically organized the history of ornaments based on the 16th century arabesque designs in particular, evaluated the current demands and condition, and suggested its application.

Professor Ro examined and applied the concept of immersion suggested in the book Finding Flow by Mihaly Csikszentmihalyi. He stated that it is possible to take pleasure in immersion within moderate accomplishment, which is neither too tricky nor simple. Moreover, he used the archetype project to bring up the meaning of craftsmanship of the age of digital tools. I place emphasis on the methodology of systematic composition. Ornamental composition is type composition—in other words, a narrower concept which is a different methodology from typography. Therefore, I use the term 'ornamental composition' and not 'ornamental typography' in order to emphasize that the methods are different from designing letterings or ornamental types. Here, there is no need to use complicated or elaborate ornaments. Very simple elements are collected, and they are combined and completed into work as composition on paper.

Jan Tschichold has written Criticism on Ornamental Typography. What Tschichold criticized here is not 'the elaborate ornaments', but 'the obsolete arrangements.' In other words, he uses the conventional 'center arrangements of typography' to represent the term 'ornamental typography.' It was 1935 when he wrote this, and after a few decades, he announced again that he didn't completely agree with what he had written back then. Tschichold did not slander or support a certain style; rather, he thought that we must get rid of the conventions and boldly advocate the new spirit for the new age. This is the true spirit we must learn from Tschichold. I believe if Tschichold was given the technology and media of the 21st century, he would have made a completely different approach on 'ornaments' as much as time had changed. To Tschichold from the 1930s,

[5] 김영나, Found Compositions, 2009-2011
Na Kim, Found Compositions, 2009-2011

일찌기 얀 치홀트는 장식 타이포그래피 비평이라는
글을 쓴 바 있습니다. 여기서 얀 치홀트가 비판한 것은
'화려한 장식'이라기보다는 '구태의연한 배열'이었습니다.
즉 얀 치홀트는 관습적인 '가운데 정렬 타이포그래피'를
'장식 타이포그래피'와 등가적인 용어로 사용합니다. 이
글을 쓴 것이 1935년이었고, 수십 년이 지난 뒤 그는
다시 당시의 글에 완전히 동의하지는 않는다는 의견을
표명했습니다. 얀 치홀트는 특정 스타일을 비방하거나
옹호했다기보다는 새로운 시대에는 관습을 떨치고
과감히 그 시대에 맞는 새로운 정신을 표방해야 한다고
생각한 것입니다. 이것이 우리가 얀 치홀트에게 진정으로
배워야 할 정신입니다. 만일 얀 치홀트에게 21세기의
기술과 매체의 환경이 주어졌다면, 그는 '장식'에 대해
시대 환경이 달라진 만큼 전적으로 다르게 접근했으리라
생각합니다. 1930년대의 얀 치홀트에게 장식이란 비싸고
아름답고 시간과 비용이 드는 낡은 가치였습니다. 그러나
장식을 떨치면 지면이 단조로워집니다. 근원적인 요소인
타입만으로 지면에 힘을 부여하기 위해 그가 제시한
개념이 장식적인 가운데 정렬과 대칭 구조를 극복하기
위한 '비대칭 타이포그래피'였던 것입니다. 1930년대, 즉
80년 전 초기 기계 시대의 이야기죠.

이런 관점에서 볼 때 저는 김영나 디자이너의 전시
발견된 추상에서 보인 스티커 연작이나 이재민 선생님과
스튜디오 fnt에서 작업한 JTBC 브랜드 아이덴티티도
스스로 의도하지는 않았더라도 장식 컴포지션의
방법론을 개척하고 있다고 봅니다. [4-5] 단순한
엘리먼트를 사용하지만 이들을 수집하고 회전시키고
재배열하며, 보일 듯 말 듯 한 원칙으로 지면을 구성하고
의미를 도출합니다. 국민대학교 학생들에게도 이렇게
단순하고 힘 있는 작업 방식 역시 권장했습니다.

타입은 방향이 정해져 있습니다. n을 돌리면 u라는

ornaments were of old values that were beautiful
and cost money and time. However, without
ornaments, papers become too simple. In order
to give strength to the paper using only type
— a fundamental element — he suggested the
concept of 'asymmetric typography,' overcoming
the ornamental center arrangement and
symmetric structure. That was 1930, the early
machine era, which was 80 years ago.

In this regard, I believe that the series of
stickers in Found Abstract by designer Na Kim or
JTBC Brand Identity by Lee Jae-min and myself
filmed at studio fnt are pioneering the ornamental
composition methodology, although unintended.
[4-5] Though they seem to have used simple
elements, they applied the principle of occasional
glimpses by collecting, rotating, and rearranging to
organize and draw out the meaning on the paper.
I recommended this type of simple and strong work
method for the students of Kookmin University.

Types are fixed in one direction. If you rotate
the letter 'n', it will become the letter 'u'. You
cannot rotate the letter 'R'. But ornaments can
be rotated by 90 degrees to make an infinite
number of combinations. Therefore, most
ornaments are symmetric, radiative, and continual.
Letter typographies progress into only one
linear direction — from the top left to bottom;
ornamental compositions can expand radially
from the center into every direction. According to
Marshall McLuhan, Gutenberg printing played the
role of fixating the perspective with one vanishing
point, which was invented around the same
time in Renaissance. The readers can read the
printed letters from a fixed viewpoint and position.
Interesting thing is, even after the invention of
print, there still were multi-view and multi-directed

[6] 안상수, 한글 만다라: 한글날 기념 포스터를 위한 에스키스,
1920 x 1300 mm, 1988
Ahn Sang-soo, Hangeul Mandara: Esquisse of Poster for Hangeul
Proclamation day, 1920 x 1300 mm, 1988

works in East Asia. They write, carve, and read the letters while rotating the papers. I believe ornamental composition will become the medium that steps away from the contemporary Western typographic perspectives, which is fixated on one vanishing point, and shed new light on the Asian, or furthermore, the Islamic arrangement of space.

Chris Ro: Though I cannot draw a definite line between East and West, most of the Western ornaments I experienced starts from the top-left and carries many images of ego, control, domination, independence, and individuality. And most ornaments I learned and experienced in Korea were seen as surrounding the center or in the form of mandala, spreading out from the center and melting into the surroundings, and carry many images of harmony, flow, affection, and togetherness. The relationships and culture among people were not so much different. Like so, the perspective of space and working methods differ greatly depending on the visual culture. And since I am more familiar with Western ornaments, I was very intrigued by the Hangeul Mandala poster and Typojanchi logo by Ahn Sang-soo. [6-7]

Lee Byoung-hak: The words decoration and ornament are both translated into Korean as 'jangsik'. I believe decoration, which seems painted over without structure, is also important. The border ornament on the cover of Looking into Graphic Design (3rd ed.)" by Professor Lee Ji-won of Kookmin University consists of adorable cars, spaceships, and fish in an unorganized and

다른 글자가 됩니다. R은 돌려서 쓸 수는 없습니다. 하지만 장식 오너먼트는 90도씩 방향을 회전시켜서 무한한 조합을 만들어낼 수 있습니다. 그래서 장식은 대개 대칭적이고 방사적이며 사방연속적입니다. 글자 타이포그래피는 왼쪽 위에서 아래로 선형적인 방향으로만 진행되지만, 장식 컴포지션은 가운데에서 방사형으로 확장되어갑니다. 마샬 맥루언에 의하면 구텐베르크의 인쇄는 비슷한 시기 르네상스의 발명인 하나의 소실점을 가진 원근법을 고정시키는 역할을 했다고 합니다. 독자는 정해진 시점과 고정된 위치에서 인쇄된 글자를 읽게 되지요. 재미있는 것은 동아시아에서는 인쇄가 발명된 이후에도 여전히 다시점과 다방향성이 나타납니다. 종이를 빙빙 돌리면서 글자를 쓰고, 새기고, 읽습니다. 저는 장식 컴포지션이 일점 소실점으로 고정된 서양 근대 타이포그래피의 관점을 탈피해 동아시아의 공간 배열, 나아가 이슬람의 공간 배열까지 재조명하는 매개가 되리라 생각합니다.

크리스 로: 동양과 서양의 이분법적으로 분명히 잘라 이야기할 수 있는 것은 아니지만, 제가 체험했던 대부분의 서양 오너먼트는 왼쪽 위에서 시작하며 자아, 통제, 지배, 독립적인, 개인적인 이미지가 많았습니다. 또 한국에 와서 배우고 느낀 오너먼트는 중앙을 감싸는 모습이거나 주변과 조화를 이루며 가운데에서 밖으로 퍼져나가는 만다라 구조가 많이 보였고, 조화, 흐름, 정, 함께하는 행동 등의 이미지가 많았습니다. 사람들 사이에 벌어지는 관계나 문화도 이와 다르지 않았죠. 이렇듯 시각 문화의 차이에 따라 공간을 바라보는 시점과 작업

[7] 안상수, 타이포잔치, 2011
Ahn Sang-soo, Typojanchi, 2011

[8] 마이클 베이루트, 제시카 헬펀드, 스티븐 헬러, 릭 포이너 엮음,
그래픽 디자인 들여다보기 3, 이지원 옮김, 비즈앤비즈, 2010
Edited by Michael Bierut, Jessica Helfand, Steven Heller and Rick
Poynor, Looking Closer 3, translated and designed by Lee Jiwon,
Viz&Biz, 2010

방식 역시 전혀 다르게 느껴집니다. 그래서인지 서양의 오너먼트에 익숙한 저에게 안상수 선생님의 한글 만다라 포스터와 타이포잔치 로고는 매우 흥미로웠습니다. [6-7]

이병학: 한국어는 데코레이션과 오너먼테이션을 모두 장식이라고 하는데요, 전 구조적이지 않거나 덧칠한 느낌의 데코레이션도 중요하다고 생각합니다. 국민대학교 이지원 선생님의 그래픽 디자인 들여다보기 3판 표지의 테두리 장식을 자세히 보면 아기자기한 자동차, 우주선, 물고기등으로 구조적이지 않고 자유롭게 구성되어 있습니다. 과하지도, 부족하지도 않고 제목에 몰입될 수 있도록 적절히 사용되어 한창 테두리 장식을 연구하던 저에게는 아주 인상적이었습니다. 이지원 선생님께 지난 학술대회 때 여쭈었더니 선생님께서 주변 생활 속의 요소들을 넣었다고 하셨습니다. 한창 장식 원리, 아라베스크의 구조적인 관점에서 테두리 장식을 바라보고 있던 와중이라 뒤통수를 얻어맞은 느낌이 들었습니다. 테두리 장식이라는 형식을 현대적으로 잘 풀어낸 디자인이라고 생각합니다. [8]

3. 기대와 예측

이재민: 앞으로 기술의 발전과 더불어 오너먼트의 가능성이 단순히 과거의 것에서 그치지 않고 더욱 발전할 가능성이 있겠네요. 그렇다면 교육이라는 분야에서는 이를 어떻게 반영할 수 있을까요?

이병학: 오너먼트에 대한 논의를 수업에 실천적으로 반영하는 것은 조형에 대한 다양한 시각을 제공할 수

free way, if you look closely. The ornaments are used in moderation — neither too much nor too little — allowing better focus on the title, and I was inspired by this during my studies on border ornaments. When I asked Professor Lee during a symposium, he told me that he used the elements of everyday life and surroundings. It hit me hard, because I was in the midst of studying border ornaments from the perspective of ornamental principles and arabesque structures. I believe that this design is a well-made modern version of border ornament. [8]

3. Expectations and Forecast

Lee Jae-min: Yes, it seems that ornaments won't just end up as a relic but develop more along with the advance of technology. Then how can we apply this to the field of education?

Lee Byoung-hak: It is important to apply the discussion on ornament to the classes, because it will provide different perspectives on modeling. But since ornaments don't have specific methodologies like the grid, it might be difficult to form a curriculum. However, Mr. Yu's ornamental composition class last year was inspiring. The results were indeed incredible, but the specific and clear methodology of ornamental composition — Am I right, Ms. Yu? (Ms. Yu: Yes!) — seemed very fascinating. Could you please tell us more about that?

Yu Jiwon: Thank you. Many professors shared with me words of compliment after reviewing the results of the Ornamental Composition class. But I want to make it clear that the incredible accomplishments by the students are not really the fruit of my curriculum. The results were made possible due to the academic traditions of the Kookmin University Visual Communication Design Department and the positive outcome from intense and systematic trainings for students of all grades by the full-time professors including Professor Sung Jae Hyouk. I was delighted with the students' passion, but I usually told them to take things easy. Students studying design have a fundamentally strong urge to express themselves. These students learn how to express and communicate their visual ideas through traditional and modern typography during the first two semesters. The unique and lively atmosphere of Kookmin University and the vital energy of the young students worked greatly

있다는 점에서 중요합니다. 다만, 장식이라는 것이
그리드처럼 구체적인 방법론을 가지고 있는 것이
아니기에 수업 내용을 구성하는 것이 쉽지 않겠지요.
하지만 작년에 유지원 선생님께서 진행하신 장식
컴포지션 수업은 아주 명쾌하게 진행되었더군요.
결과물도 놀랍지만 장식 컴포지션이라는 구체적이고
명확한 방법론을 가지고 진행하셨다는 점이
매력적이었습니다. 자세히 소개해주실 수 있을까요?

유지원: 고맙습니다. 장식 컴포지션이라는 주제로
진행한 수업 결과물을 보고 여러 선생님께서 좋은
말씀을 해주셨습니다. 그런데 학생들이 성취해낸
놀라운 밀도는 제 수업의 산물이라기보다는 국민대학교
시각디자인학과의 학풍과 성재혁 선생님 등 전임
교수님들이 저학년 때부터 체계적으로 시행하는 강도
높은 훈련의 결실이라는 점을 먼저 분명히 하고 싶습니다.
저는 학생들의 열의에 기쁘기도 했지만, 오히려 쉬엄쉬엄
하라며 말리는 편이거든요. 디자인과에 진학한 학생들은
기본적으로 표현 욕구가 강합니다. 첫 두 학기 동안 이런
학생들이 고전적, 현대적 타이포그래피를 통해 절제를
통해 시각적 의사를 표현하고 소통하는 법을 배웁니다.
그러다 보니 국민대학교 특유의 혈기 넘치는 분위기와
젊은 학생들의 왕성한 에너지가 장식이라는 소재와
방법론과 만나며 높은 밀도의 결과로 분출된 것 같습니다.
　책자로 발간된 타이포그래피 챕터 99: 장식
컴포지션은 국민대학교 시각디자인학과 3학년 학생들을
대상으로 진행한 워크숍입니다. 저는 타입을 넘어선
엘리먼트들을 사용해 배열의 방식에 대해 다양하게
접근하기를 권장했습니다. 화려한 드로잉이 아니라
단순한 엘리먼트들을 체계적으로 치밀하게 계산하여
공간 속에 구성되는 '컴포지션'을 목표로 삼았습니다. [9]
　이 과정에서 전통적인 오너먼트 양식도 활자
분류법을 가르치듯 이론적으로 다루었지만, 전통적인
오너먼트라는 엘리먼트를 넘어서 라틴 알파벳,
한자, 한글, 문장부호 등 활자를 비롯해 사진, 도장
등 일상에 이르기까지 엘리먼트를 수집하게끔
했습니다. 그중 머리카락을 엘리먼트로 사용한 작업이
인상적이었습니다.
　다음 단계는 이 1차적인 엘리먼트들을
콤비네이션합니다. 장식은 타입과 달리 방향을 변환할
수 있어 조합 가능한 경우의 수가 무한대에 이릅니다.
이 다양한 가능속 속에서 화려한 유닛들이 형상을
갖추어갑니다.
　마지막 단계로 2차적인 컴비네이션들을 3차
컴포지션의 형식으로 주어진 지면에 배열합니다. A1
내지 A0 판형의 지면을 불과 2, 3주 만에 완성해낸
학생도 있었습니다. 이때 단순 나열과 반복을 피하면서

[9] 국민대학교 시각디자인학과 3학년 학생들과 유지원,
타이포그래피 챕터 99: 장식 컴포지션, 2014
Yu Jiwon and the 3rd year Visual Communication Department
Students of Kookmin University, Typography Chapter 99:
Ornament Composition, 2014

with the subject and methodology of ornament,
creating this wonderful outcome.
　The booklet Typography Chapter 99:
Ornamental Composition shows the workshop
I had with juniors of the Kookmin University
Visual Communication Design Department.
I recommended the students to make various
approaches for the arrangement methods using
elements beyond type. We aimed for 'composition'
that is structured within the space by calculating
the simple elements instead of fancy drawings in
a systematic and elaborate way. [9]
　Although they did learn the theories of
traditional ornamental styles just like the
classification of types during this process, the
students had to 'collect' elements beyond
traditional ornaments — everything from types
such as Latin Alphabets, Chinese Characters,
Hangeul, and punctuation marks to the
surroundings such as photographs and stamps.
I was impressed with a student's work that used
hair as element.
　For the next step, these primary elements are
put together into secondary combination. Unlike
types, ornaments can be rotated into different
directions, so the number of possible combination
is endless. Splendid units form in the midst of these
various possibilities.
　For the last step, the secondary combinations
are arranged on the given paper in the form of
tertiary composition. One student even finished
the A1- to A0-sized paper in just two or three
weeks. During this step, I emphasized avoiding
simple arrangements and repetitions and keeping

균형 있는 리듬감과 역동성을 취하는 점을 무엇보다도 강조했습니다. 컴포지션의 유닛이 주로 사각형과 원에 머물러 있다는 점은 아쉽습니다. 벌집 형태의 육각 그리드로 컴포지션의 골격을 잡은 학생이 있었는데, 이 구상을 그만두었던 점도 아쉬웠고요.

장식 컴포지션은 얼핏 복잡해 보이지만, 원리를 한 번 이해하고 방법론을 몸으로 습득하면 의외로 작업이 쉽게 풀릴 수도 있고 응용하기도 용이해 워크숍 주제로 좋았습니다. 앞서 말씀드렸듯 오너먼트는 복잡하다는 편견을 벗어난 작품이 없었던 점은 다만 아쉽습니다.

정리하자면, 장식 컴포지션 워크숍은 최소 2학기 이상 엄격한 타이포그래피 훈련을 거친 학생들만을 대상으로 합니다. 장식을 알아야 해서라기보다는 첫째로 쓰려면 알고 쓰고, 둘째로 다양한 방법론을 구사해보고, 셋째로 이후 타입만으로 작업을 하더라도 알고 안 쓰는 것과 모르고 안 쓰는 것은 다르니 경험해볼 만하다고 여겼습니다. 학생들의 반응은 대체로 긍정적이었습니다. 절제에서 풀려나 엄격한 체계 속에서도 무한한 표현 가능성을 분출해내며 자유로움을 느끼는 학생도 있었지만, 타입만으로 이미 능숙하게 작업을 하던 학생이 충분히 잘할 수 있는데 굳이 장식이 필요한가 반문하는 소수의 경우도 있긴 했습니다.

시작은 단순했습니다. 어떤 학생이 장식 오너먼트를 사용했는데 양식에 맞지 않았거든요. 무작정 막을 것이 아니라 알고 쓸 수 있도록 판단의 기회를 제공하는 것이 의미 있다고 생각했습니다. 학생들에게 혹시 배워보고 싶은 생각이 있는지 조심스럽게 물었더니 호응해주었습니다. 결과는 저의 예상을 넘어섰습니다. 학생들이 진행하는 모습을 보면서 저도 함께 공부해가며 엘리먼트, 콤비네이션, 컴포지션에 이르는 체계를 이론적으로 가다듬어갈 수 있었습니다. 학생들을 통해 많은 배움과 통찰을 얻었습니다.

크리스 로: 저도 유지원 선생님 수업에서 나온 책을 보았는데요, 제가 느끼기에는 거기에 나온 몇몇 작업은 장식의 전통적인 원칙에 입각해서 컴퓨터를 통해 기존의 손이 닿을 수 없는 영역까지 확장되었다고 봅니다. 요즘 디자인은 더욱 논리와 이성을 중시하는 양적 분야가 되고 있습니다. 따라서 디자이너와 학생이 손을 사용해서 디자인을 발전시킬 수 있는 기회가 줄어들고 있지요. 따라서 손의 중요성이 줄어들거나 간과되는 영역이 되었습니다. 하지만 손은 머리가 할 수 없는 일을 할 수 있습니다. 손은 재료를 만지고 느끼면서 무작위적인 작업, 상상할 수 없는 것을 만들어낼 여지가 많습니다. 장인이 손과 연장을 다루듯 디자이너가 손과 도구의 연장으로 컴퓨터를 사용한다면 어떨까 생각했고, 제 수업에서도 이를 학생들과 실험해보기로 했습니다.

balanced rhythm and dynamics. I felt the lack of variation when I saw that most composition units were quadrangles or circles. One student created the frame of composition in the form of hexagonal grid, in a form of beehive, but I was sorry to see the plan scrapped.

The ornamental composition might look a little complicated at a glance, but it was a great subject for the workshop because once designers understand the principles and learn how it works, the work itself afterwards is fairly easy and applicable. Like I mentioned before, I was sorry to see that no work was able to overcome the prejudice that ornaments are complicated.

To sum it up, the Ornamental Composition Workshop is for students who have gone through intense typography training for at least two semesters. The goal of this workshop is not to learn about ornaments, but rather to experience them: First, you have to know what you are doing; Second, you have to try different methods; and third, you will find out that even when working with types alone, knowing what you are doing with your work does make a difference. Most students showed positive reactions. Some enjoyed the freedom from restraints, showing endless possibilities in expressing themselves even within the strict system. But in a few cases, students who are already skilled in working with types questioned the need for ornaments when they feel types are already sufficient.

The beginning was simple. One student used ornaments but didn't fit the style. I thought it was meaningful to provide an opportunity for learning before making judgments rather than stopping them from the start. When I cautiously asked the students if they wanted to learn, they responded. The results were beyond my expectation. As I watched the students work, I was able to learn with them, polishing up my theories of the system of elements, combination, and composition. I gained great understanding and insights from these students.

Chris Ro: I also read the book by Ms. Yu, and I believe that some of the works done by the students are based on the traditional principles of ornaments and expanded to the area where computer-manipulated works cannot reach. Design is currently becoming a quantitative area that values logic and reason. That is why there are fewer opportunities for designers and students to develop design using their own hands. In this

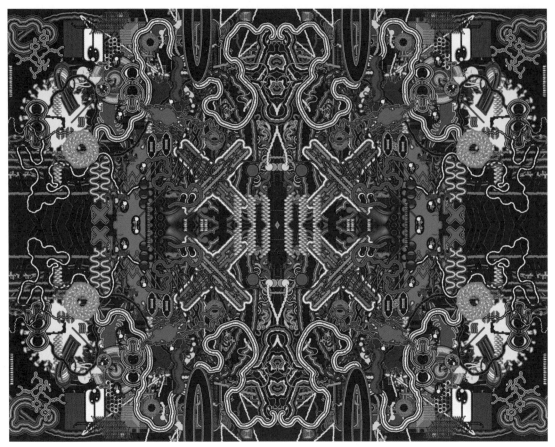

[10] 임정희, <u>로크의 신경</u>, 2014
Lim Jeong-hee, <u>Roak's nerve</u>, 2014

전종현: 저는 크리스 로 선생님의 강의가 굉장히
인상적이었습니다. 선생님은 도구를 신체의 일부처럼,
악기처럼 익숙하게 다루면 거기에서 자연스레
오너먼트가 생겨난다고 말씀하셨죠. 이건 글쓰기에도
똑같이 적용됩니다. 짧은 시간 안에 글쓰기 실력을 늘리는
가장 좋은 방법은 필사라고 합니다. 키보드를 치면
헛고생이고요. 무조건 손으로 펜을 잡고 직접 써야 한다고
합니다. 왜냐면 눈으로 글을 보고, 머리로 이해하며, 그
내용이 물리적인 손으로 내려와 현실에 구현되는 일련의
과정이 암묵지의 논리로 바라보면 살아 있는 지식의
체득이거든요. 아실지 모르겠는데 국민대학교를 졸업한
임정희 디자이너의 작업이 좋은 예라고 생각합니다.
그의 작품은 오직 디지털의 특성을 활용했지만 굉장히
공예적입니다. [10]

이재민: 임정희 디자이너의 작품처럼 컴퓨터로 제작한
작품에 대해 '손 재주 좋다'고 말하는 것이 크리스 로
선생님이 말씀하신 "악기처럼 컴퓨터를 쓴다."라는
표현과 맞닿아 있는 것 같습니다. 이제 좌담을
마무리하며 한 말씀씩 부탁드립니다.

area, importance of manual work is decreasing or
even overlooked. But hands can do what the brain
cannot. As we touch and feel the materials with
hands, there is room for creating random work
and unimaginable things. Wondering why we do
not let designers use the computer like craftsman
would use their hands and tools, I decided to try
this theory out on my students in class.

Harry Jun: I was personally impressed with
Professor Ro's lecture. He said if we can manipulate
tools like a musician's musical instrument or our
own body parts, we can naturally have ornaments
as a result. This goes the same for writing. The
best way to improve your writing in a short time
is transcribing. It is useless if you use a keyboard.
You have to use your own hand and write with pen.
If you see the text with your eyes and understand
it with your brain, its contents will be sent to
your physical hand and materialize as something
real. From the perspective of tacit knowledge,
this process is the learning of living knowledge.

유지원: 유니버스와 코스모스의 차이를 혹시 아시는지요? 유니버스는 '우주'라는 뜻입니다. 유니온의 예처럼 '하나'를 뜻하는 라틴어 우눔과 '회귀한다'는 뜻을 가진 '베르숨'을 합친 단어로, '모든 것은 돌고 돌아 하나로 회귀한다'는 의미입니다. 다른 얘기로 오늘날에는 하나가 아닌 다른 우주가 존재한다는 멀티버스, 즉 '다중우주'라는 개념도 거론되지만요.

한편 코스모스는 유니버스처럼 우주 자체를 뜻하기도 하지만, 주로 '우주의 질서'라는 의미로 사용됩니다. 카오스와 반대인 개념이지요. 이 코스모스라는 단어를 우주의 질서라는 용례로 처음 사용한 사람이 바로 피타고라스입니다. 그런데 피타고라스 시대에는 코스모스라는 단어가 다른 의미로 널리 통용되고 있었다고 합니다. 일상에서 코스모스는 '장식'이라는 뜻이었습니다. 신체를 장식하는 장신구를 일컫는 단어였지요. 보석 하나하나보다는 보석들이 정교하고 아름답게 배열되어 하나의 장신구를 구축하는 모습에서, 피타고라스는 우주의 배열과 질서를 떠올렸을 것입니다.

우주는 사각형과 원이라는 기초도형으로도 심오하게 상징될 수 있지만, 현대 기하학은 우주 속에서 프랙탈이라든가 준결정 구조 같은 복잡하고 정교한 형태와 배열을 발견하기도 했습니다. 이 또한 우주의 모습인 것입니다. 기하학이라든가 물리학이 20세기 초반부터 거쳐온 궤적에 비해, 그래픽 디자인과 타이포그래피의 공간 인식은 고대 기하학의 사각형과 직선적 정렬에만 머물러 있는 것이 아닌가 싶습니다. 이 시대의 다른 정신적 영역들의 개척지와 궤를 함께하며, 다양한 양태의 우주를 끌어안는 것은 아름다운 여정이라고 생각합니다.

이병학: 오늘 오너먼트에 대해 논의하면서 장식을 구별지었지만 이런 작품들이 대중들에게 수용될수록 장식이라는 구별이 무의미해질 것 같습니다. 제가 논문에서 핵심적으로 인용했던 구절이 고트프리드 젬퍼의 "건축은 장식적인 것과 구조적인 것의 구분이 안 되는 지점까지 나아간다."라는 명제였습니다. 옷의 스티치는 구조적인 요소지만 장식적으로도 사용되지요. 결국 이것은 디자인이다, 장식이다의 구별이 아니라 차이에 대한 이해의 문제입니다. 분명 된장찌개나 김치찌개는 맛있습니다. 하지만 그것만 먹고 살 수는 없지요. 또 다른 음식을 바라보는 시각으로 장식을 바라보아야 합니다. 오늘 좌담을 통해 추상적인 단계에 머물렀던 장식에 대한 생각이 크리스 로 선생님의 몰입이나 유지원 선생님의 장식 컴포지션 워크숍을 통해 구체적으로 정리가 되어 유익했습니다.

I wonder if you have heard of the designer Lim Jeong-hee who graduated from Kookmin University. Designer Lim's work sets a good example. Though Designer Lim applied only digital characteristics, it is indeed a crafted work. [10]

Lee Jae-min: It seems to me that describing computer-produced works such as that of Lim Jeong-hee as 'crafted' is related to what Professor Ro said about "using the computer like an instrument." Now, is there anything else you would like to add before we finish this talk?

Yu Jiwon: Do you know the difference between universe and cosmos? The word universe is a combination of the Latin 'unum,' which means 'one' like in the word 'unicorn,' and 'versum,' which means 'to return.' Thus, it means 'everything travels and returns as one.' In a different sense, there now is a concept called multiverse, an existence of other universes.

On the other hand, the word cosmos also represent the same thing, but it is normally used to define 'the order of the universe.' It is the opposite concept from chaos. The first person to use the word cosmos to describe 'the order of the universe' was Pythagoras. But during his time, the word cosmos was more widely used with a different meaning. Ordinarily, cosmos meant 'ornament.' It represented the accessories to decorate the body. Pythagoras probably thought of the arrangement and order of the universe when he saw how each jewels formed the accessories with elaborate and beautiful arrangements, rather than working individually.

Although the universe can be profoundly symbolized with basic shapes such as quadrangle and circle, modern geometry discovered complex and elaborate forms and arrangements in the universe such as fractal or quasicrystal. This, too, is the form of the universe. Compared to geometry and physics following the path since the early 20th century, perhaps graphic design and typography and their awareness of space are staying at the quadrangle and linear arrangements of the ancient geometry. I believe that the journey will be far more beautiful if we can walk along the path of the pioneers of other spiritual areas of today and embrace the diversity of the universe.

Lee Byoung-hak: We distinguished different types of ornament while discussing it, but as more ornamental works are accepted by the public,

전종현: 이병학 선생님의 말씀에 동감합니다. 21세기 개인의 표현 욕구가 솟구치면서 장식은 어느새 그 자체로 의미를 지니게 되었습니다. 여기에서 왜 장식이어야 하나, 왜 이것이 필요하나 등을 따지는 것은 의미가 없습니다. 취향으로 장식의 죄악을 논하는 시대는 지났기 때문입니다. 장식의 존재만으로 의미가 있다면, 또한 장식의 출현에 이유가 있다면 더 이상 장식은 디자이너의 뇌리에서 억지로 때어낼 필요가 없습니다.

이재민: 선생님들의 말씀 잘 들었습니다. 막연히 장식적이라고 표현하던 일련의 시각적 양상을 개념적이고 구체적으로 고찰해볼 수 있는 시간이었습니다. 특히 유지원 선생님과 크리스 로 선생님께서 수업을 통해 다루셨던 내용들이 맥락을 더 이해하고서 다시 돌아보게 되니 더욱 유익하게 다가옵니다. 학생들을 지도하고 있는 학회의 여러 선생님들, 또 현장에서 활동하고 있는 많은 디자이너들에게 유익하고 신선한 내용이 될 것 같습니다. 긴 시간 참여해주셔서 감사합니다.

참고 문헌
전종현
권영필 외, 한국의 미를 다시 읽는다, 돌베개, 2005
김종균, 한국의 디자인, 안그라픽스, 2013
네리 옥스만 www.materialecology.com
마리안 반티예스 www.bantjes.com
미힐 스휘르만 www.michielschuurman.com
제시카 히시 www.jessicahische.is
아돌프 로스, 장식과 범죄, 현미정 옮김, 소오건축, 2006
임정희 www.heeheeheeeee.com
한셔 판 할럼 www.hansje.net

유지원
김경석, 남권희 외, 목판. 나무에 새긴 지식 정보,
 한국국학진흥원, 2008
로마니, 프란체스카 로마나, 이유경, 이슬람, 생각의나무,
 2008
한국출판학회, 印刷出版文化의 起源과 發達에 관한 研究
 論文集, 청주고인쇄박물관, 1996
'A Natural History of Printers' Flowers', Idea
 No. 325, Seibundo Shinkosha, 2007
Carsten Nicolai, Grid Index, Gestalten, 2009
Cees W. De Jong, Alston W. Purvis, Jan Thonlenaar,
 'Initialen, Ornamente, Schmuck', Type: A Visual
 History of Typefaces and Graphic Styles Vol. 1
 1628-1900, Taschen, 2009
Cees W. De Jong, Alston W. Purvis, Jan Thonlenaar,
 Type: A Visual History of Typefaces and

perhaps such distinguish will lose its purpose. To support the core argument of my dissertation, I quoted Gottfried Semper's preposition that architecture progresses to the point where ornaments and structures cannot be distinguished from one another. Stitches on clothes are structural, but they are also used for ornamental purposes. In the end, it is not the matter of distinguishing design or ornaments, but it is the matter of understanding the differences. Indeed, stews made of both soy bean paste and kimchi are delicious; however, we cannot live on just those two dishes alone. We must treat ornaments as we would treat different dishes. I had a valuable time today in our talk, being able to organize my thoughts on ornaments from an abstract to a more specific level through Professor Ro's immersion or Ms. Yu's Ornamental Composition.

Harry Jun: I agree. As individual urge for expression grew during the 21st century, ornament now has its own meaning. There is no reason for us to argue why ornaments are needed and so on. This is no longer the age in which ornament as preference is considered a crime. As long as ornament has its reason for existence and appearance, there is no need to separate it from a designer's mind anymore.

Lee Jae-min: Thank you all very much for your insightful words. We were able to conceptually and specifically consider the visual aspect of what has been known vaguely as "ornamental." It was especially helpful to review the subject after understanding what Professors Yu and Ro had taught to the students. This will be something very helpful and new to many educators in the society and designers who are actively working in the field. Thank you for being with us for such a long time.

Referense
Harry Jun
Hansje van Halem, www.hansje.net
Marian Bantjes, www.bantjes.com
Michiel Schuurman, www.michielschuurman.com
Jessica Hische, www.jessicahische.is
Neri Oxman, materialecology.com
김종균, 한국의 디자인, 안그라픽스, 2013
권영필 외, 한국의 미를 다시 읽는다, 돌베개, 2005
아돌프 로스, Ornament und verbrechen, 현미정 옮김,
 소오건축, 2006
임정희 heeheeheeeee.com

Graphic Styles Vol. 2 1901-1938, Taschen, 2010

Friedrich Frossman, Ralf De Jong, Detailtypografie, Verlag Hermann Schmidt, 2002

Helmer Aslaksen, Supporting Online Material for In Search of Demiregular Tilings, year(unknown)

Jan Tschichold, 'Kritik der ornamentalen Typographie' / 'New Typography', Schriften 1925-1974. Bd. 1., Brinkmann & Bose, 1991

Jérôme Peignot, Petit Traité de la Vignette, Imprimerie nationale, 2000

John L. Walters, 'Step and Repeat', Eye 70, The Pattern Foundry, 2008

Kapitza, Geometric: Graphic art and pattern fonts, Verlag Hermann Schmidt, 2008

Mathematica, mathematica.stackexchange.com

Messingschriften und –schmuck, J. G. Schelter & Giesecke, year(unknown)

Peter J. Lu, Paul J. Steinhardt, 'Decagonal and Quasi-crystalline Tilings in Medieval Islamic Architecture', Science. Vol. 315, American Association for the Advancement of Science, 2007

Raymond Tennant, 'Medieval Islamic Architecture, Quasicrystals' / 'Penrose and Girih Tiles, Symmetry: Issue on Symmetry and Islamic Art', Culture and Science, 2009

Robert Williams, The Geometrical Foundation of Natural Structure: A Source Book of Design, Dover Publications, 1979

The topkapi scroll: geometry and ornament in Islamic architecture, ee.bilkent.edu.tr/~history/geometry.html

Yves Perrousseaux, Histoire de l'écriture typographique Vol. 2: Le XVIIIe siècle, tome I/II, Atelier Perrousseaux éditeur, 2010

이병학

'A Grammar of Type Ornament', The Monotype Recorder Vol. 42 No. 1, Monotype, 1963

Francis Meynell, Typography, Pelican Press, 1923

Francis Meynell, Stanley Morison, 'Printers' Flowers and Arabesques', The Fleuron Vol. 1, 1923

Stanley Morison, Four Centuries of Fine Printing, Ernest Benn, 1924

Frederic Warde, Bruce Rogers Designer of Books, Cambridge Harvard University Press, 1926

The Monotype Recorder, 18th Century French Typography, 1926

Paul Beaujon(Beatrice Warde), 'On Decorative Printing in America', The Fleuron Vol. 6, 1928

Yu Jiwon

'A Natural History of Printers' Flowers', Idea No. 325, Seibundo Shinkosha, 2007

Carsten Nicolai, Grid Index, Gestalten, 2009

Cees W. De Jong, Alston W. Purvis, Jan Thonlenaar, 'Initialen, Ornamente, Schmuck', Type: A Visual History of Typefaces and Graphic Styles Vol. I 1628-1900, Taschen, 2009

Cees W. De Jong, Alston W. Purvis, Jan Thonlenaar, Type: A Visual History of Typefaces and Graphic Styles, Vol. II 1901-1938, Taschen, 2010

Friedrich Frossman, Ralf De Jong, Detailtypografie, Verlag Hermann Schmidt, 2002

Helmer Aslaksen, Supporting Online Material for In Search of Demiregular Tilings, year(unknown)

Jan Tschichold, 'Kritik der ornamentalen Typographie' / 'New Typography', Schriften 1925–1974. Bd. 1., Brinkmann & Bose, 1991

Jérôme Peignot, Petit Traité de la Vignette, Imprimerie nationale, 2000

John L. Walters, 'Step and Repeat', The Pattern Foundry, Eye 70, London, 2008

Kapitza, Geometric: Graphic art and pattern fonts, Verlag Hermann Schmidt, 2008

Mathematica, mathematica.stackexchange.com

Messingschriften und –schmuck, J. G. Schelter & Giesecke, year(unknown)

Peter J. Lu, Paul J. Steinhardt, 'Decagonal and Quasi-crystalline Tilings in Medieval Islamic Architecture', Science Vol. 315, American Association for the Advancement of Science, 2007

Raymond Tennant, 'Medieval Islamic Architecture, Quasicrystals' / 'Penrose and Girih Tiles', Symmetry: Issue on Symmetry and Islamic Art, Culture and Science, 2009

Robert Williams, The Geometrical Foundation of Natural Structure: A Source Book of Design, Dover Publications, 1979

The topkapi scroll: geometry and ornament in Islamic architecture, ee.bilkent.edu.tr/~history/geometry.html

Yves Perrousseaux, Histoire de l'écriture typographique, Vol. 2: Le XVIIIe siècle, tome I/II, Atelier Perrousseaux éditeur, 2010

김종석, 남권희 외, 목판. 나무에 새긴 지식 정보, 한국국학진흥원, 2008

로마니, 프란체스카 로마나, 이유경, 이슬람, 생각의나무, 2008

Stanley Morison, 'Decorated Types', The Fleuron Vol. 6, 1928
Frederic Warde, Printers Ornaments, Lanston Monotype, 1928
Hermann Zapf, Manuale Typographicum, The MIT. Press, 1954
John Ryder, A Suite of Fleurons, Phoenix House Ltd., 1956
Ruari McLean, Victorian Publishers' Book-Bindings in Cloth and Leather, University of California Press, 1973
———, Victorian Publishers' Book-Bindings in Paper, University of California press, 1983
Idea Archieve, A Natural History of Printers' Flowers, Seibundo Shinkosha, 2010
오웬 존스, 세계 문양의 역사, 김순희 외 옮김, 다빈치, 2010

↗

한국출판학회, 印刷出版文化의 起源과 發達에 관한 研究 論文集, 청주고인쇄박물관, 1996

Lee Byoung-hak
'A Grammar of Type Ornament', The Monotype Recorder Vol. 42 No. 1, Monotype, 1963
Francis Meynell, Typography, Pelican Press, 1923
Francis Meynell and Stanley Morison, 'Printers' Flowers and Arabesques', The Fleuron, Vol. 2, 1923
Stanley Morison, Four Centuries of Fine Printing, Ernest Benn, 1924
Frederic Warde, Bruce Rogers Designer of Books, Harvard University Press, 1926
The Monotype Recorder, 18th Century French Typography, 1926
Paul Beaujon(Beatrice Warde), 'On Decorative Printing in America', The Fleuron Vol. 6, 1928
Stanley Morison, Decorated Types, The Fleuron Vol. 6, 1928
Frederic Warde, Printers Ornaments, Lanston Monotype, 1928
Hermann Zapf, Manuale Typographicum, The MIT. Press, 1954
John Ryder, A Suite of Fleurons, Phoenix House Ltd, 1956
Ruari McLean, Victorian Publishers' Book-Bindings in Cloth and Leather, University of California press, 1973
———, Victorian Publishers' Book-Bindings in Paper, University of California Press, 1983
Idea Archieve, A Natural History of Printers' Flowers, Seibundo Shinkosha, 2010
오웬 존스, 세계 문양의 역사, 김순희 외 옮김, 다빈치, 2010

↗

수집

Collection

공간의 질서: 오너먼트

김병조
뉴타입 프레스, 한국

강미연
활자공간, 한국

Order in Space: Ornament

Kim Byung-jo
Newtype Press, Korea

Kang Mi-yeon
Type-space, Korea

주제어
공간, 질서, 오너먼트

→

Keywords
Space, Order, Ornament

↓

1

2

3

↓

7

8

9

10

11

↓

東亞日報
創刊號

12

13

14

15

16

17

18

19

20

→ 21 22 23 24 25 26

```
:::::::::::::::::::::::::::::::::::::::         0x0x0x0x0x0x0x0x0x0x0x0x0x0x0x0x0

  :0:0:0:0:0:0:0:0:0:0:0:0:0:0:0:0:            *.*.*.*.*.*.*.*.*.*.*.*.*.*.*.*
                                               *:                            :*
                                               *:                            :*
mnmmmmmmmmmmmmmmmmmmmmmmmmmmmmmmmmmm            *:                            :*
:::::::::::::::::::::::::::::::::::::            *:                            :*
mnmmmmmmmmmmmmmmmmmmmmmmmmmmmmmmmmmm            *:                            :*
                                               * * * * * * * * * * * * * * * *

  )     ex    libris      )              ---(‾┐----(‾┐----(‾┐----(‾┐--=
       )    Byong Jin Kim    )            - - - - - - - - - - - L . . - - -
```

```
        * * * * * * * * * * * * * * * * * * * * * * * * * * * * * * *
        *                                                           *
    * * *                                                           * * *
    *                                                                   *
    *                            X                                      *
    *                          X   X                                    *
    *                        X   X   X                                  *
    *                          X   X                                    *
    *                            X                                      *
    *                                                                   *
    *                                                                   *
    *                            0                                      *
    *                          0 0 0                                    *
    *                        0   0   0                                  *
    *                      0 0 0 0 0 0 0 0 0                            *
    *                        0   0   0                                  *
    *                          0 0 0                                    *
    *                            0                                      *
    *                                                                   *
    *                                                                   *
    *                                                                   *
    *                                                                   *
    *                         oo0oo                                     *
    *                 o0 :: :: :: :: Oo                                 *
    *                         oo0oo                                     *
    *                                                                   *
    *                                                                   *
    *                                                                   *
    *                                                                   *
    *                                                                   *
    *                                                                   *
    * * *                                                           * * *
        *                                                           *
        * * * * * * * * * * * * * * * * * * * * * * * * * * * * * * *
```

→ 28 29 30 31 32 33 34

↓

35

36

37

38

39

40

↓

1 성서개역, 조선경성성서공회, 1938년
2 현토한한 신약성서 누가전, 1884년
3 구약개역, 조선성서공회, 1939년
4 구약전서, 1911년
5 신약전서, 1952년
6 관주신약전서, 1956년
7 소년, 신문관, 1908년
8 소년, 신문관, 1908년
9 소년, 신문관 , 1908년
10 소년, 신문관, 1908년
11 동아일보, 1921년 4월 9일
12 동아일보, 1920년 4월 1일
13 동아일보, 1921년 9월 16일
14 동아일보, 1922년 1월 8일
15 동아일보, 1921년 9월 24일
16 매일경제, 1966년 3월 24일
17 성경직해, 1887년
18 동아일보, 1920년 7월 25일
19 동아일보, 1921년 4월 1일
20 경향신문, 1946년 10월 6일
21 경향신문, 1946년 10월 16일
22 경향신문, 1946년 11월 20일
23 소년, 신문관, 1908년
24 소년, 신문관, 1908년
25 경향신문, 1946년 10월 31일
26 경향신문, 1946년 10월 8일
27 영문한글 타자교본, 장왕사, 1964년
28 매일경제, 1966년 4월 18일
29 동아일보, 1921년 7월 15일
30 동아일보, 1921년 5월 23일
31 동아일보, 1921년 9월 14일
32 동아일보, 1921년 7월 19일
33 동아일보, 1921년 10월 17일
34 동아일보, 1922년 1월 8일
35 경향신문, 1946년 10월 8일
36 경향신문, 1946년 12월 10일
37 소년, 신문관, 1908년
38 매일경제, 1966년 4월 22일
39 소년, 신문관, 1908년
40 소년, 신문관, 1908년
41 매일경제, 1966년 4월 20일
42 매일경제, 1966년 4월 20일
43 매일경제, 1966년 4월 22일
44 매일경제, 1966년 4월 15일
45 매일경제, 1966년 4월 15일
46 매일경제, 1966년 4월 15일
47 동아일보, 1921년 10월 28일

↓

1 Revised Version of the Korean Bible, British and foreign Bible Society, Seoul, Korea, 1938
2 Hyunto Chinese-Korean, New Testament Bible, Rogajeon, American Bible Society, 1884
3 Revised Old Testament, British and foreign Bible Society, Seoul, Korea, 1939
4 Complete Old Testament, British and foreign Bible Society, Seoul, Korea, 1911
5 New Testament Revised Version of the Korean Bible, Korean Bible Society, 1952
6 Reference New TestamentRevised Version of the Korean Bible, Korean Bible Society, 1956
7 Sonyeon, Shinmungwan, 1908
8 Sonyeon, Shinmungwan, 1908
9 Sonyeon, Shinmungwan, 1908
10 Sonyeon, Shinmungwan, 1908
11 Dongailbo, 9 April 1921
12 Dongailbo, 1 April 1920
13 Dongailbo, 6 September 1921
14 Dongailbo, 8 January 1922
15 Dongailbo, 24 September 1921
16 Maeil Business Newspaper, 24 March 1966
17 SungkyungJikhae, 1887
18 Dongailbo, 25 July 1920
19 Dongailbo, 1 April 1921
20 Kyunghyang Shinmun, 6 October 1946
21 Kyunghyang Shinmun, 16 October 1946
22 Kyunghyang Shinmun, 20 November 1946
23 Sonyeon, Shinmungwan, 1908
24 Sonyeon, Shinmungwan, 1908
25 Kyunghyang Shinmun, 31 October 1946
26 Kyunghyang Shinmun, 8 October 1946
27 English Korean Typewriter Manual, Jangwangsa, 1964
28 Maeil Business Newspaper, 18 April 1966
29 Dongailbo, 15 July 1921
30 Dongailbo, 23 May 1921
31 Dongailbo, 24 September 1921
32 Dongailbo, 19 July 1921
33 Dongailbo, 17 October 1921
34 Dongailbo, 8 January 1922
35 Kyunghyang Shinmun, 8 October 1946
36 Kyunghyang Shinmun, 10 December 1946
37 Sonyeon, 1908, Shinmungwan
38 Maeil Business Newspaper, 22 April 1966
39 Sonyeon, Shinmungwan, 1908
40 Sonyeon, Shinmungwan, 1908
41 Maeil Business Newspaper, 20 April 1966
42 Maeil Business Newspaper, 20 April 1966
43 Maeil Business Newspaper, 22 April 1966
44 Maeil Business Newspaper, 15 April 1966
45 Maeil Business Newspaper, 15 April 1966
46 Maeil Business Newspaper, 15 April 1966

↓

48 매일경제, 1966년 4월 11일

49 동아일보, 1921년 12월 22일

50 매일경제, 1966년 4월 8일

51 경향신문, 1946년 11월 27일

52 경향신문, 1946년 10월 22일

53 매일경제, 1966년 4월 8일

54 경향신문, 1946년 11월 9일

55 경향신문, 1946년 10월 31일

56 동아일보, 1921년 12월 21일

57 매일경제, 1966년 4월 22일

58 동아일보, 1921년 12월 14일

59 동아일보, 1921년 10월 26일

↗

↓

47 Dongailbo, 28 October 1921

48 Maeil Business Newspaper, 11 April 1966

49 Dongailbo, 22 December 1921

50 Maeil Business Newspaper, 8 April 1966

51 Kyunghyang Shinmun, 27 November 1946

52 Kyunghyang Shinmun, 22 October 1946

53 Maeil Business Newspaper, 8 April 1966

54 Kyunghyang Shinmun, 9 November 1946

55 Kyunghyang Shinmun, 31 October 1946

56 Dongailbo, 21 December 1921

57 Maeil Business Newspaper, 22 April 1966

58 Dongailbo, 14 December 1921

59 Dongailbo, October 26th, 1921

↗

대화　　　　　　　　Dialogue

엘리엇 얼스와 크랜브룩 스타일의 그래픽 디자인 교육

Elliott Earls and Graphic Design Education the Cranbrook Way

엘리엇 얼스
크랜브룩 대학교, 미국

크리스 로
홍익대학교, 서울

Elliott Earls
Cranbrook, USA

Chris Ro
Hongik University, Korea

주제어
크랜브룩 예술 아카데미, 교육, 엘리엇 얼스

→

Keywords
Cranbrook Academy of Art, Education, Elliott Earls

번역: 박경식 Translation: Fritz K. Park

[크리스 로] 현재 그래픽 디자인 교육은 보통 디자이너가 스스로 만든 작품을 설명하고 나서 해당 작품 및 이론에 대한 비평이 이루어지는 식으로 이루어진다. 반면 그랜브룩의 비평은 작품에 대한 외부의 해석을 더 강조한다. 크랜브룩에서는 보통 디자이너가 자기 작품에 대해 언급하기 전에 그 작품에 대한 논의를 길게 진행한다. 이런 방식은 실제 디자인의 99%가 해당 디자이너의 목소리나 이론적 설명 없이 존재한다는 점을 고려하면 상당히 합리적이다. 디자인은 그 자체로 자명하다는 얘기인데, 이 점에 대한 당신의 생각을 들려 달라. 어떻게 이런 방식을 채택하게 되었는가? 기존의 비평 방식으로 작업해본 적이 있는가? 왜 다른 이들은 크랜브룩과 같은 방식을 채택하지 않는가?

[엘리엇 얼스] 우선 마지막 질문부터 답하겠다. 다른 이들이 그와 같은 방식을 채택하지 않는 까닭은 두 가지라고 본다. 첫째, 그 방식이 잘 작동하는 데 필요한 전제들을 신뢰하지 않고, 둘째, 설령 그 방식을 채택한다 하더라도 뒷받침할 수 있는 구조를 가진 기관은 거의 없기 때문이다. 예술 대학의 바젤식 기초 교육, 특히 고전적인 디자인 방법론에서는 지나치게 이론과 논리, 그리고 특히 의식적인 사고를 강조한다. 궁극적으로 보면 디자인이란 비판적 사고를 시각화한 요소들로 이루어진다. 설명하기 애매한데, 일단 나는 지성에 입각한 작업 과정과 비판적 사고에 열성적으로 몰두한다는 점은 중요하게 짚어두겠다. 그런데 정신의 무의식적 측면은 디자인 분야에서 거의 배제되다시피 해왔다. 크랜브룩의 방식이 유효하려면 로버트 하이트가 올바른 정신에서 썼듯이 "직관이 먼저고, 전략적인 이론은 그 다음"이라는 흔들리지 않는 믿음이 전제가 되어야 한다. 융이 제기한 그림자 개념에 빗대어 하는 말이다. 내 안에 있지만 내가 직접 알 수는 없는 것들. 디자인 과정이 전적으로 논리적이고 의식적인 사고의 지배를 받는다는 것은 기본적으로 진실이다. 그러나 시각적 세계는 그런 식으로 작동하지 않는다. 단지 자명할 뿐이다. 경험을 통해 우리가 알게 되는 것과 디자인 과정에는 차이가 있다. 'ineffable'은 언어로 담아낼 수 없는 것들을 가리킨다. 인간에겐 누구나 언어로만은 전달할 수 없는, 논리를 초월하는 어떤 경험을 해본 적이 있다. 그런 경험을 표현하는 방법들이 있는 것이다. 역설적으로 논리와 이성, 언어적 소통은 그와 같은 경험에 대한 깊은 이해를 도모하는 데 최적의 방법이지만, 그것들은 어디까지나 이차적이다. 그 경험 자체일 수는 없으니까.

또 다른 질문에 대한 답은 '아니오'이다. 솔직히 12년간 크랜브룩의 학과를 운영하면서 다녀본(그리고 살펴본 상당수의) 디자인 학교에서 전통적인 방식에 따라 비평을 하는 모습은 한 차례도 본 기억이 없다.

Chris Ro: Under the common model of graphic design education the designer often explains their work and the critique process is in turn a response to what is displayed and what is rationalized. The Cranbrook critique model however places more emphasis on the objective interpretation of the work. So often times a common Cranbrook critique will find the work being discussed at length before the designer explains anything about their work. This seems to make sense on a number of levels as design is almost 99% of the time existing without the voice or rationalization of its designer. The design speaks for itself. So we are wondering if you can share some thoughts on this? How did you come to such a model, do you ever find yourself working with the aforementioned traditional critique model? Why has nobody else really adopted such an approach?

Well I'll address the last part of the question first. I believe that no one else has adopted this model for two reasons. The first is that they don't believe in the a-priori assumptions necessary to make it work, and the second being that there are very few institutions that are structured in a way that could make it work even if it became a priority. The Basel method of foundation studies in Art school, and classic design methodology in particular place an inordinate faith in rationality, logic and most importantly conscious thought. Ultimately Design process is a visualized component of critical thinking. This is an extremely nuanced point to make, but it's important to point out that I am passionately committed to intellectual process and critical thinking. However, the unconscious mind has been almost exclusively omitted from this realm. The a-priori principle necessary to make the whole thing work is an unwavering belief that "Intuitions come first, strategic reasoning second" as Robert Heidt discusses in The Righteous Mind. Or as the American poet Robert Bly calls it, "the long bag we drag behind us." I'm talking about the Jungian concept of the Shadow here; those things within me of which I cannot directly know. The simple truth of the matter is that design process is absolutely ruled by the tyranny of logical conscious thought. But that is simply NOT how the visual world works. It's plainly self-evident. This is not waht experience teaches us. In english the word ineffable means those things that cannot be contained by language. Every human being has had experiences that simply cannot be

크랜브룩은 아주 강도 높은 글쓰기를 통해 비평에 접근한다. 기존의 말하기가 아닌 글쓰기를 통해 디자이너들이 어떤 프로젝트를 묘사, 해석하는가 하면 이론화, 맥락화하고 또 평가한다. 왜 이렇게 글쓰기 비평에 주안점을 두는지?

매주 비평 대상으로 제출된 작품을 진중하고 의미 있는 방식으로 탐구할 수 있는 환경을 만드는 데 심혈을 기울인다. 이를 위해서는 시간과 노력, 때로는 연구 조사까지 필요하다. 우리가 나누는 비평 시간의 글쓰기는 밀도가 높고 지극히 핵심적이다. 학생들을 가르칠 때 이 점에 특별히 신경을 쓰는데, 학기마다 우리 작업실에 소속된 구성원들은 한 명당 여러 번 '발언 기회'를 얻는다. 구성원 각자는 비평을 써오라는 과제를 받으면 그 다음 시간까지 지성을 발휘할 준비를 마친다. 이때 학생들은 사고를 종합하며 서두르지 않고 자신들의 목소리를 발굴한다. 작업실에서 이루어지는 엄격하고 수준 높은 지적 활동이다. 탁월한 결과를 내기 위해 함께 노력하는 것이다. 작품의 효과를 증진하는 데 도움이 되는 분위기를 만들어내려고 다 같이 노력한다는 뜻이지, 다 같이 비판에 무게를 둔다는 뜻은 아니다.

당신은 이따금 크랜브룩의 디자인 교육이 유연하다고 말했다. 가벼운 대화는 형식적인 비평이나 교실 구조 못지않게 효과적일 수 있다. 저녁식사 시간에 맥주 한 잔을 놓고 나누는 대화가 때로는 교육이 이루어지기에 적당한 기회일 것이다. 당신은 일주일에 한 번씩 크랜브룩 동료들과 함께 학생들과 차례로 돌아가며 저녁 식사 자리를 갖는다. 이렇듯 유연한 교육 형태의 바탕에는 당신의 어떤 생각이 깔려 있는가? 학생들에게는 그런 개방적인 교육이 환상적으로 들릴 수 있다. 하지만 교육자 입장에서는 사생활과 교육의 구별이 흐려져 필요 이상으로 일의 강도가 높아질 수 있다. 이 점에 관해서도 한마디 들려준다면?

강도가 높은 것이 사실이다. 나는 종종 크랜브룩을 '라 코사 노스트라'라고 부른다. 마피아를 가리키는 이탈리아어이다. 직역하면 '우리만의 것'이란 뜻인데, 나의 강조점은 여기에 있다. 대부분의 훌륭한 교육기관에는 그들만의 '마피아', 즉 '우리만의 것'이 있다. 크랜브룩은 가족이다. 아주 친밀한 한 가족처럼 운영된다. 그런 친밀한 환경과 독특한 운영 방식이 바로 '우리만의 것'이다.

　사람들이 떼로 뭉치면 으레 그렇기도 하듯, 바로 그 '우리만의 것' 때문에 일의 강도가 지나치게 높아질 때도 있다. 1년에 8개월은 거의 1주일에 7일을 일하며 하루 중 모든 시간을 학생들과 보내게 된다. 학생들이 집에

communicated through language and seem to be transcendent of logic. There are ways to deal with these issues and paradoxically, logic, reason and communication our some of our best ways to come to a deeper understanding of them, but they are a second term. They are not the thing itself.

　And no. I can honestly say that in my twelve years of running the department at Cranbrook, I cannot remember a single critique that conformed even a little to the traditional method of critique that I see in every design school I have travelled to (and I have seen a lot).

The Cranbrook critique approach has a very extensive written component as well. Designers describe, interpret, theorize, contextualize, and assess a project through written as opposed to the traditionally practiced vocal processes. Why is there such emphasis placed on this written criticism of a project?

Well, This overlaps with your last question. I am very concerned with providing an environment where each work submitted for critiqued is explored in a deep and meaningful way. This requires time, commitment and at moments research. The written component of our critique process is intense and hardcore. It is something that I go out of my way to instruct and teach my students. It also provides a few opportunities each semester for every single member of our studio, no matter how shy, to "have the floor." Each member of our studio when called upon to write a critique gets to set the intellectual tone for the next hour. Further, in this moment they really have an opportunity to compose their thoughts, be un hurried and have their voice heard. It is a very intellectually rigorous and demanding component of our studio. It is something that as a studio we work together to make great. I'm referring to working together on the right kind of atmosphere to make it work, not working together on the critiques.

You sometimes mention the fluidity of the design education at Cranbrook. Casual conversations can be just as beneficial as formal critiques and class structure. Sometimes conversations over beer and dinner are equally valid places and moments for education. Once a week you and your family also host dinners with a rotating group of students from your program. Can you speak to some of the thinking behind such a

와서 밥을 먹기도 하고, 여행도 함께 간다. 멋진 교육의 일환이다. 크랜브룩에는 아홉 명의 동료가 있어서 나를 포함해 상주 작가가 총 열 명이다. 나는 동료 작가들을 깊이 존경한다. 그들이 얼마나 열심히 일하는지 잘 알고 있다. '꿔다놓은 보릿자루' 같은 사람은 한 명도 없다. 우리가 모두 보이는 데서만 열심히 했다면 크랜브룩은 이미 무너졌을 것이다. 크랜브룩에서는 숨을 수가 없다. 전력을 다하거나 에누리 없이 멍청하게 인식되거나 둘 중 하나이다. 분과당 학생 수는 15명이므로 일 년에 학생 수가 고작해야 150명이 전부이다. 크랜브룩은 극히 유연한 조직이다. 분과별 비평 세션이 열리는 목요일에는 학생 30명이 참여하는 것이 관례이다. 대부분의 대학원과 달리 하루에 비평을 받는 인원은 단 세 명이다. 제출된 작품당 최소 한 시간 동안 토론한다. 말했듯이 분과별 인원은 15명이므로 자발적으로 자기가 선택해서 비평과 자유 토론에 참여하는 인원이 그 속에 포함된다. 토론은 완전히 즉흥적으로 이루어진다는 점이 중요하다. 학생들은 학업 배경이 다양한데, 그들이 흥미를 느끼며 비평 속에서의 배워나가기를 즐기는지 여부가 토론의 관건이다. 그래픽 디자인과 조각, 그래픽 디자인과 건축, 그래픽 디자인과 회화 사이의 상호작용은 깊고도 심오하다. 비평에 참여하는 학생들은 각 분야가 추동하는 아이디어를 갖고 온다. 그 아이디어들은 그래픽 디자인계에 빠르게 영향을 미치고, 또 반대로 우리가 비평에서 논의하는 의제들은 다른 각 분야에 영향을 미친다. 자발적이고 철저히 유기적이며 매력적인 과정이다.

크랜브룩에는 성적, 수업, 프로젝트가 없고 분과별로 교수가 한 명이다. 그런 자율적인 구성 방식에 강한 매력을 느끼는 사람들도 있겠지만, 대부분 디자이너들은 아무래도 그와 같은 환경에 적응하는데 불안을 느낄 것이다. 자유로운 형식으로 운영되는 조직과 그로부터 비롯하는 좋고 나쁜 결과에 대해 이야기를 들려준다면?

입학한 학생 중 몇 명은 겁을 집어먹고 그런 환경에 경악한다. 그런데 그런 학생의 사례가 워낙 드물다는 사실이 오히려 더 놀랍지 않은가. 겁먹는 학생이 별로 없는 까닭은 확실히 다음 세 가지인 것 같다. 우선은 멘토로서 도움을 주기 위해 내가 그들 곁에 있다는 사실이 제일 중요하다. 학생들이 적응하도록 돕고 안전한 환경을 조성하기 위해 노력한다. 다음으로 우리는 장시간 면접을 통해 우리의 체계에 매력을 느끼고 그 안에서 능력을 극대화할 수 있는 학생들을 찾는 데 힘쓴다. 마지막으로 이미 150명의 다른 학생들이 자기 작품에 매진하느라 동분서주하고 있으므로 캠퍼스에 처음 도착해서 어떻게 시작하면 좋을지 모르겠으면 오른쪽, 왼쪽을

fluid structure? For students, this openness sounds like a dream. But perhaps for some educators, the blurred edges between personal life and education could become unnecessarily intense. Can you speak to this as well?

Well it is very intense. I often refer to Cranbrook as 'La Cosa Nostra.' That is the Italian name for the mafia. But the emphasis I'm placing here is on the literal translation 'This thing of ours' or 'our thing.' Nearly every good school has it's 'mafia.' Again, the thing I'm addressing is 'this thing of ours.' Cranbrook is very familial. It's very intimate and runs like a family. The intensity of the environment and the very unique manner in which it runs is 'our thing.' And, just like with the mob every once in a while this leads to things getting unduly intense. For about eight months of the year, I am working nearly seven days a week, at all hours of the day with my graduate students. As you mentioned they eat at my home, we travel together. It's a fantastic educational tool. I have nine other colleagues at Cranbrook. There are a ten Artists-in-Residence including me. I have a deep respect for my fellow Artist-in-Residence. I know how hard they work and there simply is no 'deadwood.' Cranbrook would fall apart if all of the Artists-in-Residence went ballers. You cannot hide at this institution, you either kick ass or you are perceived rightly as a fool. Each department has 15 students under one AIR. We are only one hundred and fifty each year. Cranbrook is an extremely fluid institution. On our departmental critique day, which is thursday, we routinely have 30 students in a critique. I want to point out what this means. Unlike most undergraduate schools, on a critique day we are only critiquing 3 people. We spend at least an hour discussing each piece submitted for critique. And again, our department is only 15 people. So, the thirty people that I'm referring to are at the critique under their own volition, by their own choosing, taking time out of their day to participate in a free ranging discussion of the work submitted. The important point is that this is completely ad hoc. The students are drawn from all over the academy and it is simply based on wether they are intrigued and enjoy learning in our critiques. Further, this interplay between Graphic Design and Sculpture, or Graphic design and Architecture, or Graphic design and Painting is deep and profound. The students that come to the critiques bring ideas with them from each of these disciplines. These ideas quickly affect our discourse.

109

둘러보며 같은 분과의 동료 학생들을 따라하면 된다. 다시 말하지만 이따금 겁을 내는 학생들도 있다. 하지만 크랜브룩은 모두가 목표에 도달하게끔 상당히 협조적인 환경을 갖추고 있다. 무척 어려운 일이긴 하지만, 내가 담당하는 분과의 의의는 자아실현을 돕는 것이다. 학생들을 무너뜨려 파괴적인 결과로 이끄는 일은 하지 않는다. 무너뜨리는 작업은 새로운 것을 빚어내기 위한 방편일 뿐이다.

크랜브룩의 교육은 스스로 배우는 것이 핵심적인 요소인 듯하다. 사람들이 스스로 배우는 법을 터득하게 될 때가 있다. 당신은 어떤 프로젝트를 두고 좋거나 나쁘다고 평가하기보다는, 스스로의 뜻대로 성장하고 발전하게 내버려두는 편을 지향한다고 밝히기도 했다. 뜻대로 하기를 가르친다는 것은 정의상, 그리고 과정상 매우 힘든 과업이다. 무슨 말로 어떻게 가르칠 수 있는가?

훌륭한 질문이다. 나 역시 크랜브룩에서 수학했다. 1990년대 초 캐서린 맥코이와 마이클 맥코이가 나의 지도 교수였다. 교육을 받으면서 스스로 가장 놀라웠던 점은 자신감과 관련이 있다. 대학원에 들어갈 때 목표 중 하나가 자신감을 얻는 것이었다. 졸업할 때는 자신감이 넘치는 새 사람이 될 거라고 자부했다. 1년이 지나고 2년째에 접어들기 직전 여름, 나는 친구 결혼식에서 들러리로 서 달라는 부탁을 받았다. 건배를 외쳐야 하는 상황이 온 것이다. 바로 그때 나는 대학원에서 1년을 보내고 나서 오히려 입학할 때보다 자신감이 줄었음을 느끼고 몹시 놀랐다. 이 느낌은 졸업 후에도 남아 있었다. 이 점을 분명히 언급하는 까닭은 당신의 질문에 좋고 나쁨이라는 표현이 마침 등장했기 때문이다. 앞서 디자이너들이 (그리고 어쩌면 디자인 학교들까지도) 수상 경력에 지나치게 신경을 쓴다는 점에 관해 이야기를 나눴다. 크랜브룩 작업실에서는 한 사람의 핵심적인 가치 체계에 근본적인 질문을 던진다. 그러다 보면 형편없다고 생각했던 작품들을 멋지다고 생각하기 시작하는 일이 속속 눈에 띄게 발생하기 시작한다. 나는 학생들이 각자 어떤 예술이나 디자인이 좋다고 하는 스스로의 사유에 대항하도록 항상 압력을 가한다. 외부를 삶의 내부로 삽입하는 것이다.

어쨌든 우스운 것은 크랜브룩에 입학할 당시만 해도 졸업할 때 자신감을 갖는 것이 목표였다는 사실이다. 학교를 떠날 무렵에는 오히려 자신감이 줄어든 것 같아서 혼란스러웠다. 이윽고 나는 자신감이 강렬한 작품을 만들어내는 데 필수 요소가 아니라는 사실을 깊이 자각하게 됐다. 이 점을 몇 번이고 강조하고 싶다. 일반적으로 우리 문화에서 자신감은 무언가를 잘하려면 필수적으로 갖춰야 할 요소라고 인식된다. 그러나 경험을

And conversely the issues that we are discussing in our critiques, and the issues at play in the work in our department are quickly assimilated back into the discourse of other departments. It's an amazing, voluntary, completely organic process.

Cranbrook has no grades, no classes, no projects, and one professor. Some might be thrilled with such autonomous accommodations for study. But a large majority of designers could find adjusting to such a setting unsettling to say the least. Can you speak to some of the history of such a free form system and some of the results both good and bad as you see them?

A few kids arrive each year and freak out. They lose their minds confronted with such an environment. But, you'd be surprised by how infrequently this happens. I'm fairly certain that the freak outs are few and far between for three reasons. The first an most important being that as my students mentor, I am there to help. I help my students adjust, and work hard to create a safe environment. The second is that we go to great lengths in the interview process to try to find students who are attracted by our system and who will probably thrive in it. And the third is, that when a student arrives on campus there are one hundred and fifty students all grinding and hustling working on their program. If they don't know where to begin, they simply look to their left or their right and model their behavior after their classmate. Again the occasional freak out happens. But we really are a supportive environment that actually wants everyone to thrive. My department in particular, while I'd like to think it is very difficult, is specifically there to help people self-actualize. I'm not in the business of tearing people down for a destructive end. If tearing down happens it is only to help fashion anew.

Auto-didactism seems to be a very key component to the Cranbrook way. People sometimes come to learn how to learn for themselves. You have sometimes mentioned that it is not your intention to discuss the good or bad of a project but more so to let things grow or develop as they will. But the teaching of this is a daunting challenge in and of itself. How is something like this spoken to or taught?

Excellent question. I too studied at Cranbrook. In the early 1990's I was a graduate student studying

통해 스스로 그 인식을 시험한 뒤, 나는 그 생각을 완전히 폐기했다. 실력과 자신감은 별개이다. 때로는 둘 다 있기도 하고, 때로는 한 가지만 있기도 하다. 탁월함에 대한 일념이 작품의 질을 향상시킨다는 사실도 깊이 깨닫게 됐다. 다시 말하면, 스스로의 작품이나 실력에 관해 어떻게 느끼든, 작품에 열정적으로 전념하면 작품은 질적으로 진화하게 되어 있다. 실력에 대한 나의 자신감은 졸업 후 몇 년간 눈부신 오만과 가련한 자기회의 사이에서 왔다 갔다 했다. 이제는 자신감이라는 주제 자체를 무시할 줄 안다. 무엇이 '좋고' 무엇이 '나쁜지'에 대한 심도 있는 질문을 던졌을 때, 이 모든 문제들이 따라 나온다. 개인적인 문제에 국한해서 설명했지만, 실제로도 나는 이 문제들을 두고 학생들과 토론하며 멘토링에 힘쓴다. 살아 있는 경험에 입각해 쓸데없는 말은 집어치우고 실질적인 것들만 논하려고 애쓴다. 가식을 부리거나 멋있어 보이는 데 관심을 쏟지 않고, 내가 이해하는 그대로 문제의 핵심적인 진실을 논하고자 한다.

기존 타이포그래피 교육을 보면 어떤 타이포그래피가 좋다, 나쁘다, 잘됐다, 잘못됐다고 평가할 때 양적 평가를 적용한다. 반면 크랜브룩에는 이런 종류의 타이포그래피 교육이 아예 없다고 보는 것이 타당하지 않은가? 크랜브룩은 모든 타이포그래피의 잠재력을 인정하는 것으로 보인다. 그런가 하면 대다수의 타이포그래퍼들은 크랜브룩에 내놓는 기치나 결과물에 반감을 가질 수도 있다. 당신의 의견은?

당신의 짐작이 옳다. 그런데 나는 이제 대다수의 타이포그래퍼를 덜 의식해도 괜찮다는 생각이 든다. 전통적인 디자인 교육의 가치는 인정하지만 그것이 나의 관심사는 아니라는 것이다. 나는 기존 디자인 교육 방식의 상당 부분에 비판적인 입장이다. 공격적인 언사를 하고 싶지는 않다. 좀 미묘한 문제인데, 이미 앞에서 언급했는지도 모르겠다. 고전적인 방법론과 훈련 방식에도 상당한 장점이 있음을 안다. 현대인의 삶에 전통 디자인 교육이 기여한 바도 전적으로 인정한다. 그러나 내 눈에는 점점 넓어지는 간극이 보인다. 어쩌면 헨리 데이비드 소로우가 말한 대로, 사람들은 대부분 잠든 상태로 인생을 지나쳐가고 있다는 느낌이 든다. 우리의 가치에 대해 끊임없는 질문을 던져야 옳다. 우리의 교육 체계에 대한 끊임없는 질문도 그로부터 나오는 것이다. 앞서 전하고자 했던 바와 같이 나는 학생들이 스스로 '좋은' 것이 무엇인지에 대해 깊이 있는 자문을 하도록 유도한다. 쉼 없이 그렇게 해야 한다. 그러면 '규범'에 의존할 때와는 다른 결과물들이 나온다. 나는 작업을 하면서 '좋거나 나쁜' 것보다는 힘에 관해 더욱 숙고한다. 내가 운 좋게 오래 살며 줄곧

under Katherine and Michael McCoy. I think one of the most surprising components of my education involved the idea of self-confidence. One of my goals in entering graduate school was to gain self-confidence. I was certain that I would emerge from graduate school a new man, brimming with self-confidence. In the summer between my first and second year of graduate school I was asked to be the best man in the wedding of a good friend. It was assumed that I would give a toast. At this moment I was struck by the sensation that after one year of graduate school, I actually had less self confidence than when I entered school. this sensation stayed with me even after graduation. I point this out because your question rightly inquires about good and bad? We have also discussed that most designers (and maybe even design schools) are hyper-concerned with winning awards. In our studio, the fundamental question of challenging ones' core value system is at play. The net result of this is looking at work that in a previous life you might think was terrible, but now think is amazing. I am always pressing my students to really challenge their thinking regarding what they believe to be good in art and design. We also extrapolate that out in to life.

The punch line to the story however, is that while my initial goal upon entering Cranbrook was to emerge with more confidence. And I was confused by that fact that I seemed to leave graduate school with LESS self-confidence. I came to the profound realization that self-confidence is not a necessary component of making powerful work. This bears repeating and restating. There is a common cultural assumption that confidence is necessary to be good at something. Tested through my own experience, I categorically reject this idea. they are simply two different things. At times they align, and at times they don't. Further I came to the profound realization, that quality stems from, arises out of, commitment to excellence. In other words regardless of how I feel about my work or my abilities, If I am absolutely passionate and committed to the work, the work will evolve towards quality. In subsequent years, confidence in my own abilities has swung wildly between extreme divine arrogance, and pitiful self-doubt. I have learned to simply ignore the entire issue of self-confidence. These issues all come out of a profound questioning of what constitutes 'good' and what constitutes 'bad.' I've personalized this issue, but this in fact the way that I discuss these issues with my students.

성장을 도모한다면 강력한 작품, 즉 삶을 건드리는 작품을 만들어낼 수 있을 거라는 확신이 있다. 학생들과의 작업이 그러기 위해 꼭 필요한 것임을 여실히 느낀다.

당신은 크랜브룩 졸업생들이 온갖 종류를 망라한 그래픽 디자인을 하게 된다고 말한 바 있다. 그래픽 디자인에 대한 기존 정의에는 들어맞지 않는 디자인까지도 말이다. 교육자로서 특별히 당신을 행복하게 하는 졸업생들의 진로나 경로, 혹은 성과가 있는지 궁금하다. 교육자로서 당신의 가장 커다란 고뇌와 과업이 무엇인지를 분명히 보여줄 것 같다. 스스로 '잘했다!'고 말하게 되는 계기는 어떤 것인지?

크랜브룩과 같은 기관에는 학생들의 성패를 가름하는 간단한 리트머스 시험지가 있다는 생각이 든다. 크랜브룩의 강력한 환경은 한 사람을 숭배하도록 유도하기 십상이다. 다시 말해, 15명의 학생들이 상주 아티스트 한 사람의 복제품이 되어버릴 수 있다. 그 경우 그 아티스트와 소그룹은 양쪽 다 처절하게 실패한 것이나 마찬가지다. 한 개인이 자기 삶에 대해 숙고하기를 장려하는 것이 바로 이 인터뷰의 주제 중 하나였다. 자기의 독특한 관점과 재능을 더 깊이 이해하고 강화하는 것. 나는 나 자신의 개인적인 특성들을 학생들과 나누되, "너 자신의 기쁨을 추구하라."라는 조셉 캠밸의 말도 반복적으로 덧붙인다. 나는 자부심으로 가득하다. 학생들 중 누군가가 용기와 확신을 갖고 오롯이 자기만의 길을 나서면 교육자로서 스스로가 잘했다는 생각이 든다.

↗

I try to mentor. I try to draw on my actual lived experience to cut through the crap and be real. I try not to posture and be concerned with looking cool, rather I try to discuss the core turth of the matter as I understand it.

A more traditional typographic education consists of very quantitative assessments about what makes typography good or bad. Right or wrong. But I think it is a safe assessment that this type of typographic education does not exist at Cranbrook? It seems that at Cranbrook, all typography has potential. But it is also safe to say that perhaps a great majority of typographers might be averse to both this thinking and output. Can you speak to this?

Your hypothesis is correct. But i think its fairly clear at this point that I could care less about the majority of typographers. I also think its fair to say that while I acknowledge the value of a traditional education in design, this is not my are of interest. I'm a critic of a considerable portion of the traditional practice of design education. I don't want to strike a strident note. The issue for me is a bit more nuanced that I may have already articulated. I do in fact see considerable merit in classical design methodology and training. I fully acknowledge, the contribution that traditional design education has made to contemporary life. However, I see gaping holes. I see massive problems. And quite possibly like Henry David Thoreau, i feel as if most people sleep walk through life. A ceaseless questioning of our values is in order. A ceaseless questioning of our educational system flows from this. So as I attempted to communicate earlier in our interview, I encourage my students to involve themselves in a deep questioning of what is 'good.' This leads to a restlessness. It leads to a different set of results than when you rely on the 'cannon.' In my own work I'm less concerned with 'good' or 'bad' and more concerned with power. I'm certain that if I am fortunate to live long enough and stay dedicated to growth, that I will make powerful work, work that touches lives. I feel very clearly that my work with my graduate is a critical component of this.

You have mentioned that graduates of Cranbrook go on to potentially do any and all kinds of graphic design. Even design that may not fit under the traditional definitions of graphic design. I am wondering if there is

though any particular path, route or outcome for graduates that really makes you happy as an educator. Something that solidifies your greatest angst and challenges as an educator. Something that makes you say, 'I done good!'

In an institution like Cranbrook I feel like there is a simple litmus test for the success of the students. Cranbrook is a powerful environment that could play to the cult of personality. In other words, there is the potential in each department for the fifteen students to become clones of the Artist-in-Residence. To my mind this would reflect an abject failure of both the system and the Artist-in-Residence. One of the many themes running through this interview is an encouragement for the individual to think deeply about their life. To come to a deeper understanding of their unique perspective and talents and to leverage them. I would hope that while I certainly share some personality traits with my students, my constant refrain is to "follow your bliss." to borrow from Joseph Cambell. I am filled with pride, and feel like I have done a good job when one of my students strikes out on their own path and faces it with courage and commitment!

↗

마리안 반티예스의 그래픽 원더

김희용

김희용 디자인, 한국

Graphic Wonder of Marian Bantjes

Kim Hee-yong

Kim Hee-yong Design, Korea

주제어
마리안 반티예스, 오너먼트, 타이포그래피

Keywords
Marian Bantjes, Ornament, Typography

→

얼마 전 사물놀이와 피아노 협연 공연을 볼 기회가 있었다. 이미 조금은 식상해진 동서양 악기의 만남이었지만, 이번에 본 공연은 뜻밖의 놀라움과 감동을 안겨주었다. 연주가 절정으로 치달으면서 땀범벅이 될 정도로 몸을 사리지 않는 사물놀이패와 피아노의 격정적인 뒤섞임이 음악 이상의 감동 에너지를 뿜어냈다. 이런 '기운'을 일상생활에서 접하기는 쉽지 않다. 더군다나 라이브로 즐기기 어려운 그래픽 디자인 분야는 더욱 그렇다. 하지만 간혹 이런 짜릿한 전율과 기운을 느낄 수 있는 디자인을 접하게 되는데, 마리안 반티예스의 나는 궁금하다가 바로 그런 종류의 그래픽 '에-네-르-기-파!'를 뿜어내는 책이다.

반티예스는 장식적인 타이포그래피를 구심점으로 작업하는 그래픽 아티스트이다. 식자공으로 시작해 디자인 작업을 해오던 그는 오랜 시간 돈보다는 자신이 진정으로 좋아하고 의미 있는 일을 하면서 세간의 주목을 받기 시작했다. 반티예스의 작업은 여러 시대의 다양한 오너먼트를 녹여놓은 용광로 같다. 중세시대 필사본의 화려한 고딕 글자체 일루미네이션을 연상시키기도 하고, 이슬람 미술의 꽃인 아라베스크 문양이나 티베트 불교의 만다라 형상을 보여주기도 한다. 저자의 작업이 특별한 또 한 가지 이유는 (거의) 모든 오너먼트 패턴과 글자를 직접 손으로 그린 다음 디지털화시킨다는 것이다. 이 작업은 대부분의 디자인을 컴퓨터에만 의존하는 요즘 디자이너에게 '손맛'의 중요성을 증명하고 있다. 더불어 저자는 벡터 그래픽뿐 아니라 주변에서 쉽게 찾아볼 수 있는 사물을 사용해서 실험적 타이포그래피 작업을 한다. 꽃과 풀잎으로 만든 포스터나 설탕 알갱이, 키친호일로 만든 타이포그래피 작업들은 저자의 일상이 곧 그래픽 디자인임을 엿볼 수 있다.

이 책은 반티예스의 작품집이 아니다. 나는 궁금하다는 영국 출판사인 탬스 앤드 허드슨에서 2010년 처음 출간되었다. 출판사의 원래 기획 의도는 반티예스의 작업을 수록하는 작품집을 만드는 것이었다. 하지만 반티예스는 작품집보다는 본인이 쓴 에세이와 그와 관련된 디자인 작업으로 단행본을 만들어보자고 역으로 제안했다. 물론 이 책은 새로 만든 '작품'들로 꽉 채워져 있지만, 기존에 만들어진 작품을 소개하는 것이 아니고 저자가 직접 선택한 주제에 대한 전문적인 지식과 방대한 양의 조사를 바탕으로 쓴 그래픽 에세이집이다.

금박과 은박으로 뒤덮인 책의 표지는 곧 펼쳐질 오너먼트 쓰나미를 예고한다. 첫 장만 넘겨봐도 매직아이처럼 눈이 아릴 정도로 강렬한 오너먼트 패턴이 그 모습을 드러낸다. 마치 보물찾기를 하듯 이 복잡하게 연결된 오너먼트 패턴 속에 숨겨둔 메시지가 있는지 찾아보는 재미가 있다. 지면의 배경 장식이나 텍스트 박스의 위치가 윌리엄 모리스의 책을 연상시키기도

Recently, I had an opportunity to watch a collaboration performance. There was not much new about East-West instrumental collaboration, but it gave me unexpected surprise and moved me. As the performance reaches the climax, an explosive mix of sweaty passionate samul nori (a traditional percussion music genre originating in Korea) players and piano gave off moving energy beyond what music can deliver. This kind of 'spirit' is not easy to experience in daily life. Graphic design is even more so, for it can't be enjoyed live. Sometimes, however, there are designs that provide us with such thrilling and energetic experiences. Marin Bantjes' book I Wonder is one of those books that gives off an e-n-e-r-g-y-w-a-v-e!

Bantjes is a graphic artist who concentrates on decorative typography. Bantjes has done design work for a long time as a typesetter and started to receive attention as she began to work for what she likes and what is meaningful to her. Her work is like a furnace into which diverse ornaments from different ages are melted. Her work is suggestive of splendid Gothic handwriting, Illumination, in the Middle Ages, and also shows the flower of Islamic arts, Arabesque pattern or the Mandala of Tibetan Buddhism. What is also special about Bantjes work is that (almost) all ornament patterns and texts are written by hand first and then digitalized. Her work manifests the importance of 'taste of handwork' to today's designers who heavily depend on computers for most of design. Also, besides vector graphics, the author does experimental typography work using objects easily found around us. Posters made of flowers and leaves or typography works made of sugar grains and aluminum foil suggest her everyday life is also her graphic design.

This book is not Bantjes' monograph. I wonder was first published by the UK publisher Thames & Hudson in 2010. They initially wanted to make a monograph, a collection of Bantjes' works. Bantjes, however, suggested the publisher that they put together her essays and relative design works in a book. The book is certainly filled with the designer's new works. And yet, it doesn't just include existing works. It is a collection of graphic essays the author wrote based on expert knowledge and a vast amount of research on subjects she personally selected.

The cover of the book coated with gold and silver is a prelude to an ornament tsunami about to unfold, and when you just flip the first page,

번역: 임유나 Translation: Im Yoona

사진: 박기수 Photography: Park Ki-su

마리안 반테예스, I Wonder, 탬스 앤드 허드슨, 2010, 양장, 208쪽, 155 x 240 mm, 821 g, ISBN 978-0500515297
Marian Bantjes. I Wonder. Thames & Hudson, 2010, 208 pages, 155 x 240 mm, 821 g, ISBN 978-0500515297

한다. 실제로 저자는 윌리엄 모리스와 존 러스킨의 말을 자주 인용한다. 본문의 지면을 구성하는 텍스트는 배경 오너먼트 이미지와 긴밀하게 연결되어 있다. '명예'의 다양한 파스타 면으로 만든 오너먼트 이미지는 화려한 장식으로 꾸며진 바로크 시대의 액자 같다. "우리는 우리에게 소중하고 의미 있는 이미지(또는 글)를 액자에 담는다."라고 주장하는 저자의 의견을 잘 표현하는 대목이다. 더군다나 이 파스타 오너먼트가 컴퓨터의 도움을 받지 않고 만든 실제 장면이라는 점이 놀랍다. 조그만 파스타 조각들을 정렬, 배치하는 데만 엄청난 시간과 에너지를 쏟았을 것을 생각하면 숭고한 장인의 숨결이 느껴진다.

본문은 경이, 명예, 기억, 세 개의 장으로 구성되어 있다. '경이'에서는 아리스토텔레스의 철학부터 중세교회 예술의 역할, 모더니즘 등 역사 전반에 걸쳐 경이로움에 대한 내용을 저자의 생각을 통해 풀어나간다. 종교, 기술, 과학, 정신문화의 발전은 경이로움, 궁금증 없이는 이뤄내기 힘들었을 것이라고 주장한다. 저자 본인이 평소 관심 있었던 분야에 대한 이야기이지만 두 장의 내용이 다소 딱딱하게 느껴질 수 있는 점이 아쉽다. 하지만 마지막 장인 '기억'에서 저자 본인의 가족사와 기억들을 더듬는 부분은 가벼운 수필집을 읽는 느낌이다. 마치 딱딱한 바게트 속에 들어 있는 크림치즈와 같이, 사뭇 진지했던 '경이'와 '명예'에 비해 말랑한 톤으로 사람들의 '추억'에 대한 내용을 자신의 가족사와 빗대어 설명하고 있다. 다만 책 전반에 걸쳐 텍스트와 밀접한 관계를 유지하던 배경 오너먼트가 이 부분에서는 그 연관성이 다소 시들해 보이는 점이 아쉽다.

세 개의 큰 주제 외에 짧은 이야기가 중간중간 구성되어 있는데, 이는 다소 무거울 수 있는 메인 주제를 완화하는 역할을 한다. '비밀'이란 장에서는 반티예스가 개인적으로 만든 시크릿과 사이퍼라는 폰트로 문장을 만들었다. 몇 번 시도해봤지만, 아직 끝까지 읽을 수 없었다. 말 그대로 '비밀'인 것이다. 글자란 재료를 가지고 실험을 하다 보면 가독성이 문제가 될 때가 있는데, 반티예스는 여기서 그 가독성을 극한으로 몰아넣고 있다. 개인적으로 가장 인상 깊었던 부분은 '두 개의 이케아 책장 조립하기'이다. 이케아 책장을 조립하는 과정을 재미있게 표현하고 있다. 글을 따라 읽다 보면 안구가 육각 스패너로 변해서 문장들을 돌리면서 조이고 있는 느낌이다. 이야기는 책장을 조립하기에 앞서 필요한 공구를 찾는 것부터 시작하고 있지만, 간단하게 생각되는 이케아 가구 조립이 결코 '간단'하지 않다는 것을 역설적으로 보여준다.

이 책에는 기본적으로 저자가 직접 만든 커스텀 글자체와 오너먼트로 구성되어 있다. 하지만 장마다 각기 다른 본문 글자체를 사용한 부분이 다소 어색하다. 물론

a stingingly intense ornament pattern like a magic eye appears. It is fun to search for a message hidden in this intricately connected pattern as if to play treasure hunt. The book's background decorations and location of text boxes bring to mind William Morris' book and actually, the author often quotes William Morris and John Ruskin. Texts in the book are closely connected to the images of background ornaments. The ornament image made of various pasta noodles in the 'Honor' chapter looks like a glamorously decorated frame from the Baroque era. "We put into a frame images (or writings) precious and meaningful to us," she says. Moreover, it is surprising this pasta ornament is an actual picture with no computer assistance. Thinking of aligning and arranging small pieces of pasta, which must have required tremendous time and energy, the touch of a novel craftsman is felt.

I Wonder has three chapters: Wonder, Honor, and Memory. In 'Wonder', the author tells her thoughts on wonders throughout history from Aristotle's philosophy to the role of medieval church arts and to modernism. She says developments in religion, technology, science, and moral culture wouldn't have been possible without wonders and curiosity. Though the author talks about her fields of interest, the first two chapters might come across as somewhat dry. The last chapter 'Memory' in which she reminisces about her family and memories, however, feels like a light essay. Compared with the quite serious 'Wonder' and 'Honor' chapters, she explains 'Memory' based on her family history in a soft tone like cream cheese on a baguette. Unfortunately, however, the close connection between texts and background ornaments that has been consistent throughout the book is somewhat lost here.

Between the three big subjects, short stories are placed to lighten main subjects that could feel more or less heavy. In the 'Secret' chapter, sentences are written in fonts called Secrets and Cipher that Bantjes created and I have tried to read them but without success. They are literally 'secrets'. When experimenting with words, readability sometimes becomes an issue. And Bantjes pushes this readability to extremes. Personally, the most impressive part was 'Assembling two IKEA bookshelves'. She explains the process of assembling bookshelves in a very interesting way and as you read it, it feels like the eyeballs turn into a hexagon spanner tightening up sentences. The story begins at finding necessary tools before assembling a bookshelf, but ironically

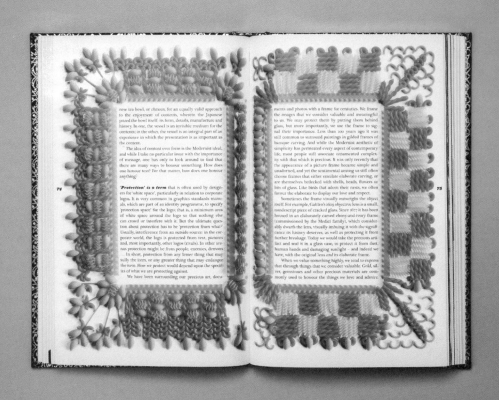

new tea bowl, or *chawan*, for an equally valid approach to the enjoyment of contents, wherein the Japanese prized the bowl itself: its form, details, manufacture and history. In one, the vessel is an invisible medium for the contents; in the other, the vessel is an integral part of an experience in which the presentation is as important as the content.

The idea of content over form is the Modernist ideal, and while I take no particular issue with the importance of message, one has only to look around to find that there are many ways to honour something. How does one honour text? For that matter, how does one honour anything?

'Protection' is a term that is often used by designers for 'white space', particularly in relation to corporate logos. It is very common in graphics standards manuals, which are part of an identity programme, to specify 'protection space' for the logo; that is, a minimum area of white space around the logo so that nothing else can crowd or interfere with it. But the ultimate question about protection has to be 'protection from what?' Usually, interference from an outside source: in the corporate world, the logo is protected from text, pictures and, most importantly, other logos (rivals). In other arenas protection might be from people, enemies, demons. In short, protection from any lesser thing that may sully the item, or any greater thing that may endanger the item. How we protect would depend upon the specifics of what we are protecting against.

We have been surrounding our precious art, docu-

ments and photos with a frame for centuries. We frame the images that we consider valuable and meaningful to us. We may protect them by putting them behind glass, but more importantly, we use the frame to signal their importance. Less than 100 years ago it was still common to surround paintings in gilded frames of baroque carving. And while the Modernist aesthetic of simplicity has permeated every aspect of contemporary life, most people still associate unornamented complexity with that which is precious. It was only recently that the appearance of a picture frame became simple and unadorned, and yet the sentimental among us still often choose frames that either emulate elaborate carving, or are themselves bedecked with shells, beads, flowers or bits of glass. Like birds that adorn their nests, we often favour the elaborate to display our love and respect.

Sometimes the frame visually outweighs the object itself. For example, Galileo's 1610 objective lens is a small, nondescript piece of cracked glass. Since 1677 it has been housed in an elaborately carved ebony-and-ivory frame (commissioned by the Medici family), which considerably dwarfs the lens, visually imbuing it with the significance its history deserves, as well as protecting it from further breakage. Today we would take the precious artifact and seal it in a glass case, to protect it from dust, human hands and damaging sunlight – and indeed we have, with the original lens *and* its elaborate frame.

When we value something highly, we tend to express that through things that we consider valuable. Gold, silver, gemstones and other precious materials are commonly used to honour the things we love and admire.

www.thamesandhudson.com £19.95
ISBN 978-0-500-51529-7
Thames & Hudson

각 장이 전달하고자 하는 내용의 성격을 반영한다지만 전체적인 구성으로 봤을 때는 조금 산만하고 통일성이 떨어진다. 이미 탄탄한 스토리와 멋진 타이포그래픽 오너먼트로 꾸며진 책인데 굳이 본문 텍스트를 장마다 다른 글자체를 사용할 필요가 있었을까 고민해본다. 특히 눈에 거슬렸던 부분은 세리아 이탤릭(디자인: 마르틴 마요르)이 어센더와 디센더가 긴 글자체임에도 글줄사이가 좁아서 위아래 알파벳이 붙는 현상이다. 이는 전체 문단을 세로로 끊어 읽는 흐름을 방해하고 있다. 글줄사이를 조절한다거나 글자체 선택에 조금 더 신경을 썼다면 더 완벽한 책이 되지 않았을까.

전체적으로 나는 궁금하다가 주는 시각적 즐거움은 대단하다. 글재주가 뛰어난 저자의 에세이를 읽다 보면, 이 책을 디자인 서적으로 분류해야 할지 수필집으로 분류해야 할지 망설여질 정도로 그 콘텐츠가 탄탄하다. 저자의 예술적, 지적 능력과 열정이 부럽기만 하다. 언제 어디서나 월드와이드웹에 연결된 세상에서 동시대 디자인 흐름에 영향을 받지 않기란 무척 힘든 일이지만, 특정 디자인 스타일이 유행했다가 금세 사라지는 한국에서 자기만의 오리지널리티와 줏대를 고집하는 디자이너가 더 많아졌으면 하는 바람이다. 이런 고집 있는 디자이너를 요구하고 수용할 수 있는 사회가 되기에는 조금 더 시간이 걸리겠지만, 언젠가 한국에도 마리안 반티예스 같은 개성 있는 그래픽 아티스트가 넘쳐나기를 기대한다.

"'나는 궁금하다.'라고 말하는 것은 '나는 질문한다.'라고 말하는 것과 같다. 사고를 가동한다. 때로는 해답을 찾지만, 때로는 찾지 못한다. 우리는 앞으로 나아가고 성숙해지기 위해 궁금해야만 한다. 이 세상에 존재하기 위해. 궁금해한다는 것은 우리에게 의미를 부여하고, 결론적으로 우리를 인간으로 완성한다." —마리안 반티예스, 나는 궁금하다, 30쪽

↗

shows assembling IKEA furniture is not really as 'simple' as it seems.

This book basically consists of custom typography and ornaments. But the use of different fonts for each chapter is somewhat strange. They reflect characters of each chapter, but the overall construction feels a bit discursive and lacks unity. I wonder why she used a different font for every chapter when the book already has strong stories and fine typographic ornaments. What was especially annoying is that although Seria Italic(designed by Martin Majoor) is a font with long ascenders and descenders, the alphabets are stuck to each other because of narrow spacing. This vertically cuts the whole paragraph, disrupting the flow of reading. It would have been a more perfect book if the adjustment of spacing and fonts were more carefully selected.

Overall, I Wonder is a great visual delight. Reading the talented writer's essays, you would find the contents are so firmly constructed that it is hard to say if the book should be classified as a design book or an essay collection. I'm just envious of the author's artistic and intellectual ability and passion. In a world connected to the World Wide Web, it is difficult not to be influenced by design trends of the age, but in Korea where a certain design style becomes a fashion and quickly disappears, I hope there will be more designers who stick to originality and principles. While it would take some time to see a society that needs and accepts these persistent designers, I look forward to seeing an overflow of graphic artists with individuality like Marian Bantjes.

"To say 'I wonder' is to say 'I question; I ask.' The mind seeks. Sometimes it find answers, sometimes it does not. We need wonder in order to keep moving and growing – to stay alive to the world. It give us meaning, and, in fact, makes us human." —Marian Bantjes, I Wonder, p. 30

↗

여기 한 권의 책이 있다 Here is a book

전가경 Kay Jun
사월의눈, 한국 Aprilsnow Press, Korea

주제어 **Keywords**
북 디자인, 출판, 제안들, 주어캄프 타쉔부흐 Book design, Publishing, Suhrkamp Taschenbuch, Propositions

→

1

여기 한 권의 책이 있다. 상단과 하단을 나누는 명쾌한
면 분할. 시선을 하단으로 강하게 이끄는 견명조의
글자들. 그리고 띠지라고 부를지, 혹은 상반신을
벗어던진 과감한 재킷이라고 부를지, 그 위에 단단하게
박힌 익숙한 이름과 제목. 프란츠 카프카. 꿈. 시선을 조금
옆으로 옮기니, 붉은색 그리고 초록색. 약간 채도가 낮은
이 색들이 중후한 분위기를 뿜낸다. 그리고 이어지는
범상치 않은 이름들의 나열들. 조르주 바타유, 불가능,
토머스 드 퀸시, 예술 분과로서의 살인. 이 책들을 본
나는 이 여섯 개의 고유명사에 압도당했다고 고백해야
할 것이다.

2

고유명사가 풍기는 아우라라고 이름 붙여야 할까.
유년 시절 나의 눈과 손을 자극했던 독일의 주어캄프
출판사의 타셴부흐가 그랬다. 굵은 타임 로만체로
인쇄된 독일 문인들의 이름이 박힌 그 표지의 자태는
독일어라는 언어가 주는 장벽을 훌쩍 넘어서 구매욕을
불러일으킬 만큼 기품 있고 아름다웠다. 아직도 선명하게
기억한다. 취리히 시내, 일종의 환승 공간이기도 했던
파라데플라츠의 어느 골목에 자리했던 서점 오렐퓨슬리.
그 서점 한쪽에는 주어캄프 책들이 한 벽면을 가득
채우고 있었고, 난 그 앞에 서서 여러 책등이 모여 만든
시각적 만찬에 역사적인 회화 작품을 감상하듯이 서
있었다. 십대였기에 호주머니는 가벼웠고 당연히
책의 구매는 매우 신중해야만 했다. 아주 조심스럽게,
관심 가는 작가들만 한두 권씩 사모았다. 헤르만 헤세,
잉게보르크 바흐만, 막스 프리쉬, 베르톨트 브레히트. 난
그 작가를 소유할 수 있다는 문학적 포만감에 나른하게
행복했고, 그 작가명이 앉혀진 표지와 판형이 주는
아늑한 착용감에 은근히 뿌듯했다.

3

책을 디자인한 김형진은 말한다. "결론적으로, 사서 갖고
싶은 책을 만들고 싶었습니다. 편집자는 읽고 싶은 책을
만드는 거고, 디자이너는 갖고 싶은 책을 만드는 거죠.
책을 단지 텍스트 덩어리만으로 파악하지 않는다면
이런 식의 구분이 지어지는 건 너무 당연한 것이죠. 책은
어떤 특정한 폼을 지닌 텍스트 덩어리죠. 저는 그 폼에
관여하는 방식으로 제안들이 누군가에게 갖고 싶은 책이
되길 바랐습니다. 안 읽어도 상관없어요. 책을 단지 읽기
위해 사나요?" 편집자와 디자이너의 어떤 감식안이나
취향을 명확하게 구분하는 그의 태도에는 공감할 순
없어도 '단지 읽기 위해 사나요?'라는 그의 반문에는
동감한다. 나도 상당히 많은 책들을 예쁘다는 이유만으로
손에 쥐고야 말았고, 그중 일부는 여전히 책장에 들어가

1

Here is a book. A clear line that divides the top
and the bottom. Fonts that powerfully catch your
eyes towards the bottom. And a familiar name
and some title firmly engraved on something like
a band or daring jacket that threw off the top.
Franz Kafka. Dream. Now move your eyes slightly
to the side. Red, green, and slightly desaturated
colors boast a stately atmosphere. And then, a
parade of remarkable names. Georges Bataille,
The Impossible, Thomas de Quincey, On Murder
Considered as one of the Fine Arts. On first
impressions, I have to confess as someone who
encountered these books, I was swept over by the
six proper nouns.

2

Should I call it an aura that proper nouns have?
German publisher Suhrkamp's Taschenbuch, a
stimulus to my eyes and hands in my childhood,
was like that. The cover on which names of
German writers were engraved in bold Times
Roman was graceful and beautiful enough to
induce me to buy it despite the language barrier. I
still vividly remember. In downtown Zurich, when
you walk into an alley from Paradeplatz, which
used to be a transfer center, there is a bookstore
called Orell Füssli. One corner of the store was
filled with books from Suhrkamp and I was
standing before the visual banquet of the backs of
many books as though I was appreciating a historic
painting. Since I was a teenager, I didn't have much
money and had to be very conservative in buying
books. Very carefully, I collected one or two books
by authors I was interested in. Herman Hesse,
Ingeborg Bachmann, Max Frisch, Bertolt Brecht. I
was languidly happy with literary satisfaction of
owning those names, and felt quite good about the
cozy feeling the book cover on which the author's
name sits and its format provided.

3

The book designer Kim Hyung-jin says, "Ultimately,
I wanted to make a book readers want to buy and
own. Editors make books people want to read and
designers make books people want to own. If you
don't regard a book as a mere chunk of texts, this
kind of distinction is so obvious. As a way to be
involved in that form, I wanted Propositions to be
a book someone wants to own. It doesn't matter
if they didn't read. Do we buy books just for the
purpose of reading?" I might not agree with his
attitude of drawing a clear line between an artistic

번역: 임유나 Translation: Im Yoona

사진: 박기수 Photography: Park Ki-su

프란츠
카프카 —
꿈

제안들 1　　　　　　　배수아 옮김

프란츠 카프카, 꿈, 배수아 옮김, 워크룸 프레스, 2014, 양장, 200 쪽, 175 x 110 mm, 280 g, ISBN 978-8994297346
Franz Kafka, Dream, Bae Su-ah trans.. Workroom Press, 2014, Hardcover, 200 pages, 110 x 175 mm, 280 g, ISBN 978-8994297346

있다. 그런 의미에서, 제안들 디자인은 성공했다. 구매욕을 자극하는 시각적 쾌감 때문이다.

4

그런데 과연 책 디자인은 '예쁘게 보이기'란 심미적 기능에서 끝나고 마는 것일까? 다시 나의 추억담이자 경험담을 꺼내본다. 내가 만난 예쁜 책들, 그래서 갖게 된 책들이 지닌 하나의 공통점은 어떻게든 그 책을 읽게 만들었다는 사실이다. 스위스에서 중고등학교를 다닐 때 보았던 교과서들의 세련된 편집과 디자인은 공부 의욕을 불러일으켰다. 조지 오웰의 <u>1984</u>를 영어로 읽었던 고등학교 2학년 때도 그랬다. 난 순전히 그 책의 디자인과 꼴이 마음에 들어서 영어와 싸워보고 싶었다. 주어캄프가 선보이는 독일 대문호들의 존재감에는 주눅이 들었지만 그 책들을 살 수밖에 없었던 것은 이 잘난 디자인이 포장하고 있는 텍스트의 비밀을 캐내고 싶었던 것이다. 일어 한 조각도 모르는 내가 얼마 전 일본 잡지를 산 이유도 수려한 편집과 디자인에 매혹당한 채 언젠가는 내용을 해독해내리라는 다짐 때문이었다. 어쨌든 나에게 적어도 좋은 책디자인은 구매욕을 불러일으키는 멋스러운 자태에서 끝나는 것이 아니라 읽기라는 행위로 나아가게끔 만드는 자극제라는, 다소 거룩한 기능도 한다는 사실이다.

5

물론 우리는 안다. 표지가 후져도, 본문 조판이 엉망이어도 읽어야 하는 내용이라면 결국 읽고 만다는 것을. 나에겐 까치출판사의 책들이 그러했고, 눈빛출판사의 사진 이론서들이 그러했다. 민음사에서 나온 박완서의 나목도 읽는 내내 도무지 굽혀질 줄 모르는 딱딱한 책등을 심하게 불평하면서 결국엔 끝까지 읽고야 말았다. 텍스트와 작가의 힘이 완독의 원동력이 되었던 것이다. <u>제안들</u>은 이 원동력을 갖춰버렸다.

6

알 듯 모를 듯, 문학에 그나마 식견이 있는 사람이나 알 법한 애매모호한 고유명사들의 향연. 이 책이 크게 주목을 받았다면 그중 절반은 이 고유명사들이 내뿜은 기묘한 아우라에 있다고 말하고 싶다. 그런데 그 기묘한 아우라가 너무나 명쾌한 디자인과 만나버렸다. 견명조의 큼직한 글자들로 꽝꽝 박힘으로써 보이지 않는 아우라가 모습을 명확하게 드러내버린 것이다. 두 가지 상이한 요소들의 합작품은 그래서 시선을 끌 수밖에 없다. 보이지 않는 어떤 기운으로서의 아우라를 벌거벗은 문자의 힘으로 정박시켜버렸기 때문이다.

eye or taste of editors and those of a designer. But I agree with him asking back "Do we buy books just for the purpose of reading?" I have owned quite many books just because they are pretty and some of them are still in the bookshelf. In this sense, the design of <u>Propositions</u> is successful. It has a visual delight which induces people to buy.

4

But, the aesthetic function of 'looking pretty' is the only purpose of a book design? I, again, look back on my memory and experience. Those pretty books I encountered, and therefore, I owned have one thing in common; they somehow made me read them. When I was in middle and high school in Switzerland, classily edited and designed school books boosted my motivation to study. As I was reading George Orwell's <u>1984</u> in English during my second year in high school, I wanted to throw down the gauntlet to English only because I liked the design and form of the book. While I was overwhelmed by German writers of great literature presented by Suhrkamp, I couldn't help but purchase them because I wanted to dig out the secrets of texts wrapped in such a nice design. The reason why I bought a Japanese magazine in Taiwan although I knew no Japanese was also because, fascinated by the fine editing and design, I was determined to decode the context someday. Anyway, at least for me, a good book design doesn't end at a fancy looking to increase purchasing needs, but works as a stimulus to make people read, quite a divine function, which is not what the designers intend.

5

Of course, we know that regardless of poor covers or messy typesetting, if the context is a must-read, we will read them eventually. For me, books from Kachi Publishing and photography theory books from Noonbit Publishing were such books. Park Wan-suh's novel <u>The Naked Tree</u> from Minumsa was another book I read from cover to cover even while I was complaining so much about the inflexible back-strip of the book. The power of the text and author was the driving force. And <u>Propositions</u> also has achieved this power.

6

A parade of puzzling, vague proper nouns that only people with some knowledge on literature would recognize. If this book has drawn much attention, I would say it is because of this eccentric aura these

잠, 깨어남 그리고 꿈에 관하여

잠 없는 밤. 벌써 사흘째나 이어지는 중이다. 잠이 쉽게 들지만, 한 시간 후쯤, 마치 머리를 잘못된 구멍에 갖다 넌 것처럼 잠이 깨버린다. (…) 이제부터 대략 새벽 5시까지, 밤새도록, 비록 잠이 든다 해도 너무나 강력한 꿈에 사로잡힌 나머지 동시에 의식이 깨어 있을 수밖에 없는, 그런 상태가 계속된다. 형식적으로야 내 육신과 나란히 누워서 잠을 자는 것이긴 하지만, 그러나 사실은 그동안 꿈으로 나 자신을 쉴 새 없이 두들겨대야만 하는 것이다. 5시 무렵, 최후의 잠 한 조각까지도 모두 소진되어 버리고 나면, 그때부터는 오직 꿈을 꿀 뿐이다. 그것은 깨어 있는 것보다 더욱 힘들다. 나는 밤새도록, 건강한 사람이라면 잠들기 직전에 잠시 느끼는 그런 혼몽한 상태를 유지하게 된다. 잠에서 깨어나면 모든 꿈들이 내 주변에 모여 있다. 그러나 나는 그 꿈들을 기억해내지 않으려 애쓴다.

일기, 1911. 10. 2. KKAT 49f.

잠이 들기에 유리하다고 생각되는 조건은 최대한 무거워지는 것이다. 그러기 위하여 나는 팔짱을 낀 후 두 손을 양 어깨에 올렸다. 그렇게 상자 속에 포장된 군인처럼 나는 침대에 누웠다. 그러자 다시금 꿈은, 잠이 들기도 전에 깨어 있는 나의 의식으로 침입해 들어왔고, 나는 잠을 이

27

7

아마도 그저 그런 이름들의 나열이었다면 독자를 사로잡는 힘은 한결 더 약했을 것이다. 샐린저, 호밀밭의 파수꾼, 스콧피츠 제럴드, 위대한 개츠비, 괴테, 젊은 베르테르의 슬픔 등의 조합이었다면 제안들의 표지 디자인이 갖는 매력은 반감되었을 것이 분명하다. 제아무리 카프카라고 한들 그것이 변신이 아닌 꿈이어서 다행이다. 제안들의 매력은 이렇듯 낯설고도 친숙함 사이를 배회하는 이질적 조합에 있다. 편집자 김뉘연 씨의 세밀한 탐색이 밑바탕이 된 사색적인 조합. "제안들은 은밀한 작가들과 작품들을 택하는 데에서 시작되었다. 어떤 이(들)에게 책장 깊숙이 꽂아두고 싶은 제목들이 될 이 책들은 비밀한, 자연히 남다른 목록을 이룬다. 다분히 개인적인 선택에서 출발한 이 총서가 시대가 요구하는 취향에 온전히 부합하기란 요원할 수 있다. 제안들은 다만, 어떤 선택이다."라는 보도자료의 이 알쏭달쏭한 내용은 제안들의 모습 만큼이나 매혹적이다.

8

나에게 제안들은 이렇게 정리된다. 고유명사의 이질적 조합의 힘이라고, 기획의 힘이 아니더라면 김형진 디자이너의 명쾌한 디자인도 절반의 성공에 불과했을 것이다. 예뻤을지는 몰라도 한 권, 한 권을 기다리게 만드는 어떤 초조함을 배양해내진 못했을 것이다. 그런데 이 단단한 기획물에 멋진 디자인이 합세했으니, 그 힘은 두 배로 강렬할 수밖에 없다. 독자에게 소유에서 끝나는 것이 아닌 독서라는 행위로 이끌고가는 원동력의 빌미를 제공한 것이다. "표지의 요소들이 지니는 현대성은 곧 작가들이 지니는 현대적인 요소에 부합해야 한다."라는 1960년대 주어캄프 출판사의 비전이 지금 이곳 한국에서 실현되고 있다고 말한다면 누구는 과찬이라고 할지 모른다. 하지만 나에겐 과찬이 아닌, 지금 한국의 어느 한 출판사에 대한 가장 적절한 평가라고 감히 말하고 싶다.

제안들은 기존 재탕, 삼탕의 문학전집의 편집과 기획, 나아가 디자인에 가하는 시원한 어퍼컷이다. 그동안 나는 디자인이라는 새옷만 말끔하게 입히면 빛이 절로 발할 것이라는 출판계의 매너리즘에 불쾌를 넘어 최소한의 반응조차도 낭비라는 심정이었다. "솔직히 제안들은 상업적으로 본전이면 다행이라고 생각하고 있습니다. 하지만 5-6년 뒤에 완간됐을 때를 생각하면 벌써부터 기대가 됩니다. 근사할 것 같아요."라는 박활성 편집자의 희망 섞인 고백에서 애초 이 기획물이 하나의 어려운 도전이었음을 읽게 된다. 난 그 도전이 멋지고 반가웠고 고마웠다.

9

시각적 쾌락은 순간일 뿐이고 그것은 서가에 들어가는

proper nouns give off. And this eccentric aura has met such a clever design. Embedded in large Gyeonmyeongjo font, the invisible aura has come to clearly show itself. This combination of two very different elements is bound to draw attention because it has anchored an aura as a certain spirit with the power of bare letters.

7

If there had been just a list of mediocre titles and authors, it wouldn't have had that power to capture readers' heart. If it had been just a collection of 'Salinger', The Catcher in the Rye, 'Scott Fitzgerald', The Great Gatsby, 'Goethe', The Sorrows of Young Werther and etc., half of the charm of Propositions cover design would have been lost for sure. Even for the coolest Kafka I am glad it is Dream not The Metamorphosis. Thus, Propositions appeal lies in this disparate mix, wandering between strangeness and familiarity. A reflective collection constructed on editor Kim Nwi-yeon's delicate exploration. "Propositions began from selecting hidden authors and works. These books and titles some people would want to keep deep inside their bookshelf make a secret, naturally unique list. There may be a long way to go for this series, which started based on quite personal choices, to adapt to the needs of this age. But Propositions is a certain choice." This puzzling remark from the press release is just as enticing as Propositions itself.

8

For me, Propositions comes down to the power of a heterogeneous combination of proper nouns. In other words, if it weren't for the power of planning, designer Kim Hyung-jin's clever design would be a half success. It might have looked pretty, but wouldn't have created some kind of jitters about waiting for the next issues. And now that this strong project is backed by a cool design, its power is twice as strong. It has the power to drive readers to read beyond just owning a book. If Suhrkamp's vision in the 1960s that "The modernity in the cover's elements should coincide with the author's modern elements" is being realized right now in Korea, some might say it is an overstatement. But I dare to say it is the most proper evaluation for one Korean publisher right now.

Propositions is a cool uppercut not only to editing and planning of literature collections that keep rehashing the past but also to design. In fact, I have been displeased about the publishing

"잠 없는 밤. (…)
잠에서 깨어나면
모든 꿈들이
내 주변에 모여 있다.
그러나 나는
그 꿈들을 기억해내지
않으려 애쓴다."

13,000원
ISBN 978-89-94207-34-6 04800
978-89-94207-33-9 (세트)

순간 시간에 묻혀버린다. 쾌감은 밤의 시간일 뿐, 낮까지 지속되지 못한다. 제안들은 시각적 쾌감을 지속가능한 무엇으로 만들어버렸다. 이제 시작이지만. 어떤 독자는 이 총서의 쾌감을 계속해 맛보기 위해 밤을 연장시켜야 할지 모른다. 그것은 즐거운 연장이다. 이미 또 시작된 연장.

0

여기 한 권의 책이 있다. 상단과 하단을 나누는 명쾌한 면 분할. 하단으로 시선을 강하게 이끄는 견명조의 글자들. 그리고 띠지라고 부를지, 혹은 상반신을 벗어던진 과감한 재킷이라고 부를지, 그 위에 단단하게 박힌 낯선 이름과 익숙한 이름을 담은 제목. 나탈리 레제. 사뮈엘 베케트의 말 없는 삶. 여기 또 한 권의 책이 있다.

↗

industry's mannerism that dressing new clothes called design will automatically make things shine and I have thought even the minimum response is a waste. "Frankly, we'll be lucky to get our money's worth out of Propositions, but I look forward to five or six years from now when the collection will be completed. It will be wonderful." Editor Park Hwal-seong's hopeful confession suggests this project was a tough challenge from the start. And I am glad and grateful about this challenge.

9

Visual pleasures are only momentary. The minute they are placed in the bookshelves, they are buried in time. Pleasures only belong to the hours of darkness and do not last until hours of light. Fortunately, Propositions has turned those visual pleasures into something that can last. It's just the beginning. But some readers may have to extend their nights in order to savor the pleasure of this series. And that is quite a pleasant extension. An extension that has already begun.

0

Here is a book. A clear line that divides the top and the bottom. Fonts that powerfully catch your eyes towards the bottom. And a strange name and title with some familiar names firmly engraved on something like a band or daring jacket that threw off the top. Nathalie Léger. Les Vies silencieuses de Samuel Beckett. Again, here is another book.

↗

글꼴에 내려진 지령, 읽히려거든 보이지 마라!

유지원

타이포그래피 연구자, 한국

To be readable, don't be visible, you typefaces.

Yu Jiwon

Typography Resercher, Korea

주제어
읽기, 글자체, 텍스트, 책, 네덜란드

→

Keywords
Reading, Typeface, Text, Book, Netherland

깨끗하고 따뜻하면서도 장난기 어린 인상을 가진 백발의 네덜란드 할아버지가 당신 앞에 와서 앉았다. 날씬하고 곧은 체격에, 편안하면서도 적당히 격을 갖춘 화사한 수트를 말끔하게 입었다. 길게 뻗은 하얀 속눈썹과 입매가 새침하다. 이 책의 저자, 네덜란드의 활자 디자이너 헤라르트 윙어르 선생이다.

당신이 '읽는' 동안

화창한 날, 맑은 하늘에는 구름이 펼쳐져 있다. 윙어르 씨는 강의실의 교탁 앞에 설 생각이 없는 듯 보인다. 이것은 사람들이 글자를 지루하게 여기도록 만들, 효과가 제법 검증된 방법이라는 사실을 그가 모를 리 없다. 대신 그는 야외의 테이블에서 음료 한 잔을 놓고 당신과 마주앉았다. 그러고는 이야기를 조곤조곤 풀어놓는다. 40여년 가까이 활자 디자인을 해오며 독자들의 읽기 경험을 아늑하게 향상시키려 노력했던 고민의 여정들을.

하늘에 구름이 펼쳐져 있다. 글라이더 조종사는 반드시 적운 형태의 구름을 '읽을' 줄 알아야 한다고 한다. 적운이 조종사를 더 오래, 더 높이, 더 멀리 날 수 있게 해줄 더운 공기가 어디로 올라가는지 알려주기 때문이다. 그런데 구름을 읽는 것도 '읽기'라고 할 수 있을까? 읽기는 실로 폭넓은 행동을 포괄하고 다양한 심상을 환기시키며, 눈과 뇌가 다층적이고 복잡한 작용을 수행하도록 한다. 자, 여기까지 읽는 동안 당신은 어떤 이미지를 상상했을 수도 있고, 읽는 행위의 범위를 헤아렸을 수도 있다. 반면 글자의 형태를 인지하고 그 형태에 담긴 의도까지 읽어낸 독자는 극히 드물 것이다.

긴 텍스트에 적용되는 글자의 형태는 독자의 읽기 과정과 어떤 상호작용을 가질까? 본문용 활자 디자이너와 본문 타이포그래피 디자이너들이 늘 당면하는 질문이다. 이 책은 이런 질문을 다룬다. 그러나 이 책을 꼼꼼히 정독하고 난 뒤 책장을 덮고서 자문해보자. 당신이 읽는 동안 무슨 일이 일어났는지 답하기 어렵다. 책이 정답을 말하고 있지 않기 때문이다. 단순한 답을 내리기에는 헤아려야 할 변수가 너무나 많다는 사실이야말로 이 책이 주는 교훈이다.

독자에게 쾌적하고 효율적인 독서 경험을 제공하기 위해 활자 디자이너들은 다음의 변수들을 일일이 헤아린다. 숨가쁘지만 이 책이 다루는 영역들을 모조리 짚어보자. 역사 속 활자 디자이너들의 상충하는 주장들과 공헌들, 각종 경험적 일반론들의 타당성과 부당함, 독서 행위가 일으키는 서정적인 마법, 보기와 읽기의 경계, 눈과

↓
이 글은 인터넷 서평 매체 프레시안 북스 (pressian.com/ books) 139호에 게재되었던 것을 일부 수정한 것입니다. This article is a re-written version of a previous article posted on the Internet book review site Pressian Books issue 139 (pressian.com/ books)

A grey-haired Dutch old man is sitting in front of you. You are firstly impressed with the clean, sweet, and playful expressions on his face. Then you can notice he has a slim and straight physique and wears a comfortable but neat and also sensible suite. He has long, stretched grey eyelashes and subtle spoken pauses of lips. Yes, this man is Gerard Unger(1942-), a Dutch type designer, the author of this book.

While You're 'Reading'

One fine day, clouds stretch across the clear sky. Unger, it seems, does not want to stand at the podium in a lecture room. He certainly knows that this manner of lecturing is a proven way to make learning about types a real bore. Instead, he chooses to sit facing you across the table with a drink in the open air. Only then does Unger talk calmly and orderly about his long arduous journey where he has designed types nearly 40 years to make reading experiences comfortable and convenient for all of the readers.

Clouds float in the sky. To glider pilots, it is essential to be able to 'read' cumulus clouds because the clouds tell you where warm air is rising, enabling you to fly longer, higher and farther. But can we really say that recognising clouds is 'reading'? Reading includes a wide range of behaviours, provokes imageable responses and involves multi-layered, complicated operation on the part of the human eye and brain. While you are reading until here, you may imagine certain images, or you may also figure out the boundary of the act of reading. Nonetheless, few of you managed to recognise the shape of letter and the purpose of the shape.

What effects do the types used in lengthy texts have on people's reading experience? This is the essential question that type designers and typographers always encounter when they work on body texts. While You're Reading is the book that addresses this question. After perusing this book from cover to cover, then close your book and ask yourself. It may be hard to answer what happens while you are reading. Because this book does not give the correct answer. One of the lessons, among other things, from this book is that there are too many variables to consider to produce a simple answer.

Type designers take into consideration the following variables so that they can provide people pleasant and efficient reading experiences. Here are, albeit its sheer number, a complete list of the

번역: 채혜선 Translation: Chae Hye-sun

사진: 박기수 Photography: Park Ki-su

당신이 읽는 동안

글꼴, 글꼴 디자인, 타이포그래피

헤라르트 윙어르 지음
최문경 옮김

work
—
ro
om

헤라르트 윙어르, 당신이 읽는 동안, 최문경 옮김, 워크룸 프레스, 2013, 반양장, 220 x 145 mm, 410 g, ISBN 978-8994207230
Gerard Unger, While You're Reading, Choi Moon-kyung trans., Workroom Press, 2013, Bound, 220 x 145 mm, 410 g, ISBN 978-8994207230

뇌가 글자를 인식하고 의미를 파악하는 (아직 완전히 밝혀지지 않은) 정교한 과학적 메커니즘, 개별 독자들의 취향과 수준 및 숙련도, 독서에 영향을 미치는 심리적 요인들, 관습과 전통에의 밀착 정도, 익숙함과 새로움의 경계, 글자와 필기도구와 책의 인체 공학, 읽기라는 다면적 문화 행위에 내포된 다양한 의미, 각 글자 시스템 본연의 형태가 가진 임의성과 필연성, 공간 배분과 리듬감 등 조형 원리들, 글자가 위치하는 각종 환경, 구술 언어와 문자 언어 및 타이포그래피 간의 긴장관계, 각종 텍스트의 종류 및 저자와 독자가 맺어지는 관계, 이루 다 헤아릴 수 없는 온갖 변수, 변수들…

당신이 읽는 '동안'

이렇게 열거된 키워드들을 그대로 설명하기 시작하면, 당신은 지루함에 몸부림치다 못해 활자 디자인의 영역으로부터 마음을 돌리게 될지도 모른다. 윙어르 선생은 독자를 그렇게 만들지 않는다. 다만 책을 덮고 나서도 '읽기'가 과연 무엇인지 속시원한 답이 떠오르지는 않는다. 그렇다고 당신이 무능한 독자인 것도 아니고 저자가 소임을 다하지 못한 것이라 보기도 어렵다.

　사실 2012년 한 해만 해도 '읽기'가 무엇인지 질문하는 영어권 서적들이 쏟아졌다. 소피 베이어의 활자 읽기, 얀 미덴도르프의 텍스트 모양 만들기, 사이러스 하이스미스의 단락 안 들여다보기 — 타이포그래피의 기본 요소들 등 탁월한 저술만도 몇 편이 꼽힌다. 사이러스 하이스미스가 최근 저서에서 밝히기를, 실험실의 과학적인 관찰 결과는 일상 속 타이포그래피의 실제적 경험과는 마찰을 일으키는 경우가 많다고 한다. 실험실에서는 비관습적인 엉뚱한 타이포그래피에도 사람들이 능숙하게 적응할 수 있다는 사실이 입증되기도 한다. 문제는 이 결론에 독자의 취향과 선호도, 선택이 배제된다는 사실이다. 앞서 언급했듯, 헤어려야 할 변수가 워낙 많고 복잡다단하여 과학적 결과들이 내리는 답만으로는 충분치 않다는 소리이다. 활자체는 어떻게 작용하며, 우리가 어떻게 읽는지는, 여전히 답을 찾아가는 여정에 있는 질문인 것이다.

　보는 것과 읽는 것은 서로 다른 행위이다. 그래픽 디자이너와 본문용 활자 디자이너는 퍽 다른 재능을 필요로 하고, 심지어 이 재능들은 서로 충돌하는 것 아닌가 싶기도 하다. 활자 디자이너에게는 육안으로 감별되지 않는 차원을 다루는 아이러니, '읽히기 위해 보이지 않는 것'을 만들어야 하는 아이러니가 존재한다. 여기서 잠깐, 읽기 위해서 보이지 않아야 한다니? 본문용 텍스트 활자 디자이너들과 타이포그래퍼들에게는 익숙할 이 명제를 부연하기 위해, 헤라르트 윙어르와 더불어 우리 시대 가장 노련하고 경륜이 오랜 활자 디자이너 아드리안 프루티거의 비유를

areas this book covers:

- The conflicting claims and contributions type designers have made for years
- The validity and invalidity of various empirical generalisations
- The lyrical spell evoked by reading activities
- The boundary of visibility and readability
- The sophistication of scientific mechanism, although not fully proven, by which eyes and the brain can recognise letters and understand their meanings
- Individual readers' taste, their sophistication, and their skillfulness
- Psychological factors affecting reading
- The affinity of people to convention and tradition
- The boundary of familiarity and novelty
- The ergonomics of letters, writing instruments and books
- Various meanings implied in the multicultural act of reading
- The arbitrariness and causative that each letter system retains
- The principle of design, such as space assignment and rhythm
- A variety of environment letters are located
- Tension between spoken language, written language and typography
- Diverse texts and the relationship between authors and readers

along with all sorts of innumerable variables, perspectives and agendas…

'While' You're Reading

The mere listing of these keywords might be boring you to the point of keeping you away from type design. Unger does not want to put readers in this situation. After closing the book, the notion of reading is still entirely unanswerable. That does not necessarily means that you are an immature reader or he is an incompetent author who did not fulfill his duties.

　In fact, the year 2012 alone saw more English books published, asking what reading is: Reading Letters: Designing for Legibility by Sofie Beier, Shaping Text by Jan Middendorp, and Inside Paragraphs: Typographic Fundamentals by Cyrus Highsmith just to name a few outstanding works. Cyrus Highsmith, in his latest book, said that what scientific observations at the laboratory tell us contradicts how we feel about typography in our everyday life. Some studies show that,

습관과 행동 패턴은 인류의 기본 특징이다. 습관은 읽을 때 편리함과 확실성을 제공한다. 만약 우리가 항상 같은 방법을 사용한다면 별다른 생각 없이 그 일을 할 수 있고, 따라서 내용에 집중할 수 있다. 이는 글꼴과 타이포그래피에 있어서도 마찬가지로 작동한다. 습관은 우리의 기대를 저버리지 않으며, 덕분에 우리의 눈과 뇌는 저자의 의도를 그만큼 더 쉽게 알아차릴 수 있다. 물론 이는 기계를 조작하는 것처럼 다른 분야에서도 똑같이 적용되는 일이다. 우리는 눈과 손, 그리고 뇌의 습관에 의존할 수 있어야 하며, 실제로 의존해서 살아간다. 인간이라는 틀, 또는 뇌를 배제한 설계는 무엇이든 일을 어렵게 만든다. 선사시대의 손도끼부터 오늘날의 자동차 운전에 이르기까지, 또 우리가 읽는 글꼴에도 이것이 적용된다. 모든 것은 인체 공학의 문제다. 즉 정신적으로나 육체적으로나 우리 자신에게 적합해야 한다.

글자가 처음으로 형태를 갖추기 시작할 때 눈과 손은 늘 같이 일했다. 글자를 만드는 거리는 읽는 거리와 같았고, 글자가 쓰일 매체 역시 눈과 손에 적합한 형태를 얻었다. 책은 정상적인 거리에서 가장 잘 읽힐 수 있다(어쨌든 대부분은 그렇다). 우리가 일상에서 사용하는 실용적인 물건들의 속성은 대부분 이와 비슷한 과정을 거쳐 만들어졌다. 우리의 해부학적 특성에 맞춰진 것이다. 컴퓨터 마우스의 형태는 잡고 사용하기에 적당하며 의자는 앉기에 편하다.

처음에는 새의 깃털로, 또 1450년 무렵에는 금속활자로 오늘날 우리가 사용하는 글자의 모양을 만든 사람들은 눈과 뇌를 길잡이 삼아 손을 움직여 글을 쓰고 글자를 깎았다. 그들의 눈이 더 잘 읽히는 글자꼴을 만들라고 손에게 지시한 것이다.

금속활자를 만들던 사람들은 가장 먼저 강철 사각기둥의 자그마한 밑면에 활자를 새겼다. 이것을 펀치(punch)라고 한다. 그들이 새긴 활자는 실제 크기였다. 예를 들어 6포인트로 조각된 e는 불과 1밀리미터의 크기에 완벽한 속공간을 가졌다. 이들은 확대경과 단단한 강도를 가진 줄과 끌을 사용해 천천히 조심스럽게, 평균 하루에 두 개의 펀치를 만들었다. 가끔씩은 자신이 새기던 조각에 불꽃 검댕을 묻혀 종이에 찍어본 후 그 자국을 완성된 활자와 비교하면서 필요에 따라

인용해보자. 프루티거에 의하면, 본문용 활자란 점심 때 사용한 스푼 같은 것이라야 한다. 먹는 동안 스푼의 형태를 계속 의식하게 된다면, 그 스푼은 제 역할을 제대로 해낸 좋은 도구였다고 보기 어렵다. 활자체 역시 마찬가지이다. 처음에 마음을 사로잡으며 주의를 끌 수는 있지만, 텍스트를 읽는 동안에도 계속 활자의 형태에 시선을 빼앗긴다면 제 역할을 제대로 해내는 좋은 도구라고 보기 어렵다. 그래서 활자 디자이너들의 관심사는 시각적 차원을 너머 광학, 심리학, 인지과학, 인체공학으로 향한다.

어쨌건 당신은 윙어르 씨와 아늑한 대화를 나누는 '동안'을 즐기며 때로는 사색에 잠기기도 하고, 무언가 만족한 느낌을 받지 않았는가? 바로 이것이 이 저서의 두 가지 미덕 중 하나이다. 지루하기 짝이 없어야 마땅할 것 같은 키워드들을 흡입력 있게도 풀어나간다. 네덜란드라는 낯설지만 성숙한 문화적 토양 위에서 펼쳐지는 에피소드와 이야기들, 활자들이 품은 천태만상의 사연들에 눈을 떼지 못하고 귀를 기울이게 된다. 한국의 활자 디자인과 타이포그래피의 일상은 교과서와 강의도 필요로 하지만, 이런 종류의 대화와 담론들에도 목말라 있었던 것이다.

네덜란드와 활자 디자인
이 책의 또 다른 미덕은 한국에 소개되는 네덜란드 활자 디자이너의 저술이라는 점이다. 그동안 한국에 번역된 대부분의 번역서는 영미권 저자들의 저술이었고, 그중 간간이 독일어권 저자의 저술이 있었다. 같은 라틴 알파벳 문자권이라도 미국과 영국, 독일과 프랑스, 이탈리아, 네덜란드는 글자체에 대한 취향과 문화적 배경, 인식이 상당히 다르다. 다양한 문화적 배경으로부터 도출된 견해들을 우리는 편중되지 않게 골고루 접할 필요가 있다.

더치 디자인이라 하여 네덜란드의 그래픽 디자인은 활발하게 소개된 바 있지만, 몇 해 전 네덜란드 활자 디자이너인 마르틴 마요르가 한국을 방문한 것을 제외하면 네덜란드의 활자 디자인은 한국에 별달리 소개된 바가 없다. 네덜란드 그래픽 디자인과는 그 궤를 달리하는 네덜란드 본문용 활자 디자인은 분야의 특성상 역사주의와 전통주의에 기반을 둔다.

네덜란드에 탁월한 활자 디자이너가 많은 이유는 이 나라에 역사주의적 정격연주계를 이끄는 탁월한 고음악 학자 및 연주자가 많은 이유와 오히려 일맥상통한다. 네덜란드는 17세기에 이르러 경제적 번영을 누리며 문화적으로도 황금시대를 구가했다. 이 풍부한 역사의 유산을 속속들이 연구하고, 우리가 호흡하는 동시대에도 그 정신이 여전히 유효하도록 숨결을 불어넣는 예술적 작업들은 정격주의자들의 본령이기도 하다.

in a laboratory setting, people can easily adapt themselves even to vagarious and unconventional typography. The problem, however, is that scientific findings do not take into account readers' taste, preference and choice. As mentioned earlier, scientific findings cannot give a full explanation of typography because it has an unusually large number of complicated variables we have to consider. This shows we are all on a journey to get the answer: How do types work? and how do we read?

Seeing and reading are totally different activities. To be more pacific, the talent needed to be a graphic designer is quite different from what it takes to become a type designer, and it appears that those two talents contradict each other. Type designers face the paradox of handling something invisible. In other words, they have to make types invisible to make them readable. Yes, just a second, but what exactly is invisibility for readability? Text type designers and typographers may already be familiar with this kind of thinking. To clarify this idea, let me quote Adrian Frutiger(1928-), who is one of the most seasoned and perspicacious type designers in our time, together with Gerard Unger. According to Frutiger, a type for body text has to be something like the spoon used for having lunch. If the spoon draws your attention all the way through your meal, it certainly fails to serve its purpose. The same is true to types. If a type keeps distracting readers' attention from the text, the type cannot be a good tool that works best for its purpose. This is the reason why type designers take their interest in subject stems beyond aspects of visual perception, from research in optics, psychology, cognitive science and ergonomics.

After all, 'while' talking fondly with Unger, you might be sometimes contemplative, and satisfied with something in mind. That is one of the two virtues this book offers. Unger is judicious in the way he handles otherwise boring keywords eminently. The episodes unfolding in the Netherlands with an unfamiliar yet matured cultural base, along with various stories behind types, are what makes this book a real page-turner. This shows that people working in the Korean type design and typography industry, they have thirst for this kind of discussions and discourses, let alone typography textbooks and lectures.

The Netherlands and Type design
The fact that the book is written by a Dutch type designer and is translated into Korean is the

abcdefghijkl
mnopqrstuvw
xyzABCDEFG
HIJKLMNOPQ
RSTUVWXYZ
1234567890
.,:;?!-('–')€@

abcdefg
rstuvwx
DEFGH
RSTUV
67890-.
&@%$£¥
ÁÀÂÄÃ
ŒØÓÒÔ
æáàâäã
øóòôöõ

네덜란드인의 실용적 완벽주의의 정서 속에서, 그들은 관습을 소중히 여기며 이 역사의 유산들을 현대화한다.

당신이 책을 넘기고 만지고 느끼는 동안

나는 사실 네덜란드어 원문인 이 책의 영역본을 몇 년 전에 소장하고 읽으면서 책에 익숙해져 있었다. 늘 말쑥하게 차려입은 헤라르트 윙어르 선생을 연상시키는, 짐짓 격을 갖춘 두툼한 양장 제본과 새하얀 종이. 비교적 큼지막한 본문 글자와 명랑한 진분홍의 간지면. 무엇보다도 양장의 표지를 펼치면 보라색 면지의 하늘에 구름의 부호들이 영역본의 책에 가득 펼쳐져 있다. "내게는, 19세기 초 영국의 기상학자 루크 하워드가 개발한 일련의 구름 문자들이 든든하게 갖추어져 있다. 그는 구름을 분류하고 권운이나 적운 같은 이름을 붙인 사람이다. 흥미롭게도 그가 만든 이 기호들은 글자의 기본 형태를 구축하는 근본 요소들과 놀랄 만큼 닮았다. 구름은 칼새[1]들에게 배경을 제공한다. 나는 그 모습에서 많은 영감을 받았다. 내가 구름을 사랑하는 이유는 여기에도 있다."

이 구름 부호는 영역본에서 그가 만든 또 다른 활자체인 걸리버로 디자인된 본문을 앞뒤로 배경처럼 감싸고 있다. 독자들에게 아늑하고 쾌적한 '읽기' 경험을 제공하고자 배려해온 저자의 연륜과 노련함은 활자 디자인뿐 아니라 텍스트 저술과 서적 디자인의 영역에서도 여유롭게 배어 나온다. 그는 이 고도로 첨예한 전문 분야에 대해 차근차근 짚어나가는 동시에, 또 '읽기'란 일상 곳곳에서 누구나 보편적으로 행하는 폭넓은 의미를 함축하는 행위임을 암시하면서 독자들이 낯설음을 느끼지 않도록 감싸주며 다가간다.

반양장본으로 다소 간소하게 제작된 한국어판에는 저자의 성품을 연상시키는 이런 유머러스한 장치들이 생략되어 있다. 원서에 비하면 다소 딱딱해서 에세이라기보다는 논픽션이나 학술서 같은 분위기를 풍기기도 한다. 하지만 한국어판만 독립적으로 보면 디자인의 자체 완결성이 우수하고 많은 고심의 흔적들이 보인다. 디자이너인 워크룸의 강경탁 씨에게 넌지시 의견을 청해보았다. "저는 저자를 개인적으로 알지 못하잖아요. 그런 척 흉내를 낼 수는 없었어요." 능청을 모르는 성실한 디자이너의 디자인적 근거, 일리 있는 답변에 고개를 끄덕이고 만다.

↗

1
저자의 대표
활자체 스위프트는
'칼새'라는 의미를
가지고 있다.

book's other virtue. For years, most type-related translations available in Korea have been written by authors from English-speaking countries, with some of the translations written by German-speaking authors. America and Britain, and Germany, France, Italy, and the Netherlands, though they share the same Latin alphabet, all have significantly different tastes for types, different cultural background and different perception of types. We need to impartially embrace voices from various cultural backgrounds.

Dutch graphic designs rousingly have been introduced in Korea from a few years ago onwards. But there were very few opportunities to meet Dutch type designs, except for the visiting of Martin Majoor (1960-), a Dutch type designer. Dutch text type design, which has taken a path different from its graphic design, is based on historicism and traditionalism by nature.

The fact the Netherlands has many outstanding type designers has something to do with the fact that the country has a lot of excellent archaic music scholars and players who have lead historical authentic performances. Into the 17th century, the Netherlands enjoyed an economic prosperity and cultural golden period. The authentist's primary job is to conduct a research into its time-honored historical legacy and to enrich their artistic works so that they can keep its contemporary spirit intact to date. The Netherlands' penchant for perfectionism allows its people to value their customs while giving it a touch of modernism.

While you are tuning, touching and feeling the book

To be honest with you, because I received an English version of this book, originally written in Dutch, I was quite familiar with this book. The hardcover of this thick book, which gives itself a formal appearance, and its pure white papers are reminiscent of the well-groomed Gerard Unger. In addition, the book features rather big body types and enjoyable pink coloured interleaved papers. Above all of these, the English edition boasts cloud types printed on both violet front and back endpapers.

"To me, one very nice addition to the armoury of characters is a series of cloud types, developed at the beginning of the nineteenth century by Luke Howard(1772-1864), the man who devised the system of cloud classification and gave clouds their

우리의 눈과 뇌는 어떻게 글자를 인식하는가?
글꼴 디자이너와 타이포그래퍼들은 무엇을 해왔는가?
과연 읽는다는 건 무엇일까?

사람들은 책을 읽으며 글자를 보지 않는다. 그것은 우리가 길을 걸으며
발을 보지 않는 것과 마찬가지다. '읽기'는 우리의 무의식 속에서
일어나는 행위처럼 보인다. 글꼴 디자이너들은 지금도 끊임없이 새로운
글꼴을 만들어내는 한편, 우리가 사용하는 글꼴의 기본 형태는 수백 년이
넘는 동안 거의 변함이 없다. 전통과 혁신 사이의 이러한 간극을 어떻게
받아들여야 할까.

이 책은 우리가 '읽는 동안 무슨 일이 벌어지는가'에 대한 책이다. 그리고
글꼴 디자이너, 타이포그래퍼, 그래픽 디자이너들이 '읽기'라는 행위를
위해 어떤 일을 하는지 다룬다. 《USA 투데이》 등 전 세계 여러
신문에서 사용하는 글꼴부터 고속도로, 지하철 표지판에 이르기까지
다양한 프로젝트를 위해 글꼴을 디자인해온 저자의 경험이 녹아 있는
이 책은 대부분의 노련한 타이포그래퍼와 디자이너는 물론, 읽기라는
행위가 어떻게 이뤄지는지 궁금한 사람들을 위한 일화와 통찰을 담고 있다.

ISBN 978-89-94207-23-0 03600
값 15,000원

names, such as cumulus and cirrus. Interestingly, they are signs that come remarkably close to the fundamental elements from which the basic letterforms are constructed. I have always loved clouds, partly because they often provide the backdrop to the swifts[1] from which I have derived great inspiration." (pp. 181-182)

In the English edition, Unger's other type 'Gulliver' has these cloud signs as its backdrop. His careful concern to give readers comfortable and convenient reading experience are also found in his felicitous writings and book designs. He tries to spell out this highly professional field; at the same time, he also makes typography more accessible to readers by demonstrating that reading is part of our everyday lives.

 These humorous elements suggesting the author's character are omitted in the Korean edition. Its modest design than the original version makes us associate with a non-fiction book or a scholarly book rather than an essay. But if we think of the Korean version separately, it has achieved its own completion in design. The Korean version provides us a glimpse of how hard he was in designing this book. I asked Kang Gyeong-Tak(1981-) who is a graphic designer at Workroom and who designed the Korean version, what his intention was. "I do not know Gerard Unger personally, so I could not pretend to know," he answered. I have no choice but to agree with the thought of this dedicated and upright designer.

↗

1
The author's
well-known
type 'Swift' took
its name from
a bird.

복스의 분류법 그 이후 50년: 분류법의 진화

50 Years After Vox: the Evolution of Type Classifications

김현미

SADI, 한국

Kim Hyun-mee

SADI, Korea

주제어
글자체, 복스, 분류법

Keywords
Typeface, Vox, Classification

→

개러몬드, 배스커빌, 보도니, 센추리 익스팬디드, 헬베티카. 타이포그래피를 공부하는 학생이라면 서양의 학생이건 동양의 학생이건, 이 다섯 가지 글자체를 만나는 것을 피할 수 없다. 이 다섯 가지 글자체는 500년 타이포그래피 역사를 통해 뚜렷한 형태적 차이를 보이는 다섯 가지 양식, 즉 올드 스타일, 과도기 스타일, 모던 스타일, 이집션, 산세리프의 대표적 글자체로 여겨진다. 다섯 가지 기본 스타일을 알고 글자체의 서로 다름을 이해하면서 시작하는 이 교육 내용은 수십 년간 타이포그래피 입문서로 자리 잡은 미국 쿠퍼유니온대학의 제임스 크레이그 교수 등이 집필한 타이포그래피 교과서(한국어판)의 영향이 큰 듯하다. 전문 분야에 대한 관심을 끌어내는 방법으로 이 다섯 가지 분류법은 매우 유효하다.

타이포그래피에 관심이 생긴 디자이너라면 또 다른 입문서, 예를 들어 탬스 앤드 허드슨 타이포그래피 지침 같은 책을 통해 글자체를 분류하는 좀 더 많은 서랍, 국제타이포그래피협회(ATypI)에서 인증하고 영국의 글자체 분류 표준이기도 한 '복스 분류법'을 알게 된다. 복스의 분류법은 로마자 글자체를 10개의 유형으로 분류해 글자체의 서로 다른 형태와 이를 낳은 시대, 문화 또 도구에 대한 이해를 넓힌다. 유형의 이름은 보다 전문적이다. 인쇄술이 시작되면서 오랫동안 유럽에서 광범위하게 사용되었던 세리프 글자체들을 '올드 스타일'이라는 일반적인 이름으로 통칭하는 대신 이 양식의 대표적 글자체인 '개러몬드'와 이런 형태를 처음 등장시킨 베니스의 출판사 '알디네'를 결합해 '개럴드'라고 한다든지, 18세기 후반에 등장한 획의 굵기의 차이가 현저하고 글자의 수직성이 강조된 세리프 글자체들을 '모던 스타일'이라고 하는 대신 대표적인 글자체인 '디도'와 '보도니'를 결합해 '디돈'이라 명명하는 식이다. 복스의 전문적 분류에서 가장 유용한 부분은 산세리프군의 세분화이다. 20세기를 대표한다고 할 수 있는 산세리프 글자체들을 네 가지 유형으로 구분해 산세리프 형태를 보는 다양한 관점을 제공한다.

이런 복스의 분류법이 국제 표준으로 인정받은 것이 1962년이다. 그동안 반세기라는 시간이 흘렀고 디지털 기술이 바꾸어놓은 현대의 타이포그래피 환경에서 새롭게 등장한 글자체들을 담아서 이해하기 위한 새로운 서랍의 제안이 필요한 상황이다. 2012년에 출간된 활자 해부학: 100개의 활자체에 대한 그래픽 가이드는 현대의 로마자 글자체 풍경을 반영하는 합리적이고 새로운 분류법과 글자체들을 소개하고 있다.

우선 이 책은 제목용 글자체보다는 본문용으로 활용할 수 있는 글자체들의 소개에 집중하고 있다. 블랙레터는 제외했고 제목용 글자 유형은 책의 말미에 형식적으로 등장한다. 크게 세리프, 산세리프, 슬래브

Garamond, Baskerville, Bodoni, Century Expanded, Helvetica. Whether you're a student of typography in Asia or the West it is inevitable to avoid these five typefaces. These represent the last 500 years of typographic classification based on letterforms: Oldstyle, Transitional, Modern, Egyptian and San-serif fonts. It is probable to say that this basic classification of type, and discerning the differences stems from the canon of typographic textbooks, that is Designing with Type by James Craig of Cooper Union University. Such classification is useful in drawing out the practicalities of an otherwise highly specialized field.

For the more learned typographer or designer, other books pertaining to the subject of type classifications can also be considered the Thames and Hudson Manual of Typography further divides type into more detail, while the International Typographic Association or ATypI certify the Vox-ATypI Classification by the Englishman typographer of the same name.

The Vox-ATypI Classification separates type into 10 distinct classes making it easier to understand each classification according to era, culture and tool or methodology. Each classification is more specific; for instance, what was termed Oldstyle, alluding to the over encompassing classification of the birth of printing and the fonts developed during that time in all of Europe, this classification combines the most prominent typefaces of the time Garamond with the most innovative printers of the time Aldine in Venice to term it as Garalde. Also in a like vein, the Modern classification points to the 18th century typefaces of contrasting thick and thin, and vertical stroke and proportions of immense elegance, here Vox again combines two into one, as Bodoni and Didot, the most prominent typefaces of the time as well as symbolic of the printing technology of that day to come up with Didone as a term of classification that is specific and unique. However, it is in the realm of the san-serif that the Vox classification is considered most helpful. Indeed the type of the 20th century is divided into four unique classes, thereby gaining a unique perspective on this type of font.

This classification method was adopted in 1962 by the Association Typographique Internationale (ATypI), and half a century later, with the advancement of digital type and type design a need to redefine this methodology as a means to address the many different kinds of fonts being



번역: 박경식 Translation: Fritz K. Park

사진: 박기수 Photography: Park Ki-su

스티븐 콜스 활자 해부학: 100개의 활자체에 대한 그래픽 가이드, 하퍼 디자인, 2012, 양장, 256쪽, 254 x 203 mm, 1089 g, ISBN 978-0062203120
Stephen Coles, The Anatomy of Type: A Graphic Guide to 100 Typefaces, Harper Design, 2012, Hardcover, 256 pages, 254 x 203 mm, 1089 g, ISBN 978-0062203120

세리프라는 세 개의 대분류가 각각의 소분류를 가지는 형식인데 기본적으로 복스의 분류법에 기반을 두면서 불합리하거나 불편했던 부분을 보완했다. 복스 분류법에서 1500년경을 기준으로 그 이전에 주로 베니스에서 제작된 글자체와 그 이후의 것을 각각 '휴머니스트'와 '개럴드'로 구분했던 것을 '휴머니스트 세리프'로 묶은 것은 합리적이다. 이 구분은 다른 유형의 구분에 비해 지나치게 미세한 형태 기준에 따른다는 비판을 받아왔다. '디돈'과 같이 특정 글자체에 의존하는 명칭은 '이성적인 세리프'라는 새로운 명칭으로 대체하면서 수직성이 강하지만 굵기의 차이가 크지 않은 헤르만 차프의 '멜리어'와 같은 글자체까지 포함한다. 복스 분류법의 또 다른 문제점이었던 슬래브 세리프를 구분하지 않고 하나의 서랍에 모두 넣었던 점은 대폭 수정해 산세리프의 분류와 같이 그로테스크 슬래브, 기하학적 슬래브, 휴머니스트 슬래브 세리프의 세 가지로 분류해 대표적 글자체들을 보여줌으로써 슬래브 세리프의 다양한 면에도 눈뜨게 한다.

헤라르트 윙어르의 '스위프트'와 같이 엑스하이트가 크고 각지고 무딘 세리프가 특징인 '컨템포러리 세리프', 피터 빌락의 '페드라 산스'와 같이 엑스하이트가 크고 속공간이 크고 개방적이면서 글자의 외형이 각진 특성을 가지는 산세리프 글자체들을 포함하는 '네오 휴머니스트 산스'와 같은 새로운 유형들은 디지털 기술이 촉발한 다양한 매체 환경에서 가독성을 중점으로 개발된 현대적 미감의 글자체들을 소개해준다. 또 하나의 독창적 유형은 20세기 초반에 미국에서 개발된 산세리프 글자체들이 가지는 특성을 공유하는 산세리프 글자체 유형인 '고딕 산스'이다. 19세기 유럽의 산세리프보다 글자폭이 좁고 글자표현이 직선적인, 대체로 모리스 벤튼의 디자인에 기인한 이 산세리프 글자체들은 따로 주목할 만한 그룹이다.

활자 해부학은 언뜻 보기에 하나의 펼침면에 하나의 글자체를 크게 보여주는 흔한 글자체 견본책과 같다. 그러나 본문용 글자체에 주목하는 새로운 체계와 유형별로 엄선된 글자체들을 보는 것은 로마자 글자체에 대한 기본 지식을 갖춘 독자에게 더욱 흥미로울 수 있다. 저자는 최초의 디지털 폰트 포털 회사인 폰트샵의 크리에이티브 디렉터 출신인 타입 전문가이다. 100개의 글자체들은 역사적 중요성, 조형적 우수성, 디자이너의 명성 등 저자가 설정한 다양한 기준의 망을 통과한 수작이라 여겨진다.

타이포그래피에서 글자체를 선택하는 일은 소통의 목적이나 메시지에 따라 필요한 시각적 목소리를 결정하고 선택하는 일이다. 로마자로 타이포그래피를 해야 할 때 수많은 글자체들 속에서 늘 같은 글자체를 사용하는 것을 피하기 위해서 목소리의 유형을 먼저

designed today is needed. A new cabinet, if you will, is required. Published in 2012, The Anatomy of Type: A Graphic Guide to 100 Typefaces (Stephen Coles, Harper Design) provides a sound method of going about this task and is worth considering.

Firstly, the focus of this book is not on display fonts but body text fonts, with the exception of black letters display fonts are discussed in brief at the end of the book. Largely, type is divided into Serif, San-serif and Slab Serifs with sub-categories within each division, this is more or less in line with Vox however, certain discrepancies or changes have been made where needed. It's reasonable to combine what Vox divided as pre and post 1500 type as 'Humanist' and 'Garald' into one category: Humanist Serif. This differentiation has given rise to some criticism as being too detailed and minute. 'Didone' in the Vox classification has been renamed 'Rational Serif' to include type that is vertical in structure yet not as contrasting in width like Herman Zapf's Melior. Another point of criticism with the Vox classification were slab serifs, all wrangled up into one larger category. Here slab-serifs take after san-serifs categorization as grotesque slabs, geometric slabs, and humanist slabs thereby diversifying the category.

Gerhard Unger's Swift with its large x-height and sharp angled serifs are categorized as 'Contemporary Serifs' while Peter Bilak's Fedra with its larger x-height and open counters are considered Neohumanist Sans thereby addressing the need for a more specific and detailed categorization methodology in this digital age of readability, and contemporary design. Another unique classification is Gothic Sans comprising the san-serifs developed in the USA at the turn of the 20th century — a group of typefaces unique from the 19th century European sans that is condensed in width and linear in form, in like vein with the Morris Benton designs of that period. At first glance, this book is similar to other books of this nature with one typeface per spread, however with the focus on body text typefaces and proposing a new method of classification and a well chosen selection of sample fonts for each class is sure to arouse the interest of any reader learned in type design and typography. The author was previously creative director at Fontshop, the world's first digital type foundry. The 100 fonts introduced in this book was rigorously selected based on historic significance, superior letterforms and prominence of the designer as well as many

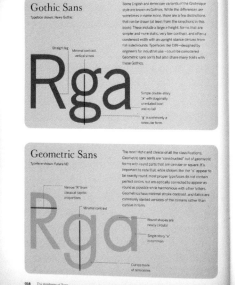

Gothic Sans

Typeface shown: News Gothic

Some English and American variants of the Grotesque style are known as Gothics. While the differences are sometimes in name alone, there are a few distinctions that can be drawn (at least from the selections in this book). These include a large x-height, forms that are simpler and more static, very low contrast, and often a condensed width with an upright stance derives from flat-sided rounds. Typefaces like DIN—designed by engineers for industrial use—could be considered Geometric sans serifs but also share many traits with these Gothics.

Straight leg

Minimal contrast, vertical stroke

Simple double-story 'a' with diagonally orientated bowl and no tail

'g' is commonly a binocular form

Geometric Sans

Typeface shown: Futura ND

The most static and classical of all the classifications, Geometric sans serifs are "constructed" out of geometric forms with round parts that are circular or square. It's important to note that, while shapes like the 'o' appear to be exactly round, most proper typefaces do not contain perfect circles, but are optically corrected to appear as round as possible while harmonious with other letters. Geometrics have minimal stroke contrast, and italics are commonly slanted versions of the romans rather than cursive in form.

Narrow 'R' from classical capitals proportions

Minimal contrast

Round shapes are nearly circular

Single-story 'a' is common

Curves made of semicircles

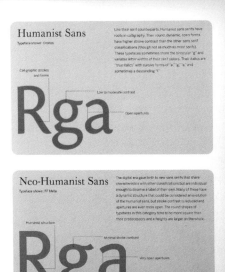

Humanist Sans

Typeface shown: Cronos

Like their serif counterparts, Humanist sans serifs have roots in calligraphy. Their round, dynamic, open forms have higher stroke contrast than the other sans serif classifications (though not as much as most serifs). These typefaces sometimes share the binocular "g" and variable letter widths of their serif sisters. Their italics are "true italics" with cursive forms of "a," "g," "e," and sometimes a descending "f".

Calligraphic strokes and forms

Low to moderate contrast

Open apertures

Neo-Humanist Sans

Typeface shown: FF Meta

The digital era gave birth to new sans serifs that share characteristics with other classifications but are individual enough to deserve a label of their own. Many of these have a dynamic structure that could be considered an evolution of the Humanist sans, but stroke contrast is reduced and apertures are even more open. The round shapes of typefaces in this category tend to be more square than their predecessors and x-heights are larger on the whole.

Humanist structure

Minimal stroke contrast

Very open apertures

Neue Swift

Designer: Gerard Unger // **Foundry:** Linotype // **Country of origin:** The Netherlands
Release years: 1985 (Swift), 1995 (Swift 2.0), 2009 // **Classification:** Contemporary Serif

ABCDEFGHIJKLMNOPQRSTUVWXYZ
abcdefghijklmnopqrstuvwxyz 1234567890 163
¼ ⅔ ⅝ [àóüßç](.,:;?!$£&-*){ÀÓÜÇ}

Neue Swift Regular

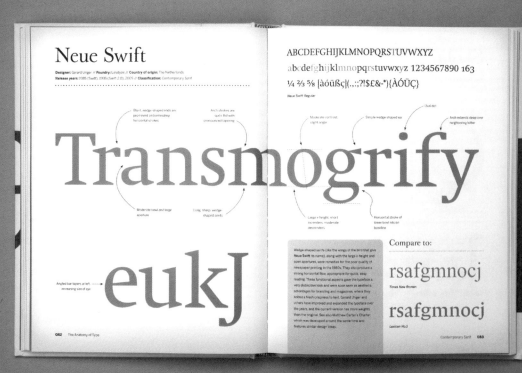

Blunt, wedge-shaped ends are prominent on overlending horizontal strokes

Arch strokes are quite flat with pronounced tapering

Modals are contrast, slight angle

Simple wedge shaped ear

Oval dot

Arch extends deep over heightening letter

Moderate bowl and wedge aperture

Long, sharp, wedge shaped serifs

Large x-height, short incenders, moderate descenders

Horizontal stroke of lower bowl hits on baseline

Angled bar tapers at left, increasing size of eye

Wedge-shaped serifs (like the wings of the bird that give **Neue Swift** its name), along with the large x-height and open apertures, were remedies for the poor quality of newspaper printing in the 1980s. They also produce a strong horizontal flow, appropriate for quick, easy reading. These functional aspects gave the typeface a very distinctive look and were soon seen as aesthetic advantages for branding and magazines, where they added a fresh crispness to text. Gerard Unger and others have improved and expanded the typeface over the years, and the current version has more weights than the original. See also Matthew Carter's Charter, which was developed around the same time and features similar design ideas.

Compare to:

rsafgmnocj

Times New Roman

rsafgmnocj

Lexicon No.1

찾아보면 어떨까. 그 유형 속에서 내가 아는 글자체 인근에 매력적인 새로운 만남이 있을 수 있다. 이 책이 주선하는 100개의 만남은 '글로벌 스탠다드'를 갖춘 것들이니 믿어볼 만할 것이다.

↗

other criteria. Choosing a typeface is based on communication objectives or the needed voice of the message being conveyed — instead of resorting to the same set of typefaces used over and over, why not search for that unique voice each typeface embodies? Type classifications can lead to well known typefaces that may in turn lead to finding new typefaces of similar flavor. The 100 fonts introduced in this book are reliable in that they set a new standard for the future.

↗

프로젝트　　　　　Project

타이포잔치 2015
프리 비엔날레

김경선
타이포잔치 2015 예술 감독

주제어
타이포잔치, 프리 비엔날레, 도시, 텍스트성

→

Typojanchi 2015
Pre-Biennale

Kymn Kyung-sun
Art Director, Typojanchi 2015

Keywords
Typojanchi, Pre-Biennale, City, Textuality

2015년 8월에 열릴 네 번째 서울 국제 타이포그래피 비엔날레인 타이포잔치 2015의 주제는 '타이포그래피와 도시'다. 이를 위한 준비로 2014년에는 타이포그래피와 도시에 대해 리서치하고 논의하는 프리 비엔날레 행사들이 다양하게 전개된다. 이 글은 타이포잔치 2015의 소개이자 프리 비엔날레 행사의 초대이다.

The theme for the fourth International Typographic Biennial Typojanchi 2015, scheduled for August 2015 is 'Typography and the City'. In preparation for this, pre-biennial events including research and discussion on the city is being held throughout 2014. This text is an introduction to Typojanchi 2015 and an invitation to the pre-events.

타이포그래피 + 도시

이 시대, 지구상의 현대인들 중 대다수가 도시에 거주하며, 그들이 머무는 도시에는 그 지역 고유의 언어, 관습, 문화의 흔적이 곳곳에 각기 다른 형태로 나타난다. 강, 공원과 같은 자연 유산, 건축물이나 기념물 같은 인공 유산에는 물론, 공항, 기차역과 같은 공공 시설물과 도로 표지, 간판 등에 기호와 문자로 표시된 거리 언어에서도 그 도시만의 특징을 찾아볼 수 있다. 이렇게 다양한 도시 환경 속에서 문자 문화에 관심을 가져온 디자이너와 예술가들의 시선으로 시대를 해석하고, 이 시대에 필요한 가치를 공유할 수 있는 기회를 갖고자 한다.

Typography + City

In this era, many of the modern population live in cities, the local language, customs and cultures are expressed in different forms in the cities. The characteristics of the city can be found in airports, train stations and public facilities, such as road signs, street signs marked with symbols and letters as well as natural heritage include rivers, parks, and also in artifact like as buildings, monuments. In these diverse urban environments, there will be opportunity to interpret the era in a sense of designers and artists that have been interested in typography culture and share necessary value for this age.

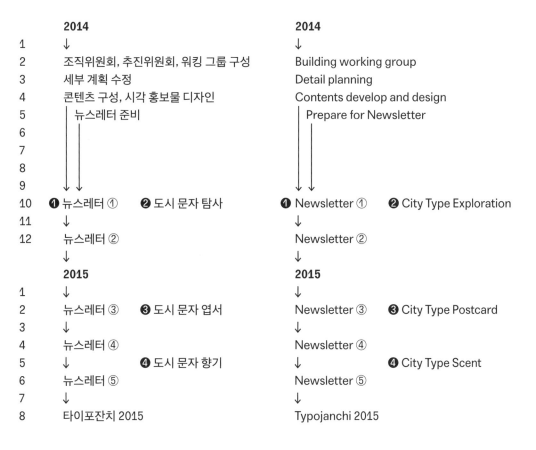

	2014	
1	↓	
2	조직위원회, 추진위원회, 워킹 그룹 구성	
3	세부 계획 수정	
4	콘텐츠 구성, 시각 홍보물 디자인	
5	뉴스레터 준비	
6		
7		
8		
9		
10	❶ 뉴스레터 ①	❷ 도시 문자 탐사
11	↓	
12	뉴스레터 ②	
	↓	
	2015	
1	↓	
2	뉴스레터 ③	❸ 도시 문자 엽서
3	↓	
4	뉴스레터 ④	
5	↓	❹ 도시 문자 향기
6	뉴스레터 ⑤	
7	↓	
8	타이포잔치 2015	

2014	
↓	
Building working group	
Detail planning	
Contents develop and design	
Prepare for Newsletter	
❶ Newsletter ①	❷ City Type Exploration
↓	
Newsletter ②	
↓	
2015	
↓	
Newsletter ③	❸ City Type Postcard
↓	
Newsletter ④	
↓	❹ City Type Scent
Newsletter ⑤	
↓	
Typojanchi 2015	

타이포잔치 2015 프리 비엔날레
프로그램

Typojanchi 2015 Pre-Bienale
Program

❷ 도시 문자 탐사
City Type Exploration
→

타이포잔치 2015
Typojanchi 2015

뉴스레터 ⑤
Newsletter ⑤
↗

뉴스레터 ④
Newsletter ④
↗

뉴스레터 ③
Newsletter ③
↗

뉴스레터 ②
Newsletter ②
↗

❹ 도시 문자 향기
City Type Scent
↑

❶ 뉴스레터 ①
Newsletter ①
↗

❸ 도시 문자 엽서
City Type Postcard
↗

주최
문화체육관광부

주관
한국공예·디자인문화진흥원, 한국타이포그라피학회

타이포잔치 조직위원회
안상수(위원장), 김지현, 라르스 뮐러, 네빌 브로디, 서영길, 폴라 셰어, 왕쉬,
하라 켄야

예술 감독
김경선

프리 비엔날레 운영위원
구정연, 박성태, 정진열, 크리스 로

자문위원
아드리안 쇼네시(위원장), 롭 지암피에트로, 피터 빌락, 케서린 그리피스,
고토 테쓰야

Hosted by
Ministry of Culture, Sports and Tourism

Organized by
Korea Craft & Design Foundation, Korean Society of Typography

Organizing Committee
Ahn Sang-soo (Chair), Neville Brody, Hara Kenya, Kim Jee Hyun,
Lars Müller, Paula Scher, Seo Yung-gil, Wang Xu

Art Director
Kymn Kyungsun

Pre-Biennale Operating Committee
Chris Ro, Jung Jin, Ku Jung-yeon, Park Seong-tae

Advisory Board Members
Adrian Shaughnessy (Chief), Rob Giampietro, Peter Bilak,
Catherine Griffiths, Goto Tesuya

도시 텍스트성
우리는 도시를 읽을 수 있을까?

도시를 구성하고 있는 유형의 구성 요소들(건물, 시설물 등)은 그 도시에 살고 있는 도시인들의 언어, 관습, 문화 등의 실재 일상과는 적잖은 괴리가 있다. 도시인들의 적나라한 삶은 그런 계획된 도시 구성 요소에서보다는 간판, 전단지와 같은 거리 언어에서 더욱 직접적으로 표출되어왔다.

> 도시는 엄청나게 많은 익명의 작가들에 의해 씌여진 엄청난 양의 책과 같다. 도시는 들여다보기만 해도 충분히 가치가 있다. 도시 속의 이미지가 이미 스스로 말하고 있기 때문이다. — 로베르 마생

현대 도시의 급속한 산업화에 따라 도시는 광고판이 되어버렸다. 치열한 경쟁 속에 살아남기 위해 간판들은 최첨단 기술력을 장착해 점점 강해지고 있다. 도시의 간판 (이젠 간판이라는 용어보다 진보된 용어가 필요하기도 하다. 거의 극장과 같은 해상도의 스크린 혹은 미디어 기술을 차용한 것들이 많아진 요즘이다보니.) 은 도시 환경의 중요한 요소로써 제 역할을 하고 있다. 간판은 공간의 상징이 되어가며 그 상징적 기호들은 공간을 점령한지 오래다. 로버트 벤투리의 말처럼.

↗

Urban textuality
Can a city be read?

Aside from the formal components in structuring a city image are the invisible components, such as language, custom and culture as derived from people's life. The connotative elements closely related to our routine can be revealed in a denotative manner through the words scattered along the streets.

> The city is like an enormous open book, written by an enormous hand. It is enough just to look; the image speaks for itself.
> — Robert Massin

Responding to the rapid industrial expansion and advanced economic development of modern society, the city itself has become a ground for advertisement. Aiming for distinction in conveying their messages, signs have equipped the most advanced technologies to become larger than ever. Signs have become details of our environment. Employed in a myriad of situations, signs play a major role within the urban environment. In 'Architecture and Graphics' Christoph Bignens points out that in shaping modern living in the city, modern architects have replaced the sculptor with the graphic designer. Stone ornamentation at best connotes the purpose of a building, while the written word on facades denotes it. Signs become a symbol of the space. Indeed, it seems not at all exaggerated when Robert Venturi says Symbol dominates space.

↗

강미연

1989년생, 한국. 활자공간에서 현재 활자 디자이너로 일하고 있다. 한글의 구조를 이용해 다양한 의미의 공간 안에서 변화하는 글자를 작업했다. 타이포그래피 잡지 히읗에 참여하고 있다.

국민대학교 시각디자인학과 타이포그래피 3

조열음 ,김형민, 김성진, 임주희, 최규성, 이아현, 서원경, 임다인.

김경선

1970년생, 한국. 그래픽 디자이너, 서울대학교 시각디자인학과 교수. 건국대학교 시각디자인학과를 졸업하고 영런 런던 센트럴 세인트 마틴스 컬리지에서 커뮤니케이션 디자인으로 석사 학위를 받았다. 디자이너 그룹 진달래의 멤버이며 타이포잔치 2015의 예술 감독이다.

김병조

1983년생, 한국. 그래픽 디자이너. 텍스트와 기호에 잠재된 개인의 기억과 물성에 대한 작업을 통해 자신의 작업 세계를 구축하고 있다. 홍익대학교에서 그래픽 디자인을 공부했고, 2012년 같은 학교 대학원에서 타이포그래피 공간의 구조에 대한 연구로 박사 학위를 받았다. 타이포그래피 사전(2012)의 공동 저자였으며, 타이포잔치 2013의 작가였다. bjkim.kr

김지현

1963년생, 한국. 한성대학교 시각디자인과 교수이자 한국타이포그라피학회의 3대 회장이다. 서울대학교 응용미술학과를 졸업하고 같은 학교 대학원에서 수학한 뒤 미국 이스턴미시간대학교 대학원에서 석사 학위를 받았다.

김현미

1970년생, 한국. SADI 교수이며 한국타이포그라피학회에서 국제 이사를 맡고 있다. 서울대학교 산업디자인학과에서 시각디자인 전공, 미국 로드아일랜드 디자인 대학 대학원에서 그래픽 디자인을 전공했다. 저서로 신 타이포그라피 혁명가 얀 치홀트(디자인하우스), 좋은 디자인을 만드는 33가지 서체 이야기(세미콜론)가 있다.

김희용

1977년생, 한국. 그래픽 디자이너. 미국 워싱턴대학에서 독어독문학과 생물학을 전공하고, 독일 함부르크 국립조형예술대학에서 알파벳 캘리그래피와 타이포그래피로 석사 학위를 받았다. 독일 URW++, 피터 슈미트 그룹을 거쳐 한국에서 필묵과 601비상에서 디자이너로

일했다. 다년간 성균관대학교에서 학생들을 가르치고 있으며, 알파벳 캘리그래피 수업과 디자인 작업을 병행하고 있다. 저서로 알파벳 캘리그래피(홍디자인)가 있다.

노민지

1985년생, 한국. 서울에서 활동하는 활자 디자이너. 홍익대학교 대학원에서 한글 문장부호에 대한 연구로 석사 학위를 받았다. 활자공간, 윤디자인연구소를 거쳐 2012년부터 현재 ag타이포그래피연구소에서 활자 디자이너로 일하고 있다. 보은체(2007), 마른굴림체(2009), 둥근 안상수체(2013) 등 여러 글자체를 개발했다.

노은유

1983년생, 한국. 활자 디자이너, 연구자. 홍익대학교 시각디자인과를 졸업하고 같은 학교 대학원에서 최정호 한글꼴에 대한 연구로 박사 학위를 받았다. 활자공간을 거쳐 현재 ag타이포그래피연구소에서 책임 연구원으로 일하고 있다. 소리체(2005), 로명체(2010) 등을 디자인했다.

민구홍

1985년생, 한국. 중앙대학교에서 문학과 언어학을 공부했다. 안그라픽스에서 기획자, 편집자로 일하며 글짜씨(2010-), 타이포그래피 디자인(2014), 획(2014) 등 타이포그래피 관련 책을 만드는 한편, 파주타이포그라피학교에서 학생을 가르친다.

박경식

1973년생, 한국. 이렇다 못할 업적 없이 디자인한답시고 여기저기 돌아다닌다. 간혹 강사로, 어떤 때는 글쟁이로, 그리고 가끔은 디자이너로 밥벌이를 겨우 해나가고 있다. 지금은 타이포그래피 잡지 히읗의 공동 편집장, N&Co.라는 그래픽 디자인 스튜디오 대표로 혼자 일하고 있다. 취미는 장난감 수집, 미국 만화책 수집, 그리고 책상 정리이다.

박기수

1980년생, 한국. 홍익대학교 디자인학부에서 시각 디자인을, 같은 학교 대학원에서 사진을 전공하고, 다수의 예술 프로젝트에서 사진 기록을 담당했다. 현재는 파주타이포그라피학교의 사진 담당 스승으로 일하고 있다.

안상수

1952년생, 한국. 그래픽 디자이너. 홍익대학교 시각디자인과를 졸업하고 한양대학교에서 이상 시에 대한 연구로 박사 학위를 받았다. 1985년에 안그라픽스를 설립했고, 홍익대학교 시각디자인과 교수를 지냈다. 2007년

구텐베르크상, 2009년 ICOGRADA 교육상을 수상했다. 현재 AGI 회원이며, 파주타이포그라피학교 날개(교장)로 있다. ssahn.com

엘리엇 얼스

크랜브룩 예술학교 그래픽 디자인 대학원 주임교수. 진보적인 그래픽 디자이너인 동시에 행위예술가, 설치예술가, 영화감독, 저술가, 음악가이다. 그의 활동은 디자인이라는 일반적인 통념을 산산조각낼 정도로 다채롭다. 1997년 뉴욕 소호에 위치한 독립 미술 공간인 '여기'에서 처음 공연을 선보인 이후 그의 행위예술은 미네아폴리스 워커 아트 센터, 포틀랜드 오크 스트리트 시어터, 리스본 익스페리멘타 99, 베를린 타이포 2000, 파크시티 리빙 서스페이스와 같은 다양한 무대에서 선보였다. 영화감독으로서 엘리엇 얼스는 2002년에 캣피쉬라는 제목의 55분짜리 영화를 만들어 에미그레를 통해 DVD로 배포했고, 이는 뉴욕 타임즈, 에미그레, 블루프린트, ID, 크레이티브 리뷰, 크레이티비티, 아이 등의 수많은 매체에 소개된 바 있다. 2005년, 그는 급기야 독기를 품은 요나의 아들이라는 이름의 밴드를 결성해 2006년 디트로이트 음악당에서 데뷔하기에 이른다.

유지원

1977년생, 한국. 타이포그래피 저술가이자 디자이너. 서울대학교 시각디자인과를 졸업하고 라이프치히 그래픽 서적 예술 대학에서 타이포그래피를 공부했다. 서울대학교와 홍익대학교 등에서 학생들을 가르치고 있다. blog.naver.com/pamina7776

이병학

1978년생, 한국. 인쇄 매체의 역사에 관심을 가지고 있는 정보 인터랙션 디자이너이다. 서울대학교 디자인학부를 졸업하고 동 전공에서 타임라인 인터페이스에 관한 연구로 석사 학위를, 표제지 장식에 관한 연구로 박사 학위를 받았다. 현재 취그루프에 재직하고 있으며 정보 미디어 개론, 인터랙션 디자인, 정보 디자인을 강의하고 있다.

이재민

1979년생, 한국. 서울대학교에서 시각디자인을 공부한 뒤, 2006년부터 그래픽 디자인 스튜디오 fnt를 기반으로 동료들과 함께 다양한 프로젝트들을 진행해 왔다. CREATIVE©ITIES, 상하이 아시아 그래픽 디자인 비엔날레, 타이포잔치 2011, 디자인코리아 2010, 그래픽 디자인 페스티벌 브레다 – 연결된 프로젝트 등의 전시에 참여했으며 서울대학교와 서울시립대학교에 출강 중이다. leejaemin.net

임유나

1983년생, 한국. 전문번역가이다. 이화여자대학교에서 프랑스 문학과 철학을 전공했다. 타이포그래피 잡지 히읗의 아카이브 번역을 맡고 있다. 2014년 현재 이화여자대학교 통번역대학원 한영번역학과에 재학 중이다.

전가경

1975년생, 한국. 문학과 그래픽 디자인을 공부했다. 독일의 1960년대 잡지 트웬의 사진 다루기를 주제로 홍익대학교 대학원 석사 논문을 썼다. 디자인 회사 AGI 소사이어티에서 사진과 그림 중심의 책들을 기획하고 만들었다. 사진과 텍스트 그리고 그래픽 디자인이라는 세 가지 항이 만들어가는 관계에 관심이 있고, 이에 대한 실천적 연구로서 2013년부터 사진책 전문 출판사 사월의눈을 운영하고 있다. 저서로 세계의 아트디렉터 10(2009)이 있으며, 현재 두 번째 책을 쓰고 있다. blog.naver.com/honeyshy1

전종현

1985년생, 국민대학교 시각디자인학과를 졸업했다. 한국문화관광연구원(KCTI)을 거쳐 월간 디자인 편집부에서 디자인 언어로 유쾌하고 다양한 이야기를 매달 기사로 풀어냈다. 읽기 4-1, DRS4: 도시의 시간, 서울 디자인 15 풍경, 따뜻한 돌 몇 개: 온돌 3에 필자로 참여했다. 현재 '사물 번역가'를 지향하며 디자인 저널리스트로 활동 중이다. huffingtonpost.kr/harry-jun

정영훈

1984년생, 한국. 그래픽 디자이너다. 목원대학교 시각디자인학과를 졸업하고, 국민대학교 대학원 커뮤니케이션 디자인학과에서 디자인 석사 학위를 받았다. younghun.net

채혜선

1980년생, 한국. 그래픽 디자이너다. 경희대학교에서 그래픽 디자인을, 영국 런던 골드스미스컬리지에서 언어와 현대 문화를 공부 후, 비평적 디자인으로 석사 학위를 받았다. 2012년 이후 서울에서 상업적으로는 브랜드 디자인을 개인적으로는 발달성 난독증 글자체를 연구하고 있다. hyesunchae.com

크리스 로

1976년생, 한국. 미국에서 태어나 자란 교포 2세로, 미국 버컬리대학교에서 건축을 전공하고, 미국 로드아일랜드 디자인 대학에서 그래픽 디자인으로 석사 학위를 받았다. 2010년부터 한국에서

살고 있는 그는 디자인 글쓰기, 타이포그래피에 대한 폭넓은 리서치를 진행하고 있다. 특히 한국 시각 문화에 대한 호기심에서 학생들과 함께 진행한 온돌 프로젝트는 3회를 맞이하며 주목받고 있다. 현재는 홍익대학교 시각디자인과 교수로 재직하고 있다.

↓

Ahn Sang-soo

Born in 1952, Ahn Sang-soo is a graphic designer and typographer. He studied visual communication design at Hongik University and got the ph.D. at Hanyang University for typographic study of Yi Sang's poetry. Ahngraphics was founded by him in 1985. And He was a professor of visual communication design at Hongik University. He won the gutenberg award in 2007. He is a member of AGI, and a principal of Paju typography institute.

Chae Hye-sun

Born in 1980, Korea. Chae Hye-sun is a graphic designer. She studied graphic design at Kyunghee University, language and contemporary culture at Goldsmiths College, University of London, then received her MA in Design Critical Practice. She is currently working in brand disciplines, exploring Korean typeface design for developmental dyslexics. hyesunchae.com

Chris Ro

Born in 1976, Korea. Chris Ro is a second-generation Korean-American designer. He studied architecture at the University of California in Berkeley, and earned his MFA from the Rhode Island School of Design. He is living and working in Korea since 2010. He has organized a student research project devoted to Korean visual culture called the Ondol Project and has published three issues so far. He has been involved in extensive researches on design writing, graphic design and typography. As a practitioner, he works across various media including book design, branding, advertising and motion graphics. Currently he is professor at Hongik University.

Elliot Earls

Born in 1966, Elliot Earls, the Head of the Graduate Graphic Design Department at Cranbrook Academy of Art, is a progressive graphic designer, performance artist, installation artist, filmmaker, writer, and musician. He certainly is a man of versatile talents that breaks the common idea about a designer. Earls began performing at the independent art center in Soho New York City in 1997. It gave him a jump start to perform in diverse places including The Walker Art Center, Minneapolice, The Oak Street Theater, Portland, Experimenta 99, Lisbon; Opera Totale, Venice; Typo 2000 in Berlin; and Living Surfaces in Park City. As a filmmaker, Earls in association with Emigre Inc., released Catfish a 55-minute film on DVD in 2002. His film work has been featured in numerous publications including: The New York Times, Emigre Magazine, Blueprint Magazine, ID Magazine, Creative Review, Creativity, and EYE magazine. In 2005, after all, Earls formed the band The Venomous Sons of Jonah. In 2006, Elliott debuted the performance at Music Hall Detroit with special guests The Venomous Sons of Jonah.

Fritz K. Park

Born in 1973, Korea. With nothing to really account for, Fritz Park wears many hats... sometimes as lecturer, writer, or designer, he likes to think he 'provides' for his family. He co-edits Hiut, a typography magazine as well as runs N&Co. a single-person business he was forced to register after he had his ass handed to him by the tax office last fiscal year. Fritz collects vintage toys, comics and ever strives for that perfect balance of zen when organizing his desk.

Harry Jun

Born in 1985, Harry Jun studied visual communication design at Kookmin University. After his first job in Govermental Think Tank, Korea Cultural & Tourism Institute(KCTI), he has worked in Monthly DESIGN as an editor who translated a variety of design language for readers. He participated in several publications: Reading 4-1, DRS4: the time of the city, A Few Warm Stones: Ondol 3, Seoul Design 15 Landscapes. Now he is a design journalist under the concept of 'Objectranslator'.

Im Yoona

Born in 1983, Im Yoona is a translator between Korean and English. She double majored in French Language and Literature and Philosophy at the Ewha Womans University. She has translated the archive article of the typography magazine Hiut. She is now studying at the Ewha Graduate School of Translation and Interpretation.

Jung Young-hun

Born in 1984, Korea, Jung Young-hun is a graphic designer. He studied visual communication design at Mokwon University and received a MFA in communication design at Kookmin University.

Kay Jun

Born in 1975, Korea. Kay Jun studied literature and graphic design. She wrote her master's thesis on the photography direction of German sixties magazine TWEN. She was in charge of publishing team at the design studio AGI Society, Since 2013, she's running Aprilsnow Press, a small press focusing on photography books. She is the author of the book World's Ten Art Directors and her second book is on the way this year.

Kim Byung-jo

Born in 1983, Korea. Graphic designer. He building his own world with works of the potential personal memory and property of matter in text and sign. He studied graphic design at Hongik University and earned a doctorate from Hongik University for a study on the structure of typographic space in 2012. He has co-wrote A Dictionary of Typography (Ahn Graphics, 2012), participated in Typojanchi 2013: International Typography Biennial. bjkim.kr

Kim Hee-yong

Born in 1977, he is a graphic designer. He studied German Literature and Biology at the Washington University in St. Louis. Then he took master's degree for alphabet calligraphy and typography at the Hamburg University of Applied Sciences in Germany. He worked as a designer at URW++, Peter Schmidt Group, Philmuk and 601 Bisang. He has taught students at the Sungkyunkwan University for years, giving lectures on typography, while running alphabet calligraphy workshops and working on design projects as well. He wrote Alphabet Calligraphy published by Hongdesign.

Kim Hyun-mee

Born in 1970 in Seoul, Korea.

Hyun-mee Kim is a professor at SADI and director of International relations for the Korean Society of Typography. She studied visual communication at Seoul National University and received her MFA in graphic design at RISD. She is author of the books Jan Tschichold, A Revolutionist of the New Typography and 33 Essential Typefaces for Good Design.

Kim Jee-hyun

Born in 1963, Korea. Kim Jee-hyun is a professor of visual communication at Hansung University and the 3rd chairwoman of the Korean Society of Typography. She studied at both the undergraduate and graduate level in applied fine arts at Seoul National University and Eastern Michigan University.

Kymn Kyung-sun

Born in 1970, Korea. Graphic designer and professor at Seoul National University. He studied visual communication design at Konkuk University. Then he took master's degree at Saint Martins College of Art and Design in London. He is a member of designer group Jindalrae. He is the art director of Typojanchi 2015.

Lee Byoung-hak

Born in 1978, Lee Byoung-hak is an Interaction designer who has an interest in history of printed media. Researching history of title-page decoration, he graduated from doctoral course of Seoul National University. At the moment he is working at CHUIGRAF and teaching Informative media, Interaction design, Information design.

Lee Jae-min

Born in 1979, he studied visual design at the Seoul National University. Since 2006, he has led various projects with his colleagues for which the graphic design studio fnt was used at a stronghold. He has participated in a number of exhibitions: CREATIVE@ITIES, Shanghai Biennial of Asia Graphic Design, Seoul International Typography Biennale 2011, Design Korea 2010, Connected Project by Graphic Design Festival Breda. He is giving his lectures at the Seoul Nation University and the University of Seoul. leejaemin.net

Min Guhong
Born in 1985, Korea. Min Gu-hong
studied literature and linguistics at
Chung-ang University. Currently
works as a planner and editor
at Ahn Graphics and teaches at
Paju Typography Institute. He
has edited typography-related
books such as LetterSeed(2010-),
Typographische Gestaltung(2014),
The Stroke(2014) and so on.

Noh Eun-you
Born in 1983, Noh Eun-you is
a Seoul based font designer. She
studied visual communication
design and got the ph.D. at Hongik
University for a study on Choi
Jeong-ho's Hangeul typefaces.
She has worked in type-space.
She is currently working as
a senior researcher at the ag
Typography Lab. She developed
the typefaces Sori(2005),
Rohmyeong(2010).

Noh Min-ji
Born in 1985, Noh Min-ji is a
Seoul based font designer. She
graduated from the graduate
school of Hongik University with a
study about Hangeul punctuation
marks. She has worked in the
organizations Type space and
Yoon design. She is currently
working at the ag Typography Lab
since 2012. She developed the
typefaces Boeun, Mareun Gulim
and Ahnsangsoo Rounded.

Park Ki-su
Born in 1980, he majored in
visual communication design at
the College of Design of Hongik
University and photography at
the Graduate School of Hongik
University. He worked as a
photographer for a number of
art projects. He now teaches
photography to the students at
the Paju Typography Institute.

**3rd year Visual
Communication
Department Students,
Kookmin University**
Cho Yeol-eum, Choi Kyu-sung,
Kim Hyung-min, Kim Sung-jin,
Lee Ah-hyun, Lim da-in,
Seo Won-kyoung, Yim Joo-hee.

Yu Jiwon
Born in 1977, Yu Jiwon is a
typography writer and designer.
She studied visual communication
at Seoul National University and
typography at the Hochschule
für Grafik und Buchkunst Leipzig.
She teaching at Seoul National
University and Hongik University.

↗

논문 투고 규정

목적
이 규정은 본 학회가 발간하는 학술논문집 글짜씨 투고에 대한 사항을 정함을 목적으로 한다.

투고 자격
글짜씨에 투고 가능한 자는 본 학회의 정회원과 명예회원이며, 공동 연구일 경우라도 연구자 모두 동일한 자격을 갖추어야 한다.

투고 유형
글짜씨에 게재되는 논문은 미발표 원고를 원칙으로 한다. 다만, 본 학회의 학술대회나 다른 심포지움 등에서 발표했거나 대학의 논총, 연구소나 기업 등에서 발표한 것도 국내에 논문으로 발표되지 않았다면 출처를 밝히고 글짜씨에 게재할 수 있다.
1 연구 논문: 타이포그래피 관련 주제에 대해 이론적 또는 실증적으로 논의한 것
2 프로젝트 논문: 프로젝트의 결과가 독창적이고 완성도를 갖추고 있으며, 전개 과정이 논리적인 것
3 기타: 그 외 독창적인 관점과 형식으로 타이포그래피에 대한 자신의 주장을 명확하게 기술한 것

투고 절차
논문은 다음과 같은 절차를 거쳐 투고, 게재할 수 있다.
1 학회 이메일로 수시로 논문 투고 신청
2 논문 투고시 학회 규정에 따라 작성된 원고를 사무국에 제출
3 심사료 100,000원을 입금
4 편집위원회에서 정한 절차에 따라 심사위원 위촉, 심사 진행
5 투고자에게 결과 통지 (결과에 이의가 있을 시 학회로 이의 신청서 제출)
6 완성된 논문 원고를 이메일로 제출, 게재비 100,000원 입금
7 논문집은 회원 1권, 필자 2권 씩 우송
8 논문집 발행은 6월 30일, 12월 31일 연2회

저작권 및 출판권
저작권은 저자에 속하며, 글짜씨의 편집출판권은 학회에 귀속된다.

규정 제정: 2009년 10월 1일

↓

논문 작성 규정

작성 방법
1 원고는 편집 작업 및 오류 확인을 위해 txt / doc 파일과 pdf 파일을 함께 제출한다. 특수한 경우 indd 파일을 제출할 수도 있다.
2 이미지는 별도의 폴더에 정리해 제출해야 한다.
3 공동 저술의 경우 제1연구자는 상단에 표기하고 제2연구자, 제3연구자 순으로 그 아래에 표기한다.
4 초록은 논문 전체를 요약해야 하며, 한글 기준으로 800자 안팎으로 작성해야 한다.
5 주제어는 세 개 이상 다섯 개 이하로 수록한다.
6 논문 형식은 서론, 본론, 결론, 주석, 참고 문헌을 명확히 구분해 작성하는 것을 기본으로 하며, 연구 성격에 따라 자유롭게 작성할 수도 있다. 그러나 반드시 주석과 참고 문헌을 수록해야 한다.
7 외국어는 원칙적으로 한글로 표기하고 뜻이 분명치 않을 때는 괄호 안에 원어를 표기한다. 단, 처음 등장하는 외국어 고유명사는 괄호로 원어를 병기하고 그 다음부터는 한글만 표기한다.
8 각종 기호 및 단위의 표기는 국제적인 관용에 따른다.
9 그림이나 표는 고해상도로 작성하며, 그림 및 표의 제목과 설명은 본문 또는 그림, 표에 함께 기재한다.
10 참고 문헌은 한글, 영어, 기타로 정리한다. 모든 문헌은 가나다순, 알파벳순으로 나열한다. 각 문헌의 정보는 저자, 논문명(서적명), 학회지명(저서는 해당없음), 학회(출판사), 출판연도 순으로 기술한다.

분량
본문 활자 10포인트를 기준으로 A4 6쪽 이상 작성한다.

Regulations for Article Submission

Purpose
These regulations are to establish a framework as to article submission to LetterSeed, the journal published by the Korean Society of Typography.

Qualification of Authors
Only the regular or honorary members of the society are qualified for article submission to LetterSeed. Co-authors should hold the same qualification.

Category of Articles
It is the principle that authors should not submit previously published work. However, if an article has been presented on the conference of the society or symposiums or printed in journals of colleges, research centers or companies, but never published as an article on any media in Korea, it can be published in LetterSeed when the author discloses the source.
1 Research articles: The articles that describe either empirical or theoretical studies on the subjects related to typography.
2 Project reports: The full length reports of which the results are original and logically delivered.
3 Others: Other types of articles that are clearly written on typography in a novel form and from a new point of view.

Submission Procedure
Articles can be submitted and published following the procedure:
1 Authors apply at any time for article submission via e-mail.
2 Authors submit the article to the office according to the guidelines for article submission.
3 Authors send 100,000 won for assessment fee.
4 The society appoints judges according to the procedure established by the editorial board.
5 The society notifies the author the result of assessment (if there is any objection to the result, the author send the statement of protest to the society).
6 The author sends the final version of the article via e-mail and 100,000 won for publishing fee.
7 The author receives two volumes of the journal (regular members receive one volume).
8 The journal is published twice a year, on June 30 and December 31.

Copyright and the Right of Publication
Authors retain copyright and grant the society right of editing and publication of the article in the LetterSeed.

Declaration: 1 October 2009

↓

Guidelines of Writing an Article

Preparation of Manuscript
1 The article should be sent in the form of both TXT/DOC file and PDF file in order for the society to check errors in the article and edit it. INDD files can be submitted in particular cases.
2 Image files should be submitted in a separate folder.
3 As to the jointly written article, the name of the main writer should be written at the top and the second and the third have to follow on the next lines.
4 The abstract, plus or minus 800 Korean characters, has to summarize the whole article.
5 The number of keywords should be between three and five.
6 The article should contain introduction, body, conclusion, footnotes and reference, parts that are clearly distinguished from each other. Articles of special types can be written in free style, but footnotes and reference cannot be missed.
7 Chinese and other foreign words should be translated into Korean. When the meaning is not delivered clearly by Korean words only, the original words or Chinese characters can be put beside the Korean words in the parenthesis. After the first

인쇄 원고 작성

1. 디자인된 원고를 투고자가 확인한 다음 인쇄한다. 원고 확인 후 원고에 대한 책임은 필자에게 있다.
2. 학회지의 크기는 171 x 240 mm로 한다. (2013년 12월 이전에 발행된 학회지의 크기는 148 x 200 mm)
3. 원고는 흑백을 기본으로 한다.

규정 제정: 2009년 10월 1일

↓

논문 심사 규정

목적
본 규정은 한국타이포그라피학회 학술지 글짜씨에 투고된 논문의 채택 여부를 판정하기 위한 심사 내용을 규정한다.

논문 심사
논문의 채택 여부는 편집위원회가 심사를 실시해 다음과 같이 결정한다.
1. 심사위원 세 명 가운데 두 명이 '통과'로 판정할 경우 게재할 수 있다.
2. 심사위원 세 명 가운데 두 명이 '수정 후 게재' 이상으로 판정하면 편집위원회가 수정 사항을 심의하고 통과 판정해 논문을 게재할 수 있다.
3. 심사위원 세 명 가운데 두 명이 '수정 후 재심사' 이하로 판정하면 재심사 후 게재 여부가 결정된다.
4. 심사위원 세 명 가운데 두 명 이상이 '게재 불가'로 판정하면 논문을 게재할 수 없다.

편집위원회
1. 편집위원회의 위원장은 회장이 위촉하며, 편집위원은 편집위원장이 추천해 이사회의 승인을 받는다. 편집위원장과 위원의 임기는 2년으로 한다.
2. 편집위원회는 투고 된 논문에 대해 심사위원을 위촉하고 심사를 실시하며, 필자에게 수정을 요구한다. 수정을 요구받은 논문이 제출 지정일까지 제출되지 않으면 투고의 의지가 없는 것으로 간주한다. 또한 제출된 논문은 편집위원회의 승인 없이 변경할 수 없다.

심사위원
1. 글짜씨에 게재되는 논문은 심사위원 세 명 이상의 심사를 거쳐야 한다.
2. 심사위원은 투고된 논문 관련 전문가 중에서 논문편집위원회의 결정에 따라 위촉한다.
3. 논문심사의 결과는 아래와 같이 판정한다.
 통과, 수정 후 게재, 수정 후 재심사, 불가

심사 내용
1. 연구 내용이 학회의 취지에 적합하며 타이포그래피 발전에 기여하는가?
2. 주장이 명확하고 학문적 독창성을 가지고 있는가?
3. 논문의 구성이 논리적인가?
4. 학회의 작성 규정에 따라 기술되었는가?
5. 국문 및 영문 요약의 내용이 정확한가?
6. 참고 문헌 및 주석이 정확하게 작성되었는가?
7. 제목과 주제어가 연구 내용과 일치하는가?

제정: 2009년 10월 1일
개정: 2013년 3월1일

↓

연구 윤리 규정

목적
본 연구 윤리 규정은 한국타이포그라피학회 회원이 연구 활동과 교육 활동을 하면서 지켜야 할 연구 윤리의 원칙을 규정한다.

윤리 규정 위반 보고
회원은 다른 회원이 윤리 규정을 위반한 것을 인지할 경우 해당자로 하여금 윤리 규정을 환기시킴으로써 문제를 바로잡도록 노력해야 한다. 그러나

appearance with the foreign word in the form of "a Korean word (the corresponding foreign word)," only the Korean word should be used in the rest of the article.

8. Symbol and measures are to be written following the international standard practice.
9. Images and figures should be included in high-resolution. Captions should be included either in the body of the article or on the image or figure.
10. References should be listed in order of Korea and English. All the works should be arranged in alphabetical order. Information of each work should include the name of the author, the title, the name of the journal (not applicable to books), the publisher, and the year of publication.

Length
Articles should be more than six pages in a 10-point font.

Printing
1. Once manuscript file is typeset, the corresponding author checks the layout. From this point, the author is accountable for the published article and responsible for any error in it.
2. The size of the journal is 171 x 240 mm (it was 148 x 200 mm before December 2013).
3. The basic color is black for the printed articles.

Declaration: 1 October 2009

↓

Article Assessment Policy

Purpose
The policy below defines the framework of the assessment practice at the Korean Society of Typography of articles submitted to LetterSeed.

Article Assessment Principles
Whether the article is accepted or not is decided by the editorial board.
1. If two of three judges give an article "pass," the article can be published in the journal.
2. If two of three judges consider an article better than "acceptable if revised," the editorial board asks the author for a revision and publishes it if it meets the requirements.
3. If two of three judges consider an article poorer than "reassessment required after revision," the article has to be revised and the judges reassess to determine whether it is qualified to publish.
4. If more than two of three judges give an article a "fail," the article is rejected to be published in the journal.

The Editorial Board
1. The chief of the editorial board is appointed by the president of the society and the chief of the editorial board recommend the editorial board members for the board of directors to approve. The chief and members of the editorial board serve a two year term.
2. The editorial board appoints the judges for a summited article who will make the assessment and ask the author for revision if necessary. If the author does not send the revised article until the given date, it is regarded he or she does not want the article to be published. The submitted articles cannot be altered unless the author gets approval from the editorial board.

Judges
1. The articles published in LetterSeed should be assessed and screened by more than three judges.
2. The editorial board members appoint the judges among the experts on the subject of the submitted article.
3. There are four assessment results: pass, acceptable after revision, reassessment required after revision, fail

Assessment Criteria
1. Is the subject of the article relevant to the tenet of the society

문제가 바로잡히지 않거나 명백한 윤리 규정 위반 사례가 드러날 경우에는 학회 윤리위원회에 보고할 수 있다. 윤리위원회는 문제를 학회에 보고한 회원의 신원을 외부에 공개해서는 안 된다.

연구자의 순서
연구자의 순서는 상대적 지위에 관계없이 연구에 기여한 정도에 따라 정한다.

표절
논문 투고자는 자신이 행하지 않은 연구나 주장의 일부분을 자신의 연구 결과이거나 주장인 것처럼 논문에 제시해서는 안 된다. 타인의 연구 결과를 출처를 명시함과 더불어 여러 차례 참조할 수는 있으나, 그 일부분을 자신의 연구 결과이거나 주장인 것처럼 제시하는 것은 표절이 된다.

연구물의 중복 게재
논문 투고자는 국내외를 막론하고 이전에 출판된 자신의 연구물(게재 예정인 연구물 포함)을 사용해 논문 게재를 할 수 없다. 단, 국외에서 발표한 내용의 일부를 한글로 발표하고자 할 경우 그 출처를 밝혀야 하며, 이에 대해 편집위원회는 연구 내용의 중요도에 따라 게재를 허가할 수 있다. 그러나 연구자는 이를 중복 연구실적으로 사용할 수 없다.

인용 및 참고 표시
1 공개된 학술 자료를 인용할 경우에는 정확하게 기술해야 하고, 반드시 그 출처를 명확히 밝혀야 한다. 개인적인 접촉을 통해서 얻은 자료의 경우에는 그 정보를 제공한 사람의 동의를 받은 후에만 인용할 수 있다.
2 다른 사람의 글을 인용할 경우에는 반드시 주석을 통해 출처를 밝혀야 하며, 이런 표기를 통해 어떤 부분이 선행 연구의 결과이고 어떤 부분이 본인의 독창적인 생각인지를 독자가 알 수 있도록 해야 한다.

공평한 대우
편집위원은 학술지 게재를 위해 투고된 논문을 저자의 성별, 나이, 소속 기관 및 어떤 선입견이나 사적인 친분과 무관하게 오직 논문의 질적 수준과 투고 규정에 근거해 공평하게 취급해야 한다.

심사 의뢰
편집위원은 투고된 논문의 평가를 해당 분야의 전문적 지식과 공정한 판단 능력을 지닌 심사위원에게 의뢰해야 한다. 심사 의뢰시 저자와 지나치게 친분이 있거나 지나치게 적대적인 심사위원을 피함으로써 가능한 한 객관적인 평가가 이루어질 수 있도록 노력한다. 단, 같은 논문에 대한 평가가 심사위원 간에 현저하게 차이가 날 경우에는 해당 분야의 제3의 전문가에게 자문을 받을 수 있다.

공정한 심사
심사위원은 논문을 개인적인 학술적 신념이나 저자와의 사적인 친분 관계를 떠나 공정하게 평가해야 한다. 근거를 명시하지 않은 채 논문을 탈락시키거나, 심사자 본인의 생각과 상충된다는 이유로 논문을 탈락시켜서는 안 되며, 심사 대상 논문을 제대로 읽지 않고 평가해서도 안 된다.

저자 존중
심사위원은 전문 지식인으로서의 저자의 인격과 독립성을 존중해야 한다. 평가 의견서에는 논문에 대한 자신의 판단을 밝히되, 보완이 필요한 부분에 대해서는 그 이유도 함께 상세하게 설명해야 한다. 정중하게 표현하고, 저자를 비하하거나 모욕적인 표현은 삼간다.

비밀 유지
편집위원과 심사위원은 심사 대상 논문에 대한 비밀을 지켜야 한다. 논문 평가를 위해 특별히 조언을 구하는 경우가 아니라면 논문을 다른 사람에게 보여주거나 논문 내용을 놓고 다른 사람과 논의하는 것도 바람직하지 않다. 또한 논문이 게재된 학술지가 출판되기 전에 저자의 동의 없이 논문의 내용을 인용해서는 안 된다.

윤리위원회의 구성과 의결
1 윤리위원회는 회원 5인 이상으로 구성되며, 위원은 운영위원회의 추천을 받아 회장이 임명한다.
2 윤리위원회에는 위원장 1인을 두며, 위원장은 호선한다.
3 윤리위원회는 재적위원 3분의 2의 찬성으로 의결한다.

and contributable to the advance of typography?
2 Does the article make a clear point and have academic originality?
3 Is the article logically written?
4 Is the article written according to the guidelines provided by the society?
5 Does the Korean and English summary exactly correspond to the article?
6 Does the article contain clear reference and footnotes?
7 Do the title and keywords correspond with the content of the article?

Declaration: 1 October 2009

↓

The Code of Ethics

Purpose
The code of ethics below establishes the ethical framework for the members of Korean Society of Typography in doing their research and providing education.

Report of the Violation of the Code of Ethics
If a member of the society witnessed another member's violation of the code of ethics, he or she should tell the member about the code and try to rectify the fault. If the member does not remedy the wrong or the case of violation is flagrant, the witness can report the ethics commission the case. The ethics commission should not reveal the identity of the reporter.

Order of Researchers
The order of researchers is determined by the level of contribution to the research, regardless of their relative status.

Plagiarism
Authors should not represent any research results or opinions of others as their own original work in their articles. Results of other researches can be referred to in an article several times when its source is clarified, but if any of the results are given as if they are the author's own, it is plagiarism.

Redundant Publication
Any works that are previously published (or soon to be published) on any foreign or domestic media cannot be published in the journal. An exceptional case can be made for the work that was presented on foreign media when the author wants to publish part of it in the journal. In this case, the editorial board can approve its publication according to the significance of its content. But the author cannot use the publication as his or her double research achievements.

Quotation and Reference
1 When using the public research results, authors should accurately quote them and disclose their source. If the data is gained from a personal contact, it can be quoted only if the provider agrees to its use in the article.
2 Authors should reveal the source through footnotes when quoting another author's language and expressions, by which the readers could distinguish the precedent research from the original thought developed by the author in the article.

Equal Treatment
The editors of the journal should treat the submitted articles equally regardless of gender or age of the author, or the institution to which the author belongs. All the articles should be properly assessed only based on their quality and the rules of submission. The assessment should not be affected by any prejudice or personal acquaintance of editors.

Appointment of Judges
The editorial board should commission as judges of an article those who are with fairness and have expertise. Those who are closely acquainted with or hostile to the author should be avoided for the fair

윤리위원회의 권한

1. 윤리위원회는 윤리 규정 위반으로 보고된 사안에 대해 증거자료 등을 통해 조사를 실시하고, 그 결과를 회장에게 보고한다.
2. 윤리규정 위반이 사실로 판정되면 윤리위원장은 회장에게 제재 조치를 건의할 수 있다.

윤리위원회의 조사 및 심의

윤리 규정을 위반한 회원은 윤리위원회의 조사에 협조해야 한다. 윤리위원회는 윤리 규정을 위반한 회원에게 충분한 소명 기회를 주어야 하며, 윤리 규정 위반에 대해 윤리위원회가 최종 결정할 때까지 해당 회원의 신원을 외부에 공개해서는 안 된다.

윤리 규정 위반에 대한 제재

1. 윤리위원회는 위반 행위의 경중에 따라서 아래와 같은 제재를 할 수 있으며, 각 항의 제재가 병과될 수 있다.
 a. 논문이 학술지에 게재되기 이전인 경우 또는 학술대회 발표 이전인 경우에는 당해 논문의 게재 또는 발표의 불허
 b. 논문이 학술지에 게재되었거나 학술대회에서 발표된 경우에는 당해 논문의 학술지 게재 또는 학술대회 발표의 소급적 무효화
 c. 향후 3년간 논문 게재 또는 학술대회 발표 및 토론 금지
2. 윤리위원회가 제재를 결정하면 그 사실을 연구 업적 관리 기관에 통보하며, 기타 적절한 방법으로 공표한다.

규정 제정: 2009년 10월 1일

↗

assessment. However, when the assessments on the same article show remarkable difference, another expert could be employed for consultation.

Fair Assessment

Judges should make a fair assessment of an article regardless of their personal academic beliefs or the acquaintance with its author. They should not reject an article without any supportive reasons or only because it is against their own opinion. They should not assess an article before reading it properly.

Respect for the Author

Judges should respect the personality and individuality of authors as intellectuals. The assessment should include the evaluation of the judges, plus why they think which part of the article needs revision if necessary. The evaluation should be delivered in respectful expression and free of any offense or insult to the author.

Confidentiality

The editors and judges should protect confidentiality of the submitted articles. Aside from the case of consultation, it is not appropriate to show the articles to others or discuss the contents with others. It is not allowed to quote any part of the submitted articles before they are published in the journal.

Composition of the Ethics Commission and Election

1. The ethics commission is composed of more than five members. The commissioners are recommended by the working committee and appointed by the president.
2. The commission has one chief commissioner, who is elected by the commission.
3. The commission makes decisions by a majority of two-thirds or more.

Authority of the Ethical Commission

1. The ethical commission conducts investigation on the reported case in which the code of ethics was allegedly violated and reports the result to the president.
2. If the violation is proved true, the chief commissioner can ask the president for approval of sanctions against the member.

Investigation and Deliberation of the Ethical Commission

The member who allegedly violated the code of ethics should cooperate with the ethics commission in the investigation. The commission should give the member ample opportunity for self-defense and should not reveal his or her identity until the final decision is made.

Sanctions for Violation of the Code of Ethics

1. The ethical commission can impose the sanctions below against those who violated the code of ethics. Plural sanctions can be enforced for a single case.
 a. If the article is not published in the journal or presented on the conference yet, the article is not permitted to be published or presented.
 b. If the article is published in the journal or presented on the conference, the article is retracted.
 c. The member is banned to publish the article or to participate in the conference or in a discussion for the next three years.
2. Once the ethics commission decides to apply sanctions, the commission informs the decision to the institution which manages the researchers' achievements and announces the decision to the public in a proper way.

Declaration: 1 October 2009

↗

학회 가입

타이포그래피를 연구하고 있는 석사 이상 또는 그에 준하는 자격을 갖고 있으며 학회 회원의 추천을 받은 사람은 입회 신청을 할 수 있습니다. 대학원 석사 과정에 재학 중이며 학회 회원의 추천을 받은 사람은 학생 회원 가입 신청을 할 수 있습니다. 도서관과 기업은 단체 회원으로 가입할 수 있습니다. 명예 회원은 이사회에서 선정합니다.

가입 신청은 학회 웹사이트에서 할 수 있습니다. 이사회의 심사 기간은 최대 8주이며 심사 결과는 이메일로 알려드립니다. 회비와 회원 혜택 등 세부 사항은 웹사이트를 참고하기 바랍니다.

정기 구독

글짜씨는 학회 회원이 아닌 사람도 구독할 수 있습니다. 구독 기간은 최소 1년이며, 세부 사항은 학회 웹사이트를 참고하시기 바랍니다. 구독은 info@koreantypography.org로 문의 바랍니다.

후원

한국연구재단
산돌커뮤니케이션

학회와 글짜씨를 후원하려는 분은 info@koreantypography.org로 문의 바랍니다.

Membership

Membership for the society is reserved for those individuals with a Master's degree or higher, and recommended for consideration by a current member, as well as a stronger than usual interest in typography.
Current Master's degree students may apply for a student membership, but must also be recommended for consideration by a current member. Libraries or corporations may also apply as a corporate member. Honorary membership will be considered by the board of the society.

To apply for membership, please visit the KTS website for further information. Membership consideration by the board is 8 weeks, and eligible candidates will be notified via email. For further information concerning membership fees and additional benefits please visit the website.

Subscription

LetterSeed subscriptions are available to non-memebrs and the general public. Minimum subscription rate is 1 year. Please visit the society website for further information. To request a subscription, please contact us via email: infor@koreantypography.org

Sponsor

National Research Foundation of Korea
Sandoll Communication

To sponsor or support the KST, or it's journal LetterSeed please contact the office via email: info@koreantypography.org

글짜씨 9: 오너먼트
LetterSeed 9: Ornament

ISBN: 978-89-7059-752-2 (94600)

2014년 9월 17일 초판 인쇄
2014년 9월 24일 초판 발행

기획: 한국타이포그라피학회
지은이: 이병학, 안상수, 노민지, 노은유, 정영훈,
 크리스 로, 유지원, 이재민, 전종현, 김병조,
 강미연, 엘리엇 얼스, 김희용, 전가경,
 김현미, 김경선
옮긴이: 박경식, 임유나, 채혜선
디자인: 김병조
사진: 박기수

펴낸 곳: (주)안그라픽스
 413-120 경기도 파주시 회동길 125-15
 전화: 031-955-7766
 팩스: 031-955-7755
펴낸이: 김옥철
주간: 문지숙
편집: 민구홍
마케팅: 김헌준, 이지은, 정진희, 강소현
인쇄: 스크린그래픽
제본: SM북

© 2014 한국타이포그라피학회

이 책의 국립중앙도서관 출판시도서목록(CIP)은
서지정보유통지원시스템(seoji.nl.go.kr)과
국가자료공동목록시스템(nl.go.kr/kolisnet)에서
이용할 수 있습니다.

CIP제어번호: CIP2014025004

이 학술지는 2013년도 정부(교육부) 재원으로
한국연구재단의 지원을 받아 출판되었습니다.

↗

First printed in 17 September 2014
First published in 24 September 2014

Concept: Korean Society of Typography
Author: Lee Byoung-hak, Ahn Sang-soo,
 Noh Min-ji, Noh Eun-you,
 Jung Young-hun, Chris Ro, Yu Jiwon,
 Lee Jae-min, Harry Jun, Kim Byung-jo,
 Kang Mi-yeon, Elliott Earls,
 Kim Hee-yong, Kay Jun, Kim Hyun-mee,
 Kymn Kyung-sun
Translations: Fritz Park, Im Yoo-na,
 Chae Hye-sun
Design: Kim Byung-jo
Photography: Park Ki-su

Publisher: Ahn Graphics Ltd.
 125-15 Hoedong-gil, Paju-si,
 Gyeonggi-do 413-120, South Korea
 Tel +82-31-955-7766
 Fax +82-31-955-7755
President: Kim Ok-chyul
Chief Editor: Moon Ji-sook
Editor: Min Gu-hong
Marketing: Kim Heon-jun, Lee Ji-eun,
 Jung Jin-hee, Kang So-hyun
Printing: Screen Graphic
Binding: SM Book

© 2014 Korean Society of Typography

A CIP catalogue record for this book is
available from the National Library of Korea,
Seoul, Republic of Korea.

CIP Code: CIP2014025004

This journal was supported by the National
Research Foundation of Korea Grant funded
by the Korean Government (MOE).

↗